THE PRACTICAL ART OF
Chinese brush painting

THE PRACTICAL ART OF

Chinese brush painting

PAULINE CHERRETT

Published by SILVERDALE BOOKS
An imprint of Bookmart Ltd
Registered number 2372865
Trading as Bookmart Ltd
Desford Road
Enderby
Leicester LE19 4AD

© 2003 D&S Books Ltd

D&S Books Ltd
Kerswell
Parkham Ash, Bideford
Devon, England
EX39 5PR

e-mail us at:
enquiries@dsbooks.fsnet.co.uk

This edition printed 2003

ISBN 1-856057-40-2

DS0068. Practical Chinese Brush Painting

Creative director: Sarah King
Editor: Yvonne Worth
Project editor: Clare Haworth-Maden
Designer: Axis Design Editions

Fonts used in this book: Americana BT,
BellGothic BT, Bernard BT and Arial.

Printed in China

1 3 5 7 9 10 8 6 4 2

Contents

Introduction

History

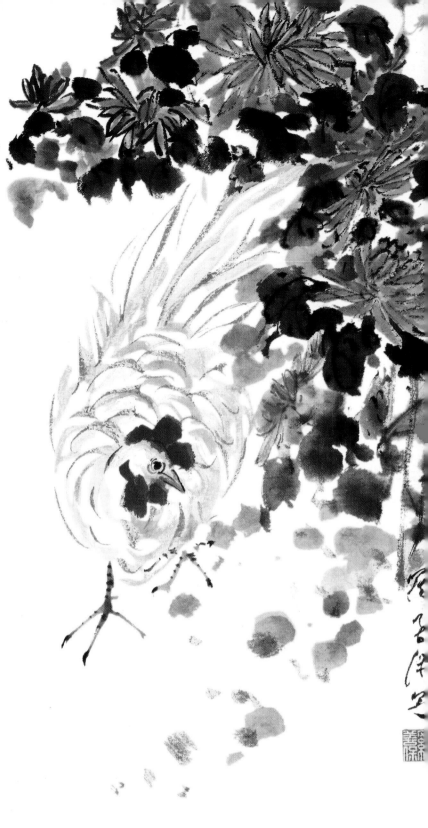

The beginnings of Chinese brush painting can be traced back to an ancient art form in which simple marks were made on a variety of surfaces using a burnt stick. From these early beginnings, the technique of painting on silk (and later paper), using a hair brush, gradually evolved (with rabbit hair being the first fibre to be used for such brushes).

The purpose of most early painting was for recording facts, mainly for religious purposes. Funeral banners and tomb or cave paintings showed deities, along with the deceased, their family, household and possessions. At this early stage, figure work was the only form of painting to be found, it being preferred by the Confucian idealists. Faces and attitudes were stylised and often painted using mineral colours. Today, there are many surviving sites that have paintings dating from the Han to the Tang Dynasty, for example, the Buddhist paintings at the Cave of A Thousand Buddhas in Dunhuang, which have been wonderfully preserved by the desert sands.

During the Six Dynasties period (AD 317–420), the Daoists favoured landscape painting over figure work. For them, nature represented perfection. They preferred to withdraw from the struggles of life and meditate in seclusion. In Chinese spiritual practice, the human state is entirely at peace with inactivity, unlike the Christian tendency in the West, where the individual constantly strives towards salvation through activity. In Chinese paintings of this era, sages and emperors represented heaven, while landscapes depicted the earth, and flowers and birds provided the link with man – these formed the three elements of the universe.

During the Five Dynasties (AD 907–960) period, and into the early part of the Song period, the art of landscape painting was perfected, especially using the 'level distance' viewpoint, as if looking from one mountain top to another, and greater value was placed on order and precision.

Above The autumn chrysanthemum may well harbour some food for this cockerel. Notice the space to the left of the painting by Joseph Lo.

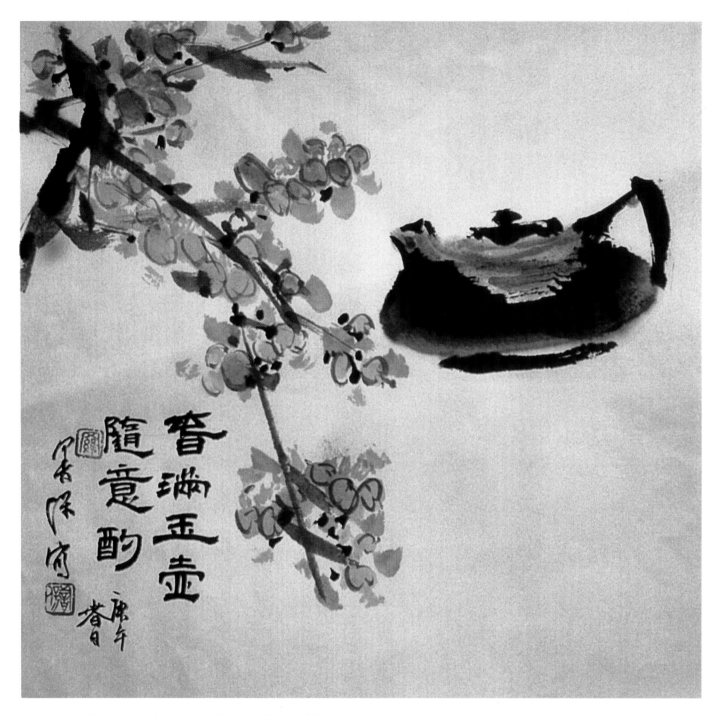

Above One of my favourites by Joseph Lo. The unusual colour of the plum blossom, the clerical calligraphy and the rustic teapot complete a lively painting.

By the 10th century, court life had become a popular subject in Chinese painting. The artist Chou Wen-chu produced many court scenes, such as A Palace Concert, in which he depicts tipsy court ladies. His later work included records of life at court, with such masterpieces as The Admonitions Scroll, which showed the ladies of the court how they ought to behave. The brushwork and technique used to paint fabric became highly skilled, while the faces depicted began to show the variation of nationalities at court, along with a gradual transition from a reverence for plump, mature figures to a preference for slimmer, younger ladies. By the 11th century, the painter Wang Wei was known more for his landscapes than his figure paintings. He changed many concepts about composition, painting numerous scenes that contained large areas of space.

altered the style of landscape painting. Album leaves became very popular with foreigners, especially the work of Ma Yuan (known as 'One-corner Ma'), who used minimum line work. There was also a move away from the idealistic to the realistic in painting styles at this time. The Confucian literati painters used only ink or ink and light wash, with the brushwork itself being of utmost importance.

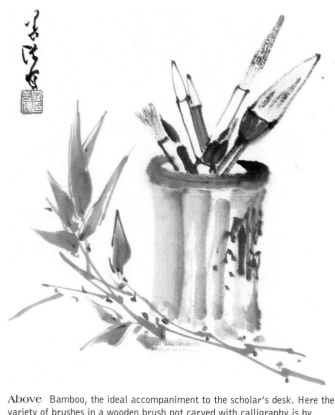

Above Bamboo, the ideal accompaniment to the scholar's desk. Here the variety of brushes in a wooden brush pot carved with calligraphy is by Joseph Lo.

Below The exotic colour and shape of the orchid contrast with the elegant simplicity of this teapot. Another painting by Joseph Lo.

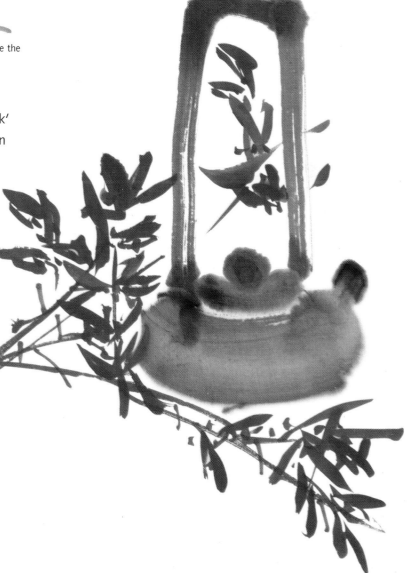

He is also thought to have introduced the 'splash-ink' techniques. At the time, there were also many action painters, who painted using their own hair or even worn-out brushes. By now, a shift towards the importance of depicting nature had occurred that has persisted ever since.

When the court moved south during the Song Dynasty (AD 1127), the change of scenery from the ruggedness of northern China to the gentler vistas of the south also

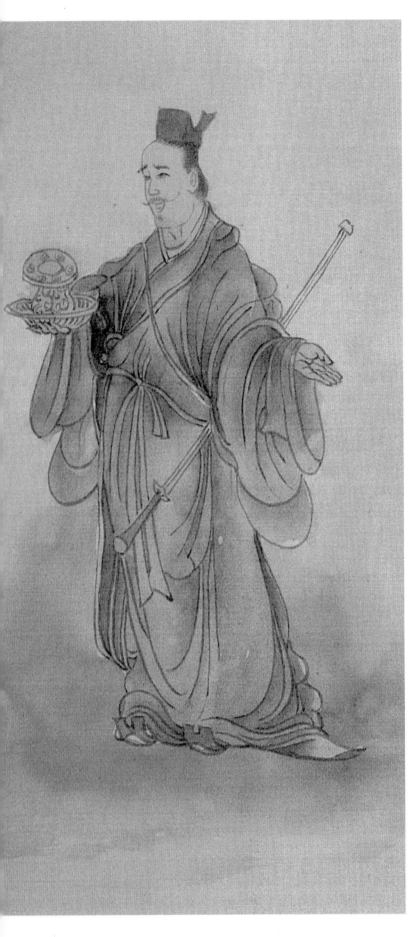

The Northern Song period (AD 960–1127) included many Buddhist figure paintings, but these works were not by famous artists because they were intended purely for purposes of worship. It was during this period, too, that Emperor Hui Zong (Hui Tsung) formed the Imperial Academy of Painting. The emperor was so keen on literal renderings of the subject matter that he dictated this style to all of the artists at court at this time. The main subjects tended to be flowers and birds, but landscapes were also included, with many of the academy's painters copying works by earlier artists.

Given the firm dictates of the emperor, it is not surprising that literati painters and Buddhist-monk painters chose instead to work in a manner known as 'flying free as clouds', painting in a method directly opposed to that laid down by the academy, and one that led to the development of new techniques. At the same time, there were also reclusive artists who fled from the political and national problems and looked to the past for their subjects, styles and inspiration. Naturally, this continual harking back to the work of past masters kept the techniques intact, but left no room for new artistic development.

The early Ming Dynasty (AD 1368–1644) saw two distinct types of painters: those with a sponsor or patron and the scholar painters. The former were considered to be very low in the hierarchy at court. There were also many inferior artists producing works at this time. The Wu School, however, produced some very good painters.

During the 18th and 19th centuries, the Qing Dynasty saw the development of various groups, each responding to the Manchu government in a different way. The individualists, the eccentrics and the orthodox masters have all influenced many contemporary artists. One of the best known at the time was Shih Tao. Qi Baishi (see page 81) had a major impact on Chinese

Left This courtier by Qu Lei Lei (based on an ancient painting) uses ink with little colour. There are also few props and very little to suggest a setting or background.

brush painting during the 19th and 20th centuries, but the traditionalists in Beijing did not accept him. By the early 1900s there was little forward movement, merely a copying of 7th- to 10th-century art. Soon younger artists started to challenge this conservatism and new work began to emerge. As pollution and manufacturing became more common, interests turned once more to nature, and paintings started to emerge depicting birds, flowers and the purity of snow scenes.

The Chinese character for hua, 'to paint', comes from the image of a hand grasping a tool and defining the sides of a field (or frame). The mark made by the brush is paramount in Chinese brush painting. In the West, the attention of many artists was turning away from a focus on the actual marks made to a desire to show mass, light and shade, thus losing any similarities that there may have previously been between the work of the East and West. In the West, the primary interest is in the eye and what it sees, whereas in the East the Chinese use the whole body to perceive. The West needs to examine and measure, while the Chinese are familiar with nature and have an understanding of the links between themselves and the natural world and so seek to show what they know, not what they see.

There has been a fascinating comparison made by Sinologists between the Chinese (a farming society in an area rich in water, clouds and mist, with many objects made from clay) and the ancient Greeks (largely occupied with stone carvings, pens and swords). The art of those two civilisations reflects both the landscape and lifestyle.

In Japan, there had been indirect contact with China via Korea as far back as AD 265, with direct contact by about AD 600. Chinese scripts were used in Japan at about this time, too. In about AD 800 the Chinese influence waned, not being renewed until the 13th century. Most major Japanese artists (painters and printmakers) lived during the last four hundred years.

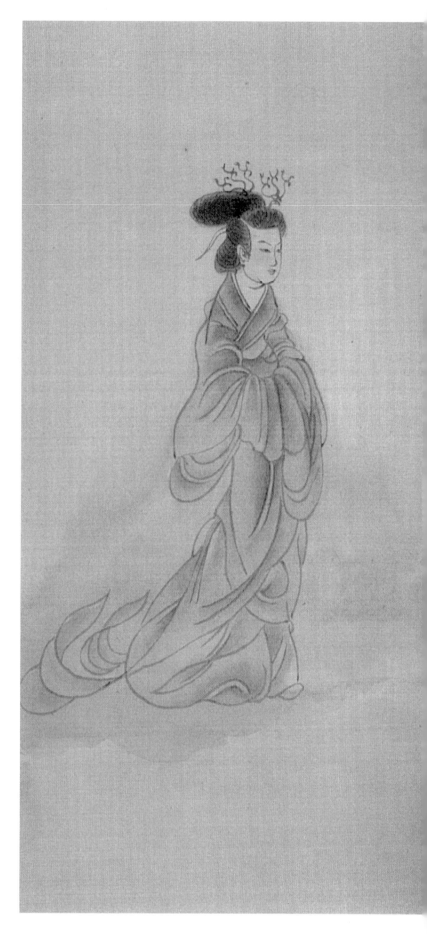

Right A typical meticulous figure painting of a court lady by Qu Lei Lei. This is painted on deep gold silk in shades of ink and only a little colour. Many layers of washes are added after the initial ink drawing.

Aims of Chinese brush painting

Chinese brush painting is best described as what is in the mind, i.e., impressions and feelings, rather than what is in the eye. During the 6th century, when figure painting was popular, Xie He (Hsieh Ho) introduced the 'Six Canons'. These are:

1 Rhythmic vitality (qi)

2 Structure and brushwork

3 Modelling after an object

4 Appropriate colouring

5 Careful composition

6 Following and copying

These have since been applied to all aspects of Chinese painting, whereas at the time they were probably intended to refer purely to the genre of figure work, as flowers, birds and landscapes were considered only as accessories to the figures themselves.

The first of these, rhythmic vitality (qi), can be difficult for the Westerner fully to understand. It tends to be thought of as liveliness or spontaneity. Chinese painting should be examined with the mind, not just with the eye, and many paintings require the viewer to complete them in their imagination.

The middle principles are easier to understand, while the last one (following and copying) means casting the eye back to the work of past masters, as all techniques have been used before and the student artist needs to amend and perfect past techniques in order to achieve ultimate originality. This can involve tracing, reproduction, interpretation and reduction. Certainly, throughout the world, musicians, actors and dancers are constantly playing and adapting the work of great composers, playwrights and choreographers.

It is said that if you practise and copy 'the masters', eventually your own personality will emerge. I hope that some of the suggestions and ideas in this book will encourage you to explore and develop new paintings and to consider how you might improve work that you may have already completed.

Equipment & materials

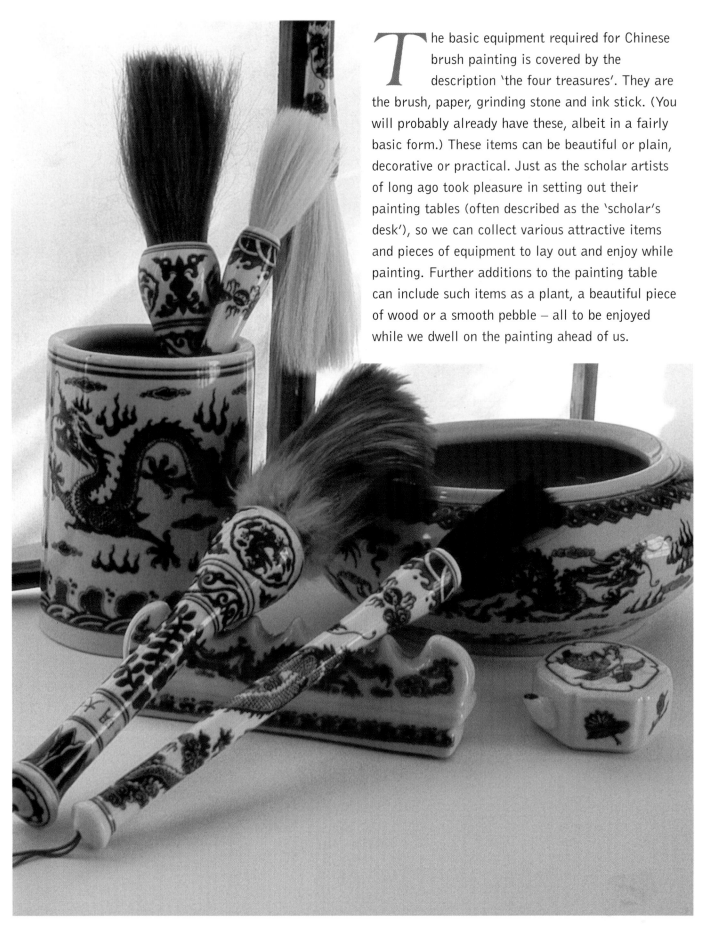

The basic equipment required for Chinese brush painting is covered by the description 'the four treasures'. They are the brush, paper, grinding stone and ink stick. (You will probably already have these, albeit in a fairly basic form.) These items can be beautiful or plain, decorative or practical. Just as the scholar artists of long ago took pleasure in setting out their painting tables (often described as the 'scholar's desk'), so we can collect various attractive items and pieces of equipment to lay out and enjoy while painting. Further additions to the painting table can include such items as a plant, a beautiful piece of wood or a smooth pebble – all to be enjoyed while we dwell on the painting ahead of us.

Above Blue-and-white porcelain has always been a popular choice. However, the brush handles were first used when the court had to move to the south, when wooden handles became too hot to hold. The shadow of plants on a screen first inspired artists to paint bamboo in black ink.

Brushes

The first brushes to be recorded were formed from rabbit hair, set in bamboo handles and date from around 250 BC. However, other historical evidence suggests that the first brushes were made from deer hair surrounded by goat hair and set in wooden handles. The Chinese, being very practical, used whatever was readily available, which is why sheep or goat hair (soft) was used primarily in the north of the country, and wolf (this term usually infers weasel), fox or bear fibre (coarse) in the south. More exotic hair, such as leopard, tiger or wildcat, was also collected and used in places where these animals were found.

The use of various materials for the handles also depended partly on what was available in the area, and also on the purpose of the brushes and the desired

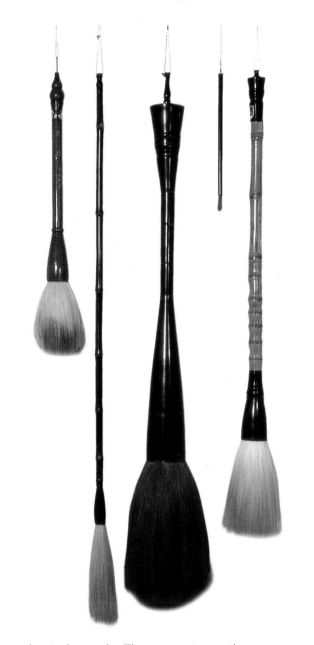

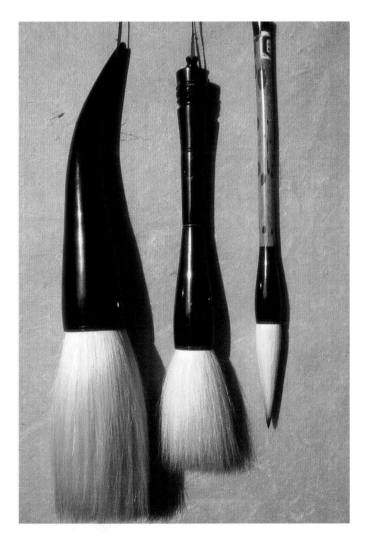

impression to be made. The emperor was thus presented with handles of precious metals, jade, sandalwood, lacquer, ivory and porcelain, while the ordinary scholar artist enjoyed a variety of patterned or plain wood, horn or bamboo–handled brushes. (There were around 180 varieties of bamboo to choose from, some of which were quite rare.) In earlier dynasties, such as the Ming Dynasty, brush handles were very long (some of these brushes have been copied

Left Buffalo horn can be used for the whole handle (this picture includes two designs, one using the whole horn). The brush on the right uses horn for just the ferrule.

Above From the sublime to the ridiculous? The longest brush is 84 cm (33 in) long. The shortest, a plum-blossom brush, is a mere 21 cm (8¼ in). The handles are horn, wood or bamboo.

Above A range of fine and thin brushes. Those on the left have mixed fibres, and those on the right have supple, springy heads.

today, being described as 'from ancient masters'). When the court moved southwards during invasions from the north, the handles were found to be too warm to hold, and many court artists, including the emperor himself, ordered the brushmakers to provide them with ceramic handles instead. Currently, bamboo and horn are the most common materials for brush handles, but a wide variety of fibres are used for the brush head itself.

Choosing brushes

When buying brushes, it is best to have some idea of the effect that you want to achieve. Look for a brush with a good shape and lustrous fibres. As most brushes are protectively sealed with alum for safe transportation, it can be difficult to assess the quality and size of the brush. It does sometimes seem incredible that you will ever obtain a good point using such a large, unyielding brush! However, some manufacturers are now selling brushes that do not have the same stiffness and protection, and it is therefore easier to obtain a better idea of their eventual size, although the quality of the point is still difficult to assess. As a general guide, always buy a bigger brush than you think that you need.

The size of the brush will dictate the stroke, or, conversely, the size of the stroke desired will dictate the size of brush needed to complete such a stroke. You will see from some of the illustrations in this book that the design of brushes can

Right Soft brushes for line and wash techniques. The thinner brushes are capable of making strokes with great character.

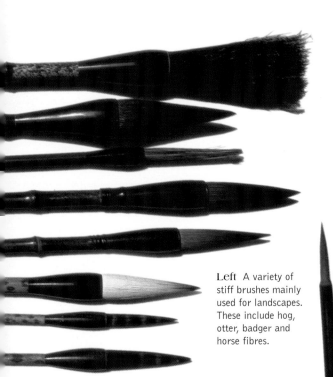

Left A variety of stiff brushes mainly used for landscapes. These include hog, otter, badger and horse fibres.

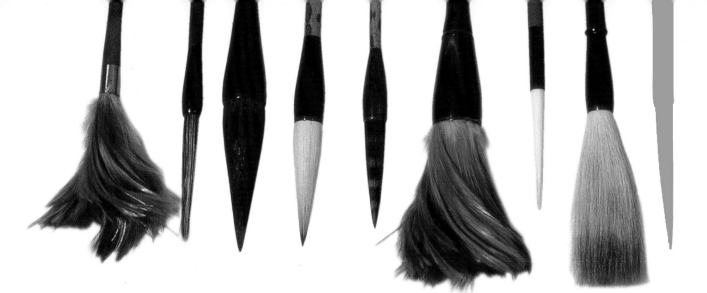

Above Unusual brushes: cock's feather, squirrel, otter, 'blue blade point' (mixed), mountain cat, feather, long sheep, 'ancient masters' and bear.

be very elegant. Most ordinary brushes are plain or spotted (teardrop) bamboo, but other, more decorative, examples include ox bone set with abalone shell or cloisonné flowers.

The heavier materials change the balance of a brush, so it is wise to try holding every brush before purchasing it, if possible. If you have any difficulty holding brushes with thin handles, this will restrict the number of brushes from which to choose. However, it need not prevent you from having quite a collection.

As a rough guide, use a soft, sheep or squirrel brush for flowers, leaves or animals, a wolf, weasel or bear brush for stems, landscape and calligraphy, changing to badger, horse or hog for textured landscapes or figure work. The hake brush is used for washes, while white-cloud (mixed-fibre) brushes are necessary for painting on sized silk or paper.

Remember, though, that this is only a broad generalisation, and that many artists switch to almost the opposite type of brush with great success. Be prepared to experiment and test your brushes, taking note of which types you use for different tasks. You may even like to start keeping a notebook to see how your preference changes, if at all, with experience.

If you have a couple of general brushes to start with, you may wish to extend the range of fibre types that you use. On the other hand, you may already be able to produce a range of subjects with the one fibre, and may simply want to increase the size range of your brushes. As Chinese brushes are so versatile, you do not need to have a closely sized collection.

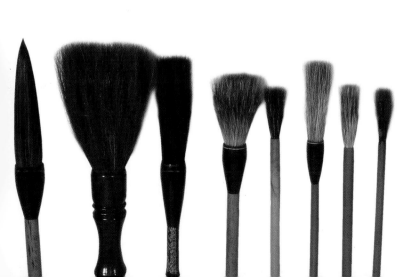

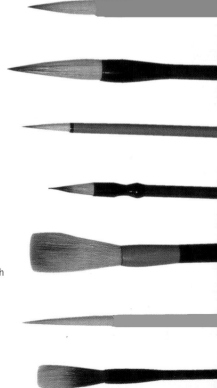

Left Stiff fibres: mountain horse, horse, hog, badger, horse, badger/goat/wolf mixture, badger and horse.

Right Various mixed-fibre brushes, all with the stiffest fibres in the centre, except for the one at the bottom, which is the reverse.

Paper

The oldest paintings found so far (from at least 3000 BC) were on silk, which was very expensive. (If an ancient silk painting is brown, this is often due to the preservatives used to protect the silk from insects rather than discolouration of the silk itself.) Calligraphy, on the other hand, was found on bamboo slats, which were heavy, but cheaper and more robust.

Paper, invented during the Han Dynasty, was made from a variety of materials, usually waste products from village activities (e.g., straw, clothing, hemp, bark or old fishing nets). The purity of the product was not always an important factor. Paper for artists was first made in Sichuan and Anhui during the Tang Dynasty.

There are many different papers to choose from, depending on the sources of supply available, of course. Papers vary in absorbency, from grass paper (made from bamboo or straw, for example), which is rated as a practice paper, along with the commercially produced Moon Palace, to some of the very absorbent Xuan papers (including sandalwood bark) used by most artists. These may actually be produced in the vicinity of Xuan or simply made 'in the style of Xuan paper'. Papers can also be dyed in soft colours, sprinkled with spots of gold or be semi–sized or even completely sized to prevent the ink or paint from running. Again, the idea is to experiment, make notes and be prepared to try as many different papers as possible.

Paper sizes vary enormously. They can be A3 size (grass); in continuous rolls of two or three widths (Moon Palace and bark Xuan); a collection of 10 or 12 sheets in a roll, again in two widths (Xuan) or in large sheets (many papers, including grass paper). Obviously, the large sheets (often 1,200 x 600 mm/48 x 24 in or 1,400 x 700 mm/55 x 28 in) and the fibrous versions (at around 850 x 600 mm/33 x 24 in) are more difficult to store.

To practise, or to try out a composition, it is often a good idea to use a cheaper paper. In order to progress, however, you will need to experiment using papers with more character to them made of such fibres as cotton, mulberry, pineapple, linen or hemp. The latter are the longer fibres, giving a stronger paper. If you require a technique with many washes, choose one of the stronger papers. On the other hand, a simple design of a few bold strokes will look best on the thin, finer quality of Xuan or bark Xuan paper. If you paint a simple design using only a few strokes, the fibres visible on the stronger papers will detract from your work.

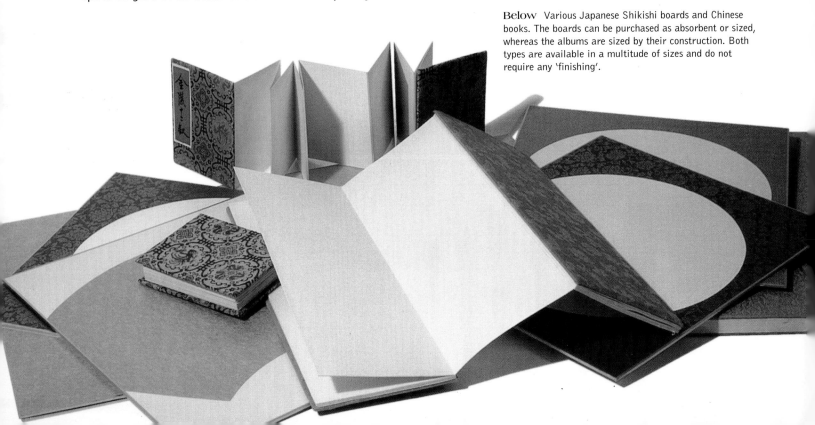

Below Various Japanese Shikishi boards and Chinese books. The boards can be purchased as absorbent or sized, whereas the albums are sized by their construction. Both types are available in a multitude of sizes and do not require any 'finishing'.

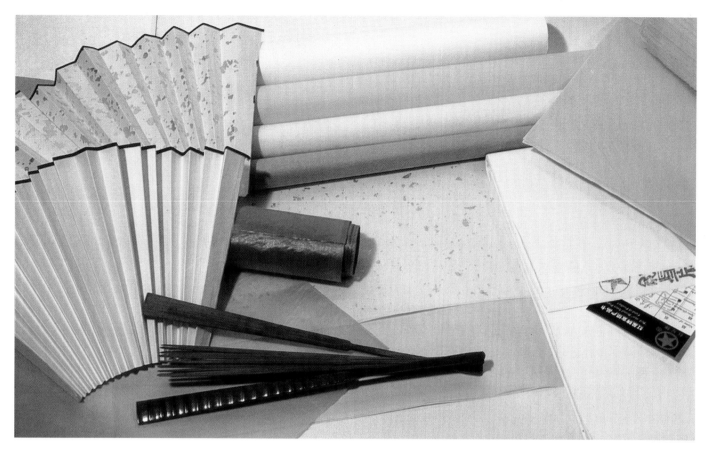

Above A selection of painting surfaces. From left to right: sized silk, fans and fan frame, antique-gold sized silk rolled on a length of pipe insulation (very light), glitter Xuan paper, dyed Xuan paper, Moon Palace paper in a roll, Red Star Xuan paper (with its certificate), grass paper (mao bian), lighter-coloured sized silk and yuan shu (bamboo) paper. In the background is an unpainted scroll with silk borders ready for painting.

Right Xuan papers dyed to imitate the paper from various dynasties, paper with straw–like qualities (very strong, and especially good for layer-ing washes) plus various calligraphy practice papers. These are printed with different-sized grids to enable the artist to produce evenly sized characters. These show a mixture of Japanese and Chinese grids. The scripts are often the same (just different pronunciation).

A meticulous (and often quite realistic) painting will require sized paper or silk that is produced by adding several coats of alum. This can be purchased specially prepared, which will give an even quality to your work, or you may prefer to make it yourself (but beware: this may give variable results). Even this sized paper – often called 'cicada', 'icy' or 'clearwater' paper – comes in differing thicknesses. The sized silk is sometimes paper–backed for convenience, but cannot then be used for traditional 'double–side' silk painting. You need to have patience when using this method of painting, and to try to avoid creating watermarks between the layers when using sized paper or silk.

Absorbent paper should be allowed to mature (like old wine), but meticulous or sized paper should be used more quickly. As the latter is rather brittle, it is easily damaged, especially at the edges. Paper should be kept flat, if possible, and stored in drawers or cardboard tubes to protect it. Because paper will quickly absorb moisture from the atmosphere (causing problems when painting), you should consider the storage of your stock of paper carefully.

Ink stones

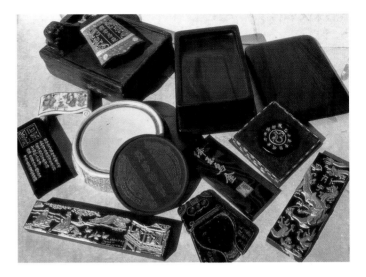

Ink stones date back to around 400 BC, with many being made of earthenware. Tang artists used the baked sedimentary-clay versions from the river Fen prior to the first stone versions of around AD 600. Some of the best examples are from Anhui, Guangdong and Gansu provinces.

Ink stones come in a variety of colours of stone or slate, and can be round, rectangular, square or irregular. They are sometimes beautifully carved with animals, plants or dragons. The water recess at one end will often contain an animal swimming. The larger, more ornate, versions usually have a specially sized box with a lid, while the plainer designs tend to have a lid of the same material as the grinding surface. The advantage of a lid is that it prevents the ground ink from drying up during or after painting.

Another design that is fairly common is the 'land and sea' stone. This is a flat, rectangular stone, with a deeper recess at one end. It does not have a lid, but one can easily be made from a piece of wood, rigid plastic or glass. Many ancient stones were rectangular in form, and were originally much taller than modern versions. Some could be used on the base, as well as the upper surface.

It is possible for a stone to be too smooth or too rough. Neither instance will make good ink. Sometimes a stone will appear good, but after some time can become too smooth (if it was formed from a composition material, for example). Of course, it is only after the painter has acquired some familiarity with using ground ink that the quality of the ink becomes apparent. This is all part of the experience and skill that come with practice.

Above Ink stones and ink sticks, ranging from the ancient (top left), with a porcelain ink stone below, right up to the Millennium-era round stick in a red box. The small, black jade dish (centre front) is for pointing the brush.

Below Various ink stones are shown here. The porcelain version and large stone at the back are much older than the rest. The stone with the lid resting on it (a Duan stone) has a recess underneath to enable it to be picked up easily. The three-compartment version is primarily for use with coloured ink sticks.

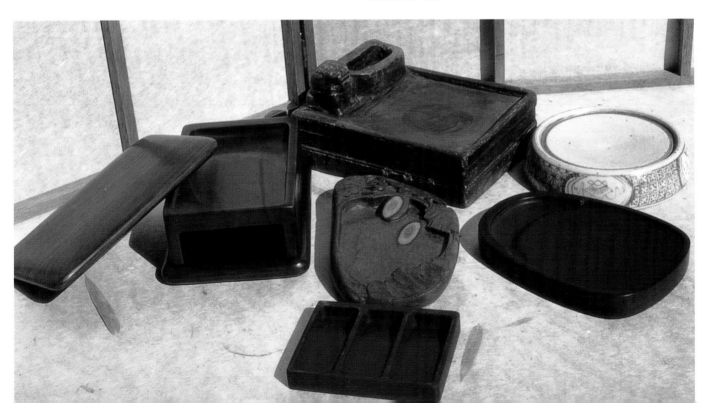

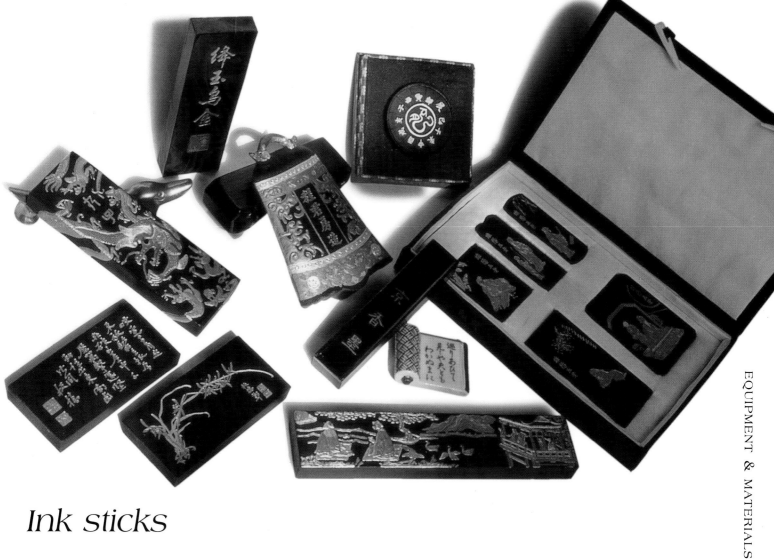

Ink sticks

Ink was first used in around 300 BC, and was made from a mixture of pine soot and deer-horn resin. Later, pine soot and graphite were combined with tree resin. Nowadays, ink can be made from pine soot or oil soot plus resin. Each of these produces a different colour: pine grinds to a blue-black and is good for calligraphy and meticulous painting, while oil gives a warm black for general use. Commercial charcoal sticks contain less glue and are favoured for freestyle work. Many painters prefer to use the one variety, and it is again mainly experience that will allow you to tell the difference on paper.

Soot is mixed with the resin, along with other ingredients, such as fragrance, formed into sticks using moulds and left to dry. There are many sticks that an artist would not feel inclined to use as they are either very pictorial or formed into unusual shapes, such as bells, octagons, flowers, cicadas or turtles. In the past,

Above Ink sticks of various qualities, including an export set from the last century. The plainer stick with red calligraphy is a medical stick. Also shown are some ink-stick rests.

some sticks also contained jade chips, gold or pearls. Indeed, you can quickly build a very attractive collection of ink sticks.

Other unusual sticks include a medal-winning stick formed from a mixture of black and red (cinnabar), which, when ground, gives a brown ink, and a medical stick which is made to be taken internally, as well as to be used for painting! Naturally, sticks such as these are a rarity rather than the norm. Coloured ink sticks should really have a dedicated stone for each colour (the sets of colours are derived from minerals, which produce opaque colours). Coloured ink sticks can be more useful for coloured calligraphy rather than painting as they can be rather gritty in consistency.

Colours

Paint was used before ink, mainly a red mineral colour that was ground. Chinese brush painting is a watercolour technique, in which the delicacy of the vegetable and mineral colours is juxtaposed with the power of the ink. Oriental colours contain more resin than their Western equivalents, and therefore bond with, and are held within, the paper thickness in a more satisfactory manner. Western colours can be used, but have a tendency to spread when the finished painting is backed ready for framing. The secret when using non-specialist pigments is to be sparing with the colour to avoid a build-up of pigment on the surface, and therefore the risk of the colour running. You could also experiment with dissolving some glue in the water.

Oriental colours can be obtained in granules (also called chips or flakes), tubes or pans. The stone colours (e.g., azurite, malachite, cinnabar and white) also come in powder form (usually preferred for silk work). These powders need to be dissolved in hot water and mixed or ground carefully using a pestle and mortar. The green and blue both come in four to six shades, the darkest being the most expensive. For this reason, it is wise to use the powder colours on the front of a silk painting and the tube versions on the reverse side.

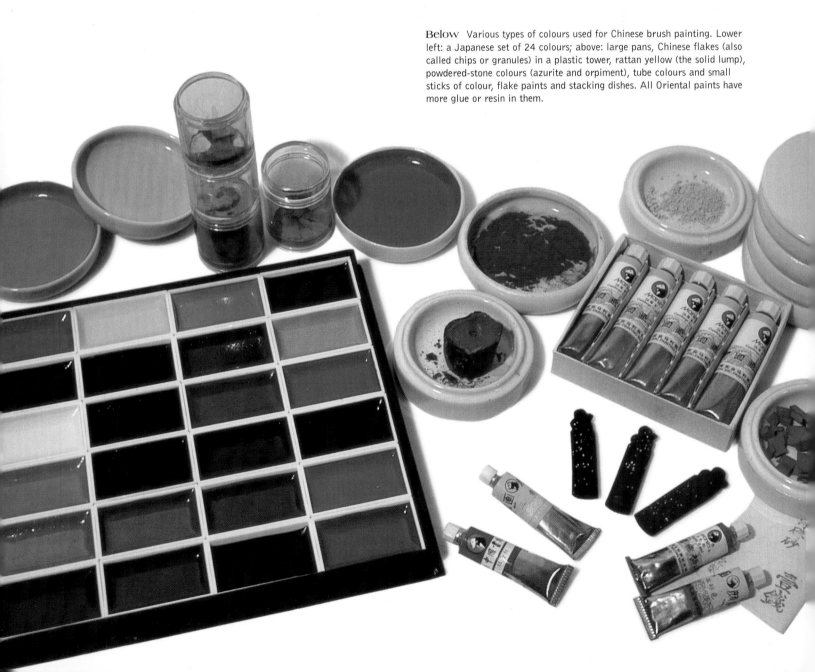

Below Various types of colours used for Chinese brush painting. Lower left: a Japanese set of 24 colours; above: large pans, Chinese flakes (also called chips or granules) in a plastic tower, rattan yellow (the solid lump), powdered-stone colours (azurite and orpiment), tube colours and small sticks of colour, flake paints and stacking dishes. All Oriental paints have more glue or resin in them.

Other equipment

Items such as brush rests and hangers, paperweights and water pots can be found in a variety of outlets. They can be decorative and pleasing to use or simply utilitarian. (You can see just a few examples in the photographs here.) Many other items, such as palettes, dishes and storage containers in which to keep your painting equipment, can be obtained from more general sources. You can make basic purchases to get you started and then gradually replace them with more suitable or decorative items as you find them.

Below Various methods of storing your brushes. These should be dry before being stored 'head up' in a brush pot.

Brush hangers and rests

Brush hangers are wooden and can hold from two to ten brushes. Some look more like items of furniture than simple hangers. If you travel to classes, the most practical design is one that folds or dismantles. Brush rests can be made of metal, porcelain or wood and can take many different forms, such as mountains, dragons or even a row of ducks like mine (this was not designed as a brush rest, however). You will just need to keep looking until you find the items that are right for you.

Brush rolls

Brush rolls, with or without pockets, will keep your brushes protected when travelling. These are usually made from split bamboo.

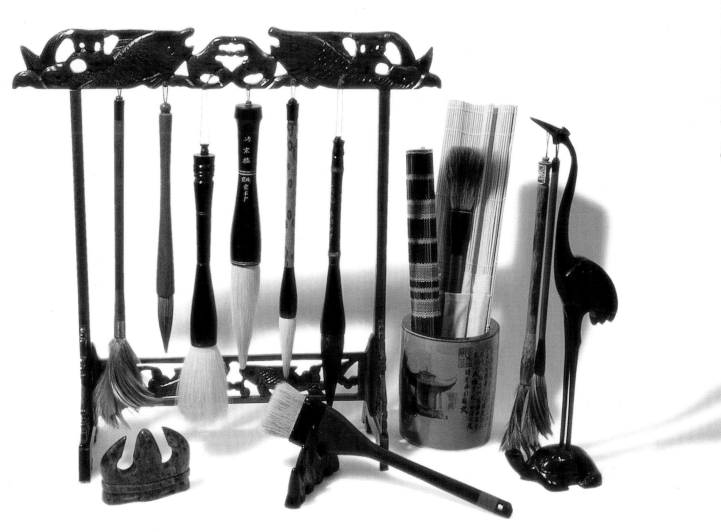

Paperweights

Paperweights need to be heavy, and you can either use one at the top of your painting (this can be thick) or two at the top and bottom (in which case they need to be thinner). They are usually made of either metal (often brass) or wood, with a metal core.

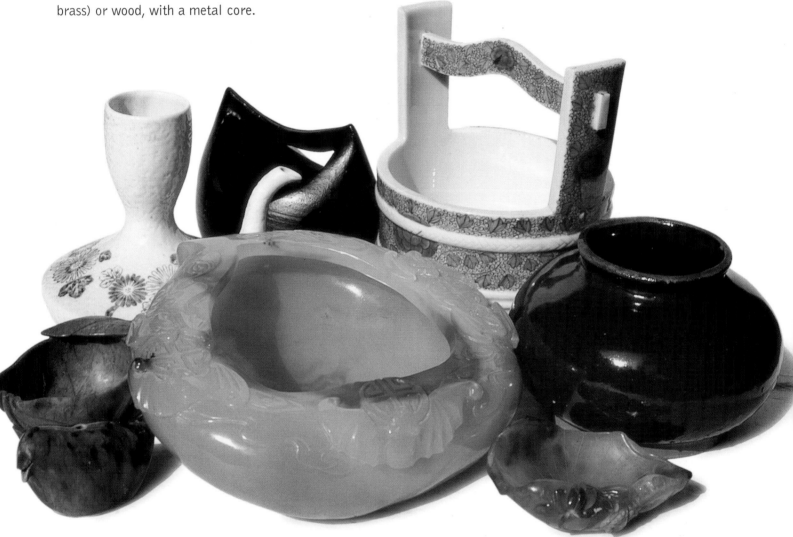

Above A variety of water containers, from a jade peach bowl to a modern pot and pickle container. The small bird water dropper (front left) was made by Katharine Fraser.

Water pots and droppers

Water pots and droppers are frequently made of porcelain or pottery. Some are beautifully decorated or designed in a traditional shape, while others are more mundane. Either way, you need sufficient space for both clean and dirty water, plus a stable base. Pigments, such as chip colours, are stored in stacking dishes, and these may again have the traditional blue-and-white decoration.

Painting felt

A painting felt is ideal. This is usually made from horsehair and comes from China. Ordinary household felt or baize is too absorbent, so the other alternative (which, incidentally, is better for creating washes on a painting) is a well washed, or felted, woollen blanket. All that you need is a piece that is large enough to support the maximum size of painting that you are likely to create, although many Chinese artists prefer to cover the entire painting table with the proper felt.

Seals

Seals are used to include a signature or message in your painting. (The use and design of these is covered in more detail on page 146.) Besides a carved seal, which may be made of stone, horn or metal, you will need some cinnabar paste. This is made from silk or plant fibres, oil and cinnabar. Red is always used on paintings; there are black and blue versions, but I have not been able to find out what they are used for.

Below Seals and seal paste in pots. The seal stones are varied in colour, and there is one in a glass substance and several metal seals. The seal on the box (centre back) contains a total of 25 engravings. Seal paste is shown in red (the most common colour), but also in blue and black versions.

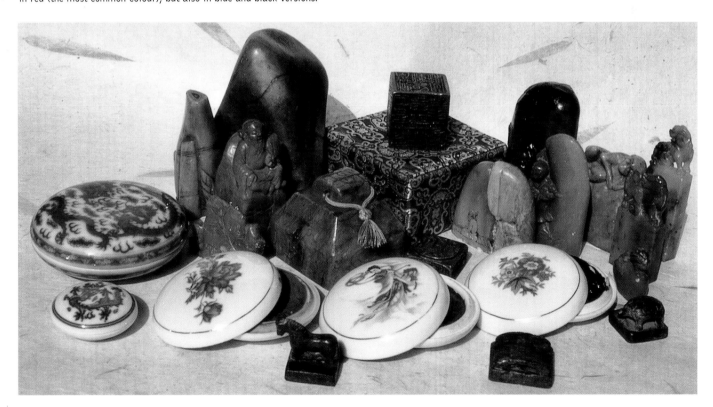

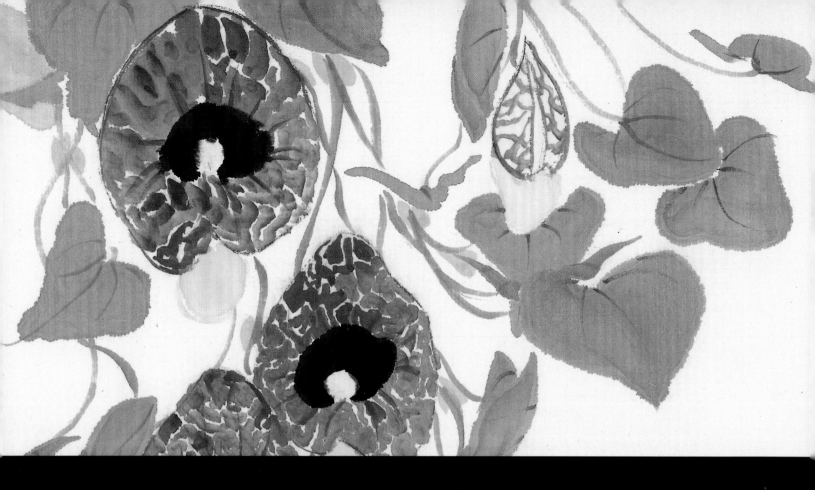

A summary of the main principles

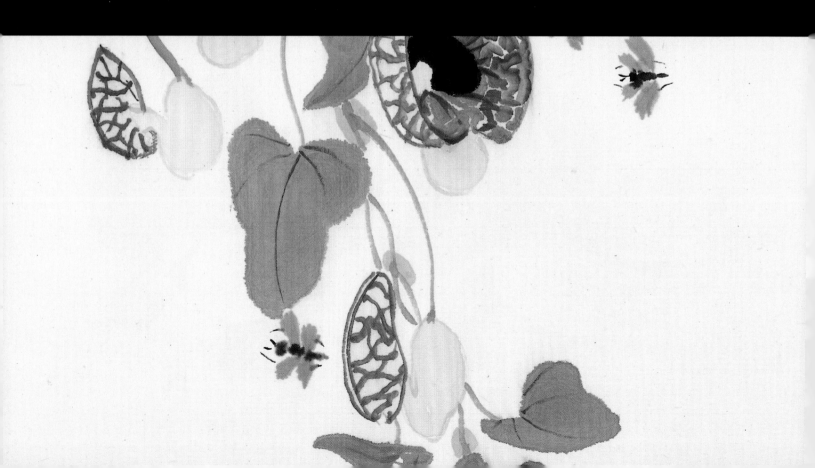

Main principles

As you progress, you will require more space to allow for the greater complexity of your compositions and the possibility of more equipment. This, of course, depends on the money and items available to you. The basic strokes and techniques are included here in a brief form as a reminder.

When setting out your workspace, remember that you will need sufficient space to allow for free arm movement (try not to lean on the work surface) and room to stand or sit, so do not work in too restricted a space. It will help if you always set out your equipment in the same position (on the right if you are right-handed, on the left if you are left-handed) because you will then be aware of exactly where everything is. That is the general idea, anyway! If you look after your equipment carefully, it will last for many years. What tends to happen with most artists is that as you become more skilled, your appreciation of your equipment leads you to acquire better-quality versions (this is especially true of ink and brushes).

Below First lay out your table. If you always set it out the same, you will know where everything is. Ensure that items are within easy reach. Your palette, and maybe a tile (for blending colour and shaping your brush), should be near your painting hand. Weights will hold your paper in place; these can be elegant or pebbles or rulers. Something to inspire you, such as a bamboo plant, will help to create a pleasing atmosphere.

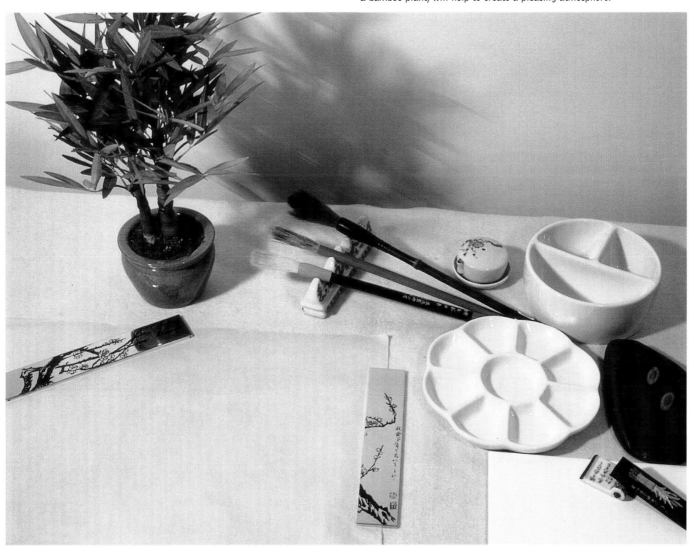

Below First, add some water to your stone with a brush, dropper or salt spoon. Holding the stick upright, and with your index finger on the top, grind the ink using steady, circular movements. When the ink leaves dry patches on the stone and has an oily consistency it is ready to use.

correct size, with square edges, you will be able to consider the spaces left by your composition of strokes. These are very important. You may find it useful to restrict your selection of sizes to start with to allow yourself to become familiar with the space available.

Be prepared to experiment with sizes and textures (using both the rough and smooth sides of your paper). You will achieve better-textured strokes on the rougher side of the paper, which makes it particularly useful for landscape painting.

Grind your ink by adding some water to the ink stone with a dropper or spoon. Holding your ink stick vertically, use rhythmic, circular movements, and continue until the ink is black, with dry patches on the stone. You will notice that the liquid appears to

Your brushes are your most important tools, so treat them with respect. By now you may already have quite a selection (having started with two or three), in a variety of fibres. You may be storing them by hanging their loops on brush hangers or in brush pots once they are dry. Either way, you should always clean and dry them carefully after use. It is a good idea to hold a piece of tissue paper in one hand and gently to pull the brush head across the tissue to dry it. This ensures that the fibres lie the same way. Lay brushes down horizontally, or hang them upside down, to dry.

Whether you use paper from a roll or large sheets, you should cut an appropriately sized piece for your work. By using the

Below When you require a thin stroke, hold the brush in an upright stance and carry out the stroke without your arm touching the table.

be of an oily consistency. This process will help you to prepare for the painting that you plan to do. Some artists use liquid ink, which is fine, as long as you wash your brushes very carefully at the end of your painting session. (The preservatives in ready-made ink dry at the base of the brush, causing it to lose its suppleness, and because it can be difficult to get the right brushes in the West, we should take care of the ones we do find.) If you have a choice of sticks, always select the most appropriate one for the task. When your ink is ready, load your brush. Get into the habit of stroking the brush across the stone or palette, making sure that all of the fibres are lying adjacent to each other. This prepares your brush for the brushstrokes to come.

When making the various brushstrokes, imagine a caressing movement. Many students try to make the movement too complicated, causing unsightly marks on the paper. Sliding the brush sideways makes different brush marks. Remember that an upright brush is for strong strokes, whereas an oblique brush will give softer strokes. With a little practice, you will start to do these automatically. Most importantly, you should keep your focus on the progress of the brush tip across the paper as you make your stroke.

Do not use the whole brush if you can help it. This will enable liquid from the handle and heel of the brush to flood onto the paper. You can remove some of that liquid by using a tissue or cloth to absorb any excess from the handle or heel of the brush junction. Use the sides of your ink stone, palette or water pot to remove spare paint or ink before using the tissue.

Notice from the examples shown on pages 31 to 34 how the speed and the pressure used affect the resulting stroke. Practise trying to achieve the principles of wet and dry, wide and narrow, long and short on the paper by your use of the brush. Next, vary the strokes to give large and small, dense and sparse groupings. Change the dilution of your ink or colour to achieve light and dark. All of these methods will help you to obtain qi, making your painting livelier.

When mixing colour, be careful not to pick up constantly from a pool of colour, but try to tip the brush into a darker area to create some variation within a leaf or petal. A colour that is too bland can be just as boring as repetitive brushwork. If you already paint in watercolours, beware of twisting the brush as you load it; the fibres will try to untwist themselves when you place the brush on the paper. Always move your brush slightly rather than dabbing or placing it on the paper. This will assist your control of the liquid.

To load your brush with more than one colour, first decide on the palest colour (it is possible to load the darkest first, but not so easy). Load most of your brush with this colour and then wipe any excess off the tip.

Left In order to adjust the level of liquid in the brush, wipe the head carefully on a tissue. In the example above, I am pulling the brush to the lower right of the picture to make the fibres all lie in the same direction. You can also remove excess liquid from the heel (and the handle) of the brush using a folded tissue or cloth.

Next, place your brush in a medium-shade colour and load about half of the fibre length, wiping the tip on the edge of the palette. Lastly, tip the point of the brush into a darker colour. When the brush is moved with a sideways motion on your paper, you will now create a stroke with varied colouring. As with too much bland colour, however, the effect of using varied strokes all over your painting can be equally boring.

Most brushstrokes fall into two categories: those that hide the tip and use the tip of the brush in the centre of the stroke and those that express the tip and use more of the side of the brush. Landscape painting probably uses both of these more than any other subject, using first the tip and then the side of the brush, leading to the phrase 'a dancing brush'. Follow the exercises given in this book and try to establish a regular pattern to your practice.

Brushstrokes are important for a great deal of Chinese painting. Once you can perform the strokes with ease, you can develop faster or more fluid strokes, which will greatly improve the quality of your work. Many Chinese art establishments encourage students to practise calligraphy, fine line work or grass orchids every day. All of these subjects require excellent brush control. Try to find the time to paint regularly, even if only for a short time.

Once you have gained confidence in your brushwork, you can turn your attention to the composition of your paintings. Hopefully, with the help of the suggestions in this book, you will quickly feel able to move on from making copies of previous works to maybe producing adaptations of some of them, and then finally to creating your own compositions.

Reminder of strokes

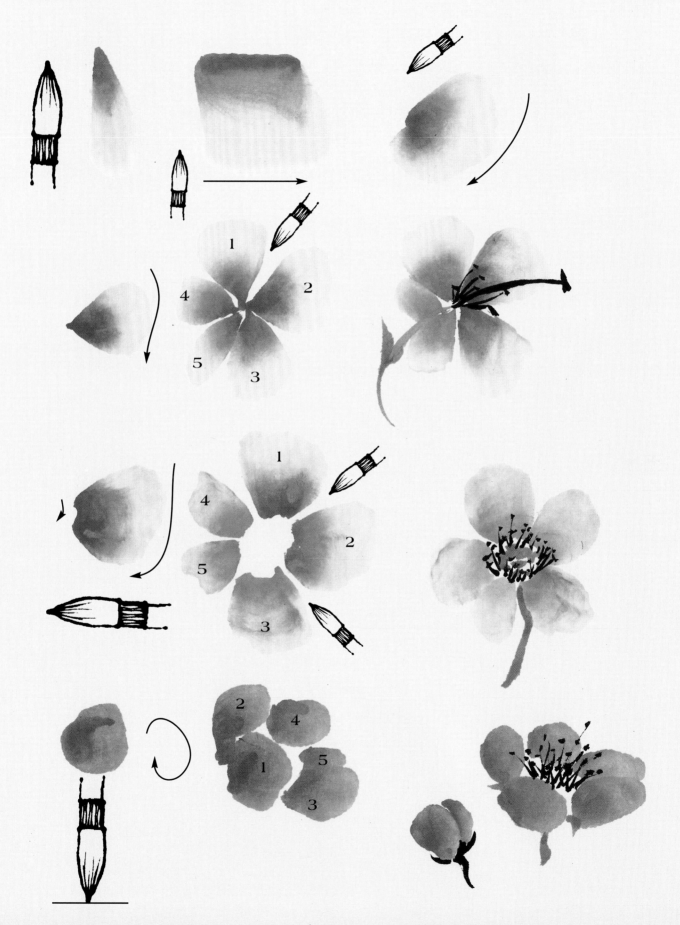

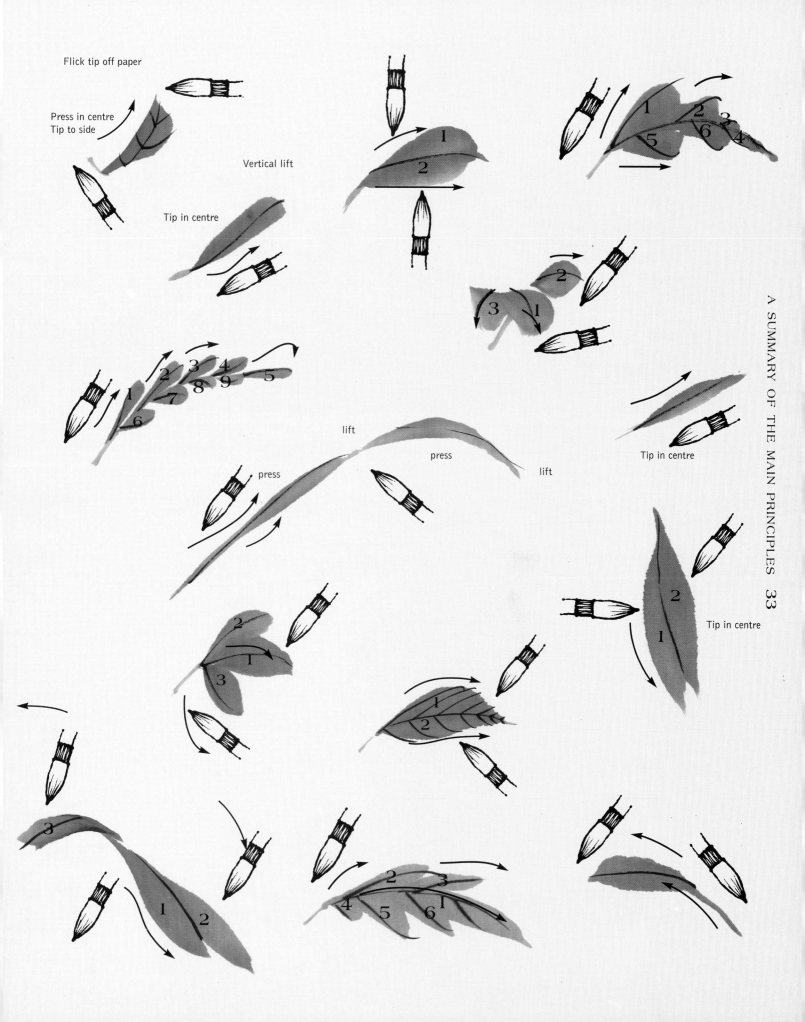

Flick tip off paper

Press in centre
Tip to side

Vertical lift

Tip in centre

1

2

Tip in centre

lift

press

press

lift

Tip in centre

If you are working out new shapes of leaves and they are not going well, sketch the outline of the leaf first as a guide

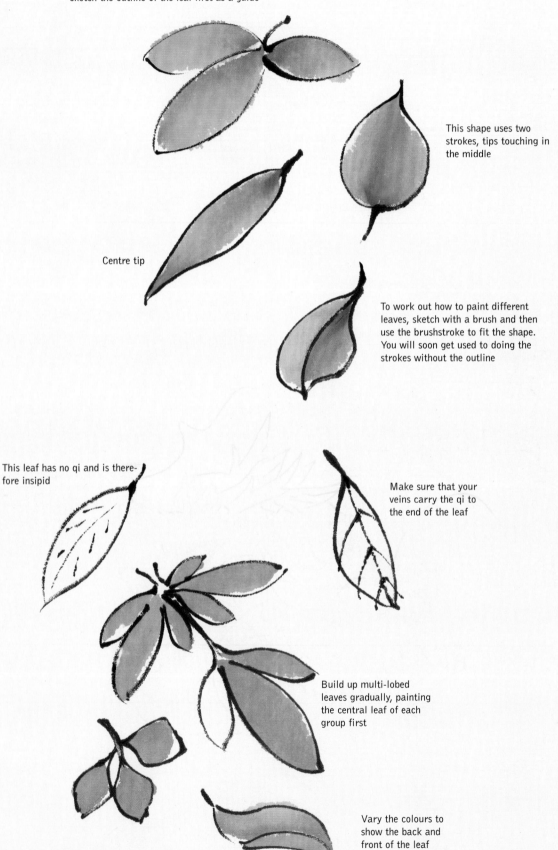

This shape uses two strokes, tips touching in the middle

Centre tip

To work out how to paint different leaves, sketch with a brush and then use the brushstroke to fit the shape. You will soon get used to doing the strokes without the outline

This leaf has no qi and is therefore insipid

Make sure that your veins carry the qi to the end of the leaf

Build up multi-lobed leaves gradually, painting the central leaf of each group first

Vary the colours to show the back and front of the leaf

Styles & forms of brush painting

During the long history of Chinese brush painting, styles have changed according to the fashions of the time. The original use of paintings had an impact on both the style and materials used. As described in the Introduction, pages 6 to 12, early paintings were stylised figures based on religious observances and customs. Later work depicted life at court, with the clothes and fabrics rendered with much skill on silk. At its high point, this type of figure painting was extraordinarily detailed and precise. This style of painting and its later development is called meticulous, or gongbi, painting.

When Emperor Hui Zong set up the Imperial Academy of Painting, the scholar painters of the court rebelled against his insistence upon a literal painting style and started to develop xieyi, or freestyle, work,

often choosing landscapes as their subject. This style of painting gradually crept in to all areas of painting, with the two distinct styles (gongbi and xieyi) developing side by side.

To learn good gongbi brushwork, you should spend some time studying early figure paintings. To gain freedom in your xieyi work, you need to practise simple, bold strokes, which tell the story without stating the obvious. Whichever style you are drawn to, you should also study the opposite method, in order to develop your ability to produce good strokes and compositions that have life and energy. The danger with the meticulous style is that it can easily start to look and feel Western in character, and you may well find that your strokes have changed to that style as well.

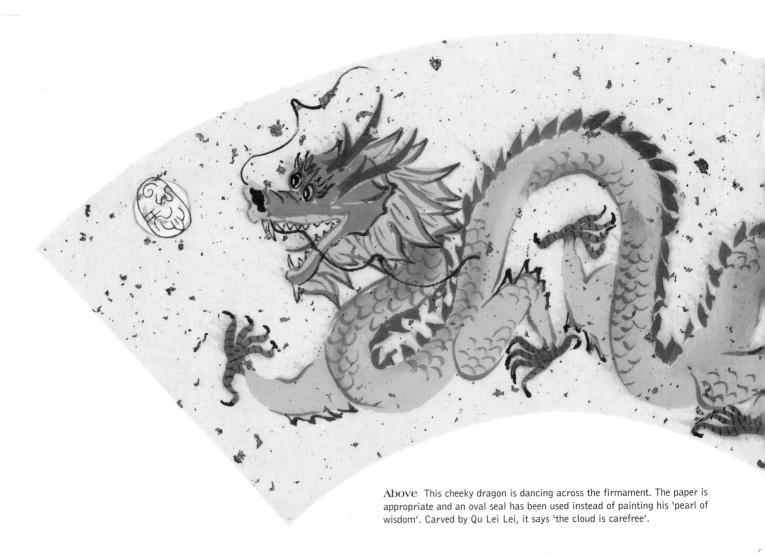

Above This cheeky dragon is dancing across the firmament. The paper is appropriate and an oval seal has been used instead of painting his 'pearl of wisdom'. Carved by Qu Lei Lei, it says 'the cloud is carefree'.

Meticulous

This style can be painted on either silk or paper, which is usually sized. Qi Baishi (Ch'i Pai Shih) (1863–1957) was highly skilled at using unsized paper for exquisite, detailed insects, which he combined with a few bold, free strokes to show lotus seed heads or mushrooms. His disciple, Lou Shi Bai, continued teaching this skill after Qi Baishi's death.

Sized silk or paper can be purchased, or even produced at home using an alum-and-water solution.

However, it is very difficult to get the sizing even (personally, I would rather spend the time painting!) When painting on silk, there are particular skills to be mastered, most of all the initial brushwork. Once you have completed the outline work, several ink washes are added to give depth. Many would-be meticulous painters have given up by this stage! It does demand a great deal of time and patience. Sized paper is similar, but does not allow so much movement of the washes. Meticulous paintings tend to be busier in composition, with greater detail than xieyi work.

Below A meticulous (gongbi) round fan by Kaili Fu, showing a charming landscape in autumn. This is painted on silk and emphasises the small scale of man's endeavour.

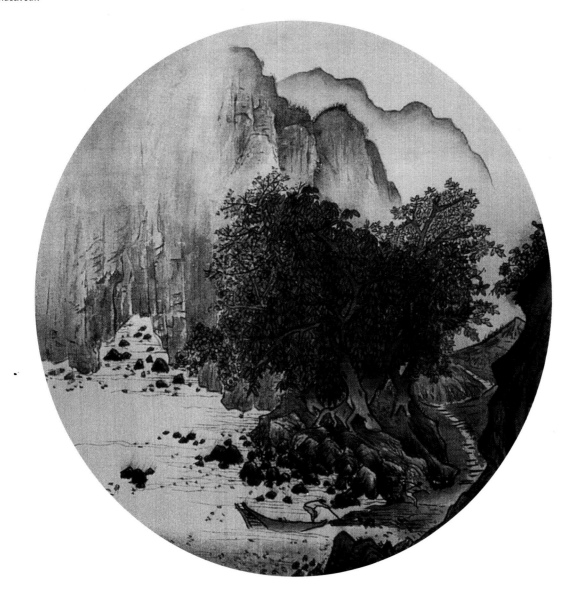

Freestyle

Many people are attracted to the apparent simplicity of Chinese brush painting – of course, the fewer the strokes in a painting, the greater the importance of each one. Naturally, the shades of ink play an important part in creating expression and liveliness in your painting.

Within this style, the degree of realism is variable, and will depend on your own taste and preference. Many artists have developed their own particular style over a period of years; this will often depend on who, or what, has been their source of inspiration, also being determined by the materials that they have chosen or have been able to acquire. My own inspiration has come from a variety of artists, both Oriental and Western, and, like me, you may even find that, given your different influences, your style changes depending on the subject and particular medium that you are using.

Your brushstrokes will vary according to your choice of brush and the manner in which you apply it to the paper. The composition of a xieyi painting will be less busy than that of a gongbi painting. This means that the arrangement of the subject will be more important and the resulting free space will have more impact. Your brushstrokes will also be influenced by other factors, such as your mood, state of health, level of tiredness and so on. It can be a good exercise to

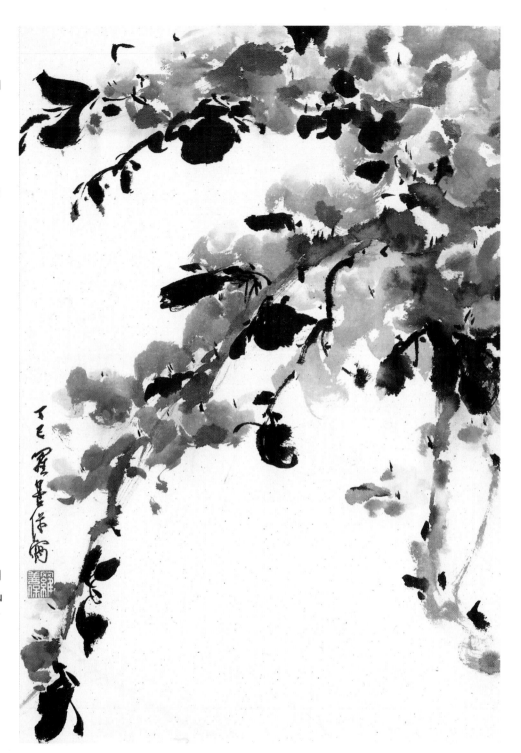

Above A very freestyle painting, possibly of a camellia, by Joseph Lo, which is a delightful composition. It accentuates the freedom of the growth of the plant.

discipline yourself to spend time painting regardless of how you feel, and it is therefore important for you to set aside time to paint, and to have your equipment laid out ready, if possible.

Developing your technique

In order to progress, you could try converting a painting from one style to the other. Try to simplify a gongbi painting, deliberately using fewer strokes while adding space into the composition. Conversely, you could add to a freestyle work, including more detail on a sized medium. This will make you think more carefully about what you are doing, but still provides a starting point, something that many painters find to be elusive as they strive to improve.

Below A painting of a group of narcissi on a rock. Both the flowers and leaves are outlined, but rooted by the rock in free strokes.

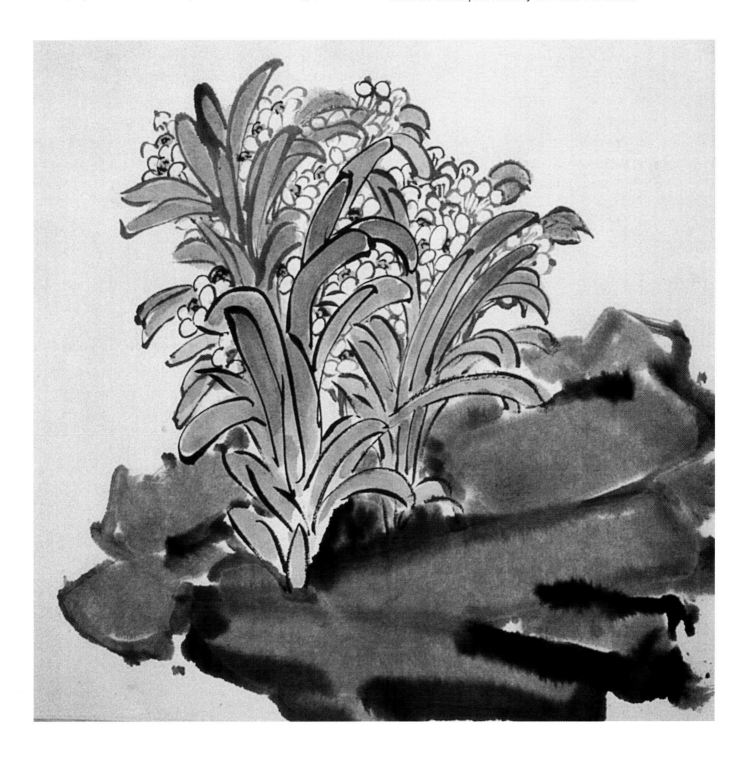

Painting formats

The context and format of Chinese painting has changed over the years to suit the purpose of the work. Originally, there were tomb and cave paintings, with no particular frames or borders. Next came painted silk-funeral banners which were dictated by the hanging mechanism and the particular situation.

Later, paintings were mounted in a scroll format, which suited the desire to rotate a selection of paintings in one position (thus giving the work more importance), and, when rolled up and tied, made them easier to store. Frequently, scrolls were not hung in view, but were kept as academic exercises, being carried by servants or apprentices to scholarly meetings where they were used purely for discussion purposes. The Chinese attitude to the use of paper has differed to that in the West. Many parts of China are extremely damp for much of the year, and, in any case, work was not considered to be for posterity, which is why more importance was placed upon the portability of the paintings than their preservation.

However, all of this changed after the forming of the Republic of China, when officials were forced to find different ways in which to earn their living. When the first exhibitions were held, the vertical and horizontal (hand-scroll) formats were found to be rather impractical for display, given the vast numbers of visitors attending. A change was therefore made to 'ordinary' framing, a form that is now favoured by most Chinese artists. However, many Oriental painters do not include extra space at the bottom to offset the optical illusion, but have equal borders all round.

Right A beautiful fan painting by Qu Lei Lei, exhibited at the Chinese Embassy, London. It shows a white lotus (purity) framed by heavier leaves. Lei Lei has used a stone-green mineral colour to 'lift' the painting.

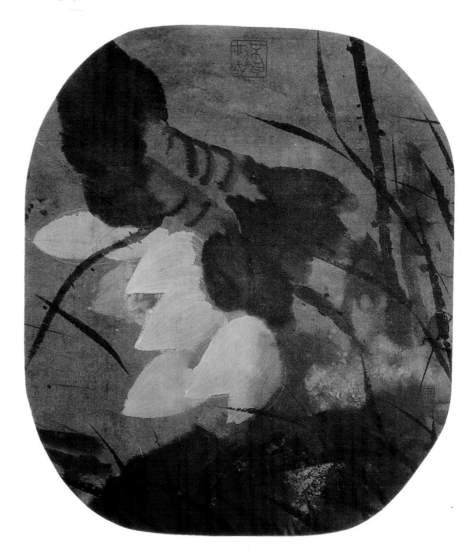

Fan format

Fans have been described as 'poetry on the wind'. They were painted for use (folded or flat, depending on their shape) or as an art form. The earliest fans (flat, stiff constructions on long poles) were used for ceremonies during the 11th century BC. Personal fans are recorded from the 1st century AD. Craft workers often made everyday fans from large leaves, feathers or smaller leaves woven together.

The desire to decorate fans led to a preference for plain surfaces, which could be painted. Some fans combined both painted and woven surfaces. The shapes – circular, oval, hexagonal, square or floral – varied, with a painting surface of white silk or paper. The round version, popular during the Sung Dynasty, was known as a palace fan, and later as a moon-shaped fan. These fans were originally small enough to fit inside a sleeve; they later became a fashion statement, and larger ones came into vogue. In ordinary life, fans were used to dry anything wet, to encourage a fire to burn or to protect the face from the sun or from dust blown by the wind. Many fans were painted on the front and inscribed with calligraphy on the reverse. Some of the best-preserved examples were dismantled after use and mounted as album leaves. The Japanese adapted the flat fan format during the 6th century.

The folding-fan design was thought to have been inspired by bat wings, and was known in China from AD 1000, although the format seems to have originally come from Japan. Dark-blue or black fans were popular from the Ming Dynasty onwards. Important areas for fan-making were Suzhou and Sichuan. Fans were popular items to give as presents and had many meanings (in some cases, they could even imply status). Folding fans were often divided into panels, with each panel being worked on by a different artist. Once the painting was finished, the work was complete, and so artist groups used this form as a spontaneous exercise. By the 15th century, fans were usually 300–450 mm (12–15 in) long (including the ribs, or fan–bones), with the paper element being 175–200 mm (7–8 in). The proportions and number of ribs varied enormously, but were often 16 to 18 in number. Gold-leaf backgrounds were extremely popular, and fans were often renewed once the paper had worn along the creases.

Round fan paintings are similar to album leaves, but the folding fan is a more difficult format to decorate, and the composition of a fan painting is possibly one of the most complex, requiring great thought and care. Where the 'normal' viewing lines are used, the design can appear awkward, but if the landscape or design follows the fan shape in an arc, the composition can be more comfortable and unique to this format. Many fan paintings show tranquil scenes or peaceful subjects to offset the problems of the day. Pu Ru (a relative of the last emperor) is listed as decorating at least one fan by finger painting (see page 134).

Subjects vary tremendously. There is a tendency to think of the fans themselves as being solely for feminine use, but scholars used them as well. The round, flat fans were usually used by ladies and the folding fans by gentlemen. The fan format was an accepted decorative item and was probably painted more for flat display rather than for actual use. That is why fan decoration is equally likely to take the form of light, flowery designs with butterflies or birds of or scenes depicting animals, landscapes, fruit and figures. Calligraphy was frequently featured on the reverse of the fan, but there are also numerous examples of fans with calligraphy as the sole decoration. You will find instructions and templates for you to try your skills at emulating the work of these scholars later in this book (see pages 135 to 138).

Screens

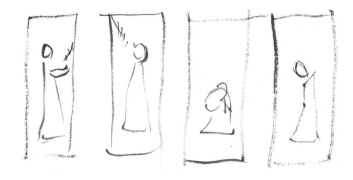

Another typically Oriental format is the screen. It was used in ancient Chinese civilisation to suggest that the emperor was the highest authority 'under heaven'. A screen was also placed as a form of protection behind the emperor so that assassins could not approach him from behind.

The structure of these screens usually took the form of four or six panels. They could be decorated with figures, landscapes or flowers. With figure work, care had to be taken to make the design interesting: four standing figures would not provide a good composition for the overall screen (see the sketch). Landscapes were often divided into the four seasons, while flower and bird designs usually depicted the 'four gentlemen' (plum, orchid, bamboo and chrysanthemum). I have included a photograph of some commercial screens for your reference below, but it is fun to design your own, either as a card format or to cover an old, full-sized frame.

Above A sample sketch to test an idea for a screen. You can see how the juxtaposition of the figures is important to obtain an interesting result.

Below Commercial screens showing different layouts. The larger screen has landscapes of spring, summer, autumn and winter. You need to consider the juxtaposition of your compositions.

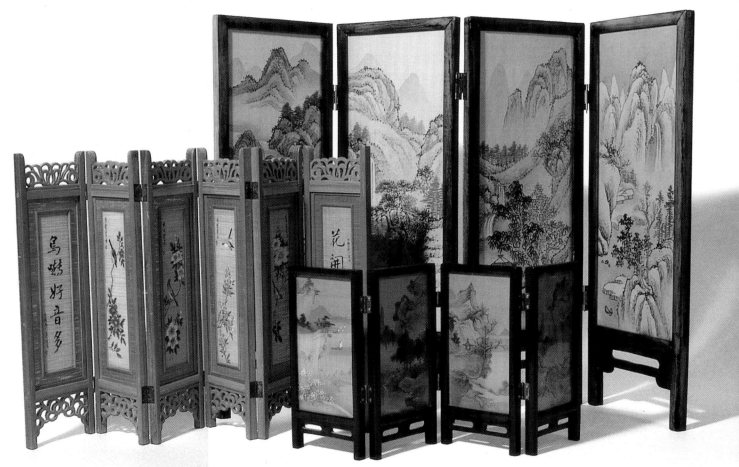

Flowers

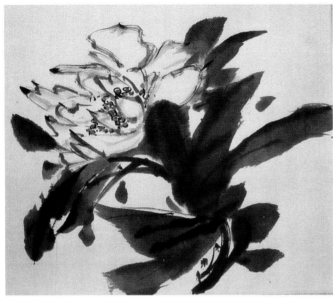

Left Outline xieyi peony by Joseph Lo.

Below A composition inspired by an idea by Tony Carroll, which conveys the stiff uprightness of the rose trying to rise above the sinuous climbing nature of the convolvulus. The colours are very complementary, too.

Flowers

For Western artists, flower painting must be the most popular subject that Chinese brush painting has to offer. There are many different styles, some more meticulous, others more expressive. Each artist has his or her own preference, which may, or may not, have been fostered by a particular tutor or inspired by an individual painter. In the introduction to this book, there is a brief description of the history of Chinese painting and the ebb and flow of subject popularity, but flowers and plants (along with landscapes) must be the subjects that have endured for the longest period. Most people seem to have more confidence in their ability to paint flowers than in creating representations of animals or figures, and yet there is much less scope for fun or comical appearances when painting flowers and plants.

The painting of traditional floral subjects is a very popular choice, especially the 'four gentlemen' (plum, bamboo, orchid and chrysanthemum), although any flower or plant may be painted in xieyi style. Of course, the symbolism or colouring of many flowers will appeal to, or be

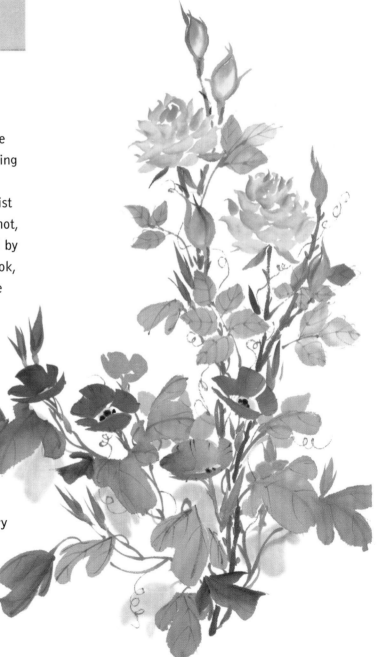

suitable for, particular occasions. Some subjects are more dramatic, while others are more graceful. You can experiment with painting flowers in, or from, your garden, maybe keeping pace with the seasons. Or you can enjoy painting an exotic flower in the middle of winter. The important thing is to observe the plant very carefully before you start work. Chinese artists are naturally more observant than most of us in the West, and patiently study their subject in great detail before putting brush to paper. Nowadays, many artists use sketches and photographs to assist the drawing process, but previously they relied simply on pure, unhurried observation.

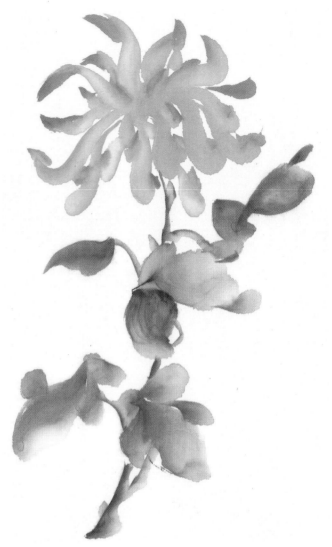

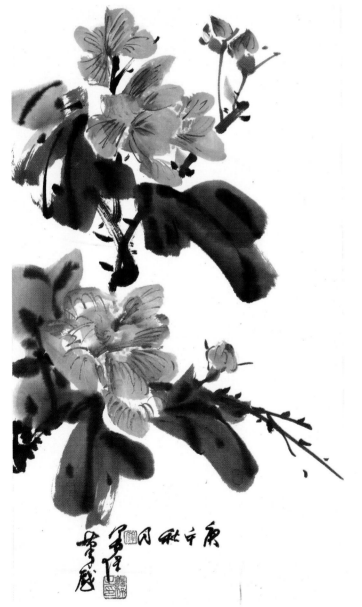

Above A very freestyle chrysanthemum that does not need any detail.

Examine, and then imitate, the structure and attitude of your chosen plant or flower. Some are stiff and bold, while others flow gracefully downwards or to the side. Picture the way that some climbing plants reach for the sun, for instance, and take this into account when painting the various flowers. Make them face in different directions to add interest.

Left Hibiscus, by Joseph Lo.

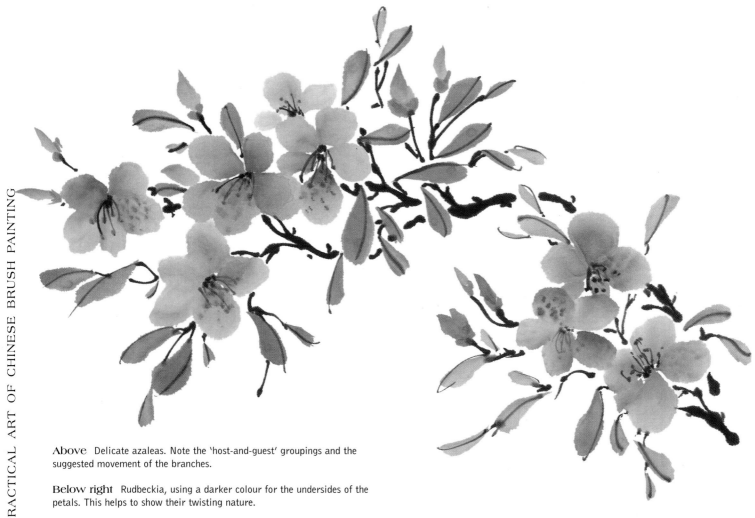

Above Delicate azaleas. Note the 'host-and-guest' groupings and the suggested movement of the branches.

Below right Rudbeckia, using a darker colour for the undersides of the petals. This helps to show their twisting nature.

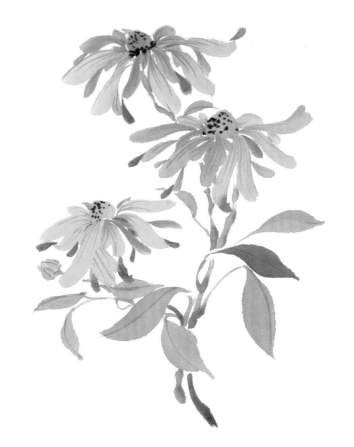

In general, flowers should be painted with some consideration of the effect that you wish to create. Do you want your painting to express the fragility or the liveliness of a flower (the mauve azalea, for instance)? If it is the fragility that you are aiming to capture, then you may wish to use the outline or contour method of painting. This also suggests white or pale-coloured petals, as in the outline peony by Joseph Lo (page 44). Conversely, if the energetic growth of a hibiscus or chrysanthemum appeals to you, it would be better to use bold brushwork. Vary your petals and paint them in such a way that the angle of the flowerhead is clearly seen. The reflection and echoing of colour from other growth will change the colouring of each flower, so do not strive to keep them all the same. If you accidentally paint a slightly darker version, make sure that you have another elsewhere in the painting.

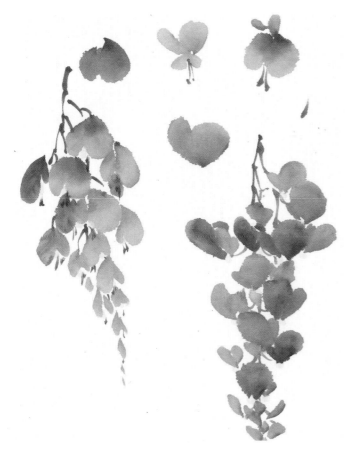

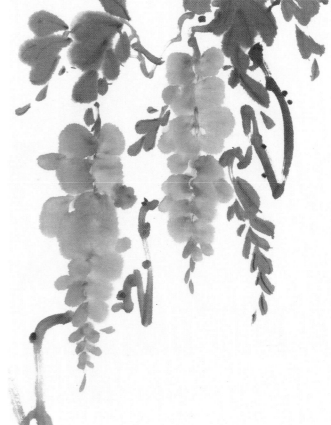

From the various versions of wisteria shown here, both by the author and other artists, you can see the wide variety of expression that can be achieved. Some versions are more conservative, while others are free-flowing and lack attention to detail.

Above left Samples of varying techniques, with the brush tip pointing in different directions.

Above right A more freestyle technique.

Bottom left Different styles of wisteria. You can see how the direction of the brush and the way that it is moved gives a very different version of this much-loved flower.

Bottom right The flower raceme by Cai Xiaoli shows a more dramatic style in this partial painting.

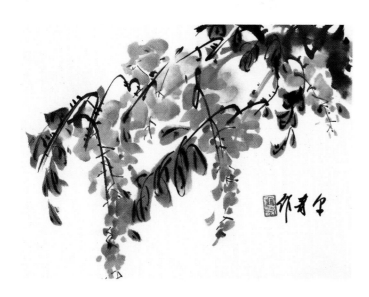

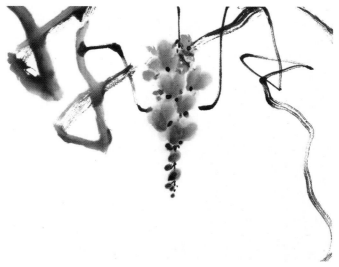

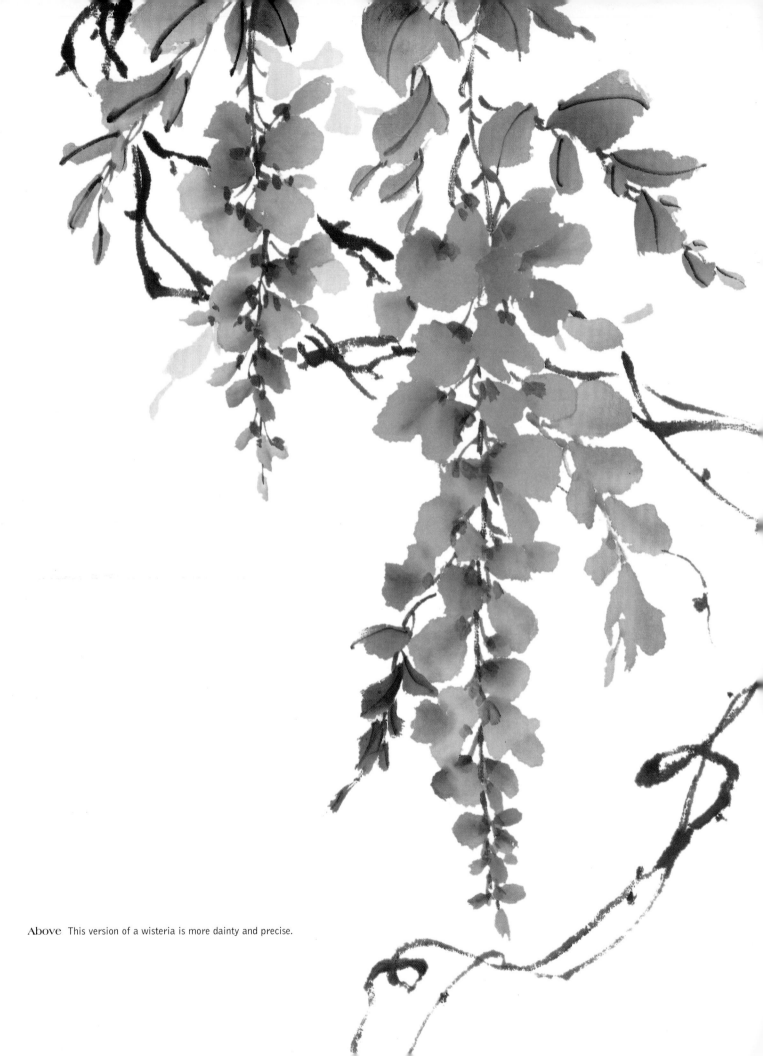

Above This version of a wisteria is more dainty and precise.

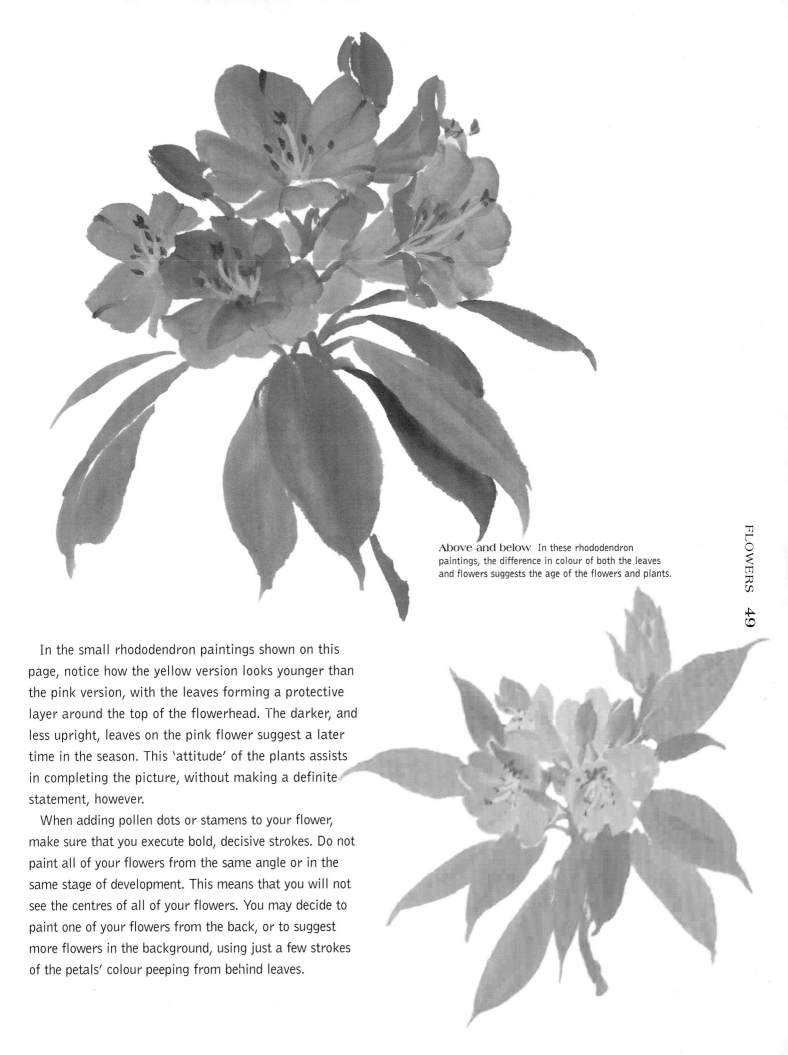

Above and below In these rhododendron paintings, the difference in colour of both the leaves and flowers suggests the age of the flowers and plants.

In the small rhododendron paintings shown on this page, notice how the yellow version looks younger than the pink version, with the leaves forming a protective layer around the top of the flowerhead. The darker, and less upright, leaves on the pink flower suggest a later time in the season. This 'attitude' of the plants assists in completing the picture, without making a definite statement, however.

When adding pollen dots or stamens to your flower, make sure that you execute bold, decisive strokes. Do not paint all of your flowers from the same angle or in the same stage of development. This means that you will not see the centres of all of your flowers. You may decide to paint one of your flowers from the back, or to suggest more flowers in the background, using just a few strokes of the petals' colour peeping from behind leaves.

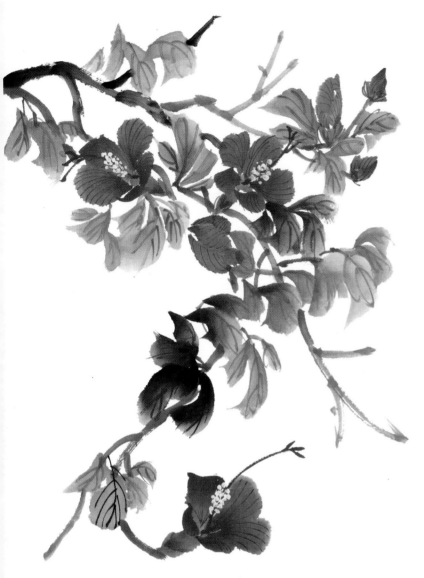

Below Hibiscus, by Kaili Fu. Notice the strong stem strokes.

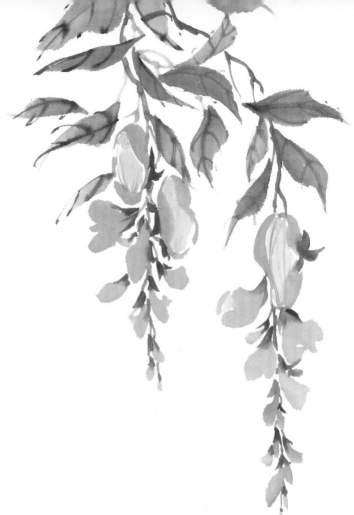

Above Thumbergia. This plant is found in many greenhouses, and its hanging habit is always pleasing in a composition.

The leaves and stems are best added after the flowers themselves, although experience will guide you in the order of painting as you develop your technique. By painting first the flowers and then the leaves, you will allow the flowers to gain importance.

When the leaves are the most important or dominant element of the plant (as in the case of the grass orchid, for instance), you should paint these first. By painting the stems last, you will not allow them to dominate the painting, but will instead let them support the other elements. In the hibiscus painting by Kaili Fu (left),

you will notice how the strong stems do not dominate, but give the plant a very healthy, energetic appearance.

Leaves can be a protection for flowers: narcissi, for instance, are thought of as 'water fairies hiding amongst the leaves'. If you have painted your flower in great detail, the leaves can be simplified. If the flower is painted with many strokes, the leaves can be painted using a single brushstroke, or vice versa. All of these considerations can add qi to your work.

Get into the habit of standing back from your work several times during the painting process, even walking right away from it – you will be surprised by what you notice on your return. Look at the spaces and the distribution of leaves, for example, and always leave out any additions that are unnecessary.

Viburnum opulus
(Snowball tree)

Within the various painting techniques and actual appearance of the subject matter itself lies a wealth of expression. It is the individual's artistic preference (and ability) that allows personal style to develop. This is especially true of flower painting, where the contour or freestyle strokes employed can dictate the delicacy or flamboyant nature of the individual flowers. The snowball tree, for example, is a shrub that suggests balls of fluff, and is therefore an ideal plant to choose for the contour method of painting. In this exercise, take care that you do not paint in meticulous style, and make sure that you keep the strokes free and expressive as you work.

Below Viburnum opulus with a butterfly. The whiteness of the flowers is accentuated by the colour around each.

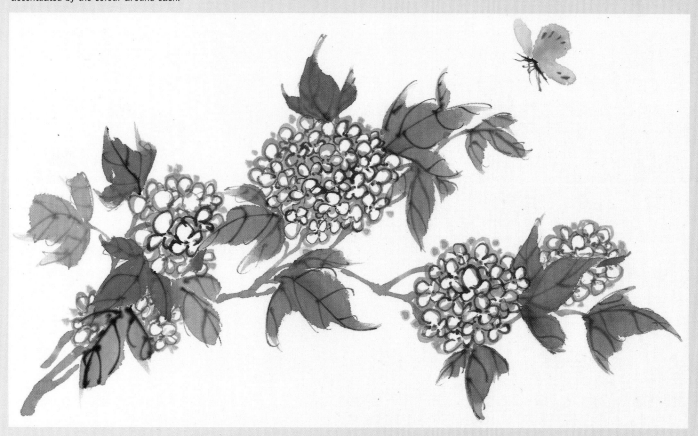

1 Using grey ink and a small brush (not too small as you want to create expression within the flowers), paint the blossoms, starting with the one nearest to you. These blossoms consist of four petals, triangular in shape, but without sharp corners. Add the small dot in the centre — it will help you to see where the flowers are. Gradually work outwards, avoiding any regularity. Many of the blossoms will mask others, hiding some, or parts, of the petals.

2 Where any of the flowers are partially hidden behind leaves, paint those leaves next.

3 Add any additional flowers, gradually working from the front to the back of your composition. Then paint the remaining leaves, varying the greens by adding yellow, brown or blue.

4 Now add the stems, using some brown in the paint mixture for the older stems. Using either burnt sienna or vermillion, repeat the dot of the flower centre, but not always right on top of the grey ink.

5 In order to give roundness to the flower, and to add to its delicacy, choose a pale green, pink or yellow to paint around the outside of each blossom. Then add some dots of the same colour to the outside of the flowerhead to suggest more blossoms in the background.

You will see from the species of hydrangea illustrated below that you paint this plant in the same manner as the viburnum. This version is shown using pale-green lines inside the flower petals.

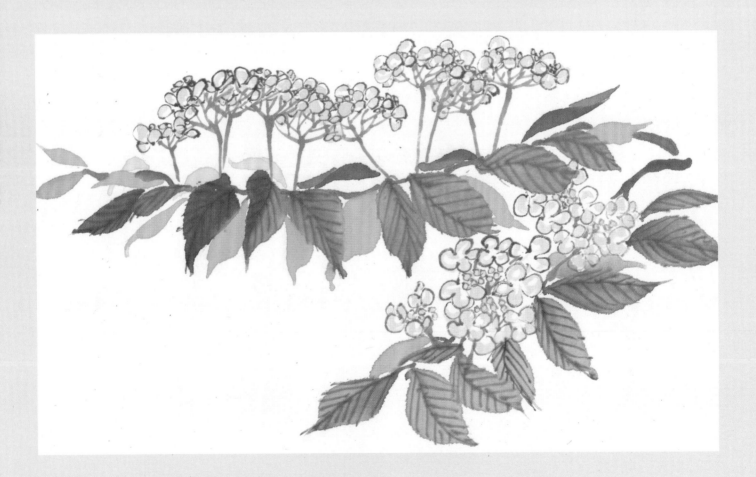

Above A different style depicting a hydrangea, again combining outline and solid strokes. Some of the leaves in the background do not have veins, making them seem more distant.

Heliconia
(Lobster claw)

Heliconia is actually a dramatic member of the banana family. There are several varieties – mainly originating from the jungles of South America – one of the most common being the lobster claw (H. humilis). The bracts of these monocotyledonous perennials are tightly packed onto the stem, jutting out stiffly, first to one side, then to the other, the one above rising from between the 'lips' of the lower bract. The small, green or white flowers are inconspicuous, being concealed within the bracts. Good colour-loading and bold brushstrokes are essential to this exercise.

This plant can be used as one of the elements in a mixed grouping, offsetting these shapes with another, different-shaped plant. There are other members of this family for you to try painting, using a slight variation of the brushstrokes and shapes; some have touching bracts, while others, like the parrot flower (H. psittacorum), are spaced out.

1 Load a mixed-fibre or wolf brush with golden yellow or orange and the top half of the brush with scarlet red. With the tip pointing towards the top of the flower spike, pull the brush in, towards the stem, so that as you pull the brush off the paper in a vertical direction, you achieve a rounded base to each bract. You need to ensure that removing the excess with tissue has controlled the liquid in the heel of the brush.

2 Add the stems, working from the flower downwards, flicking the brush off the paper to suggest its origin within the plant.

3 Using a variety of sideways brushstrokes, paint the leaves from tip to base, adding the stems as for the flowerhead (step 2). Make sure that you create an interesting base to the plant, avoiding both straight lines and groupings.

4 You could add veins to this composition, but will add to the drama by leaving the brushstrokes plain.

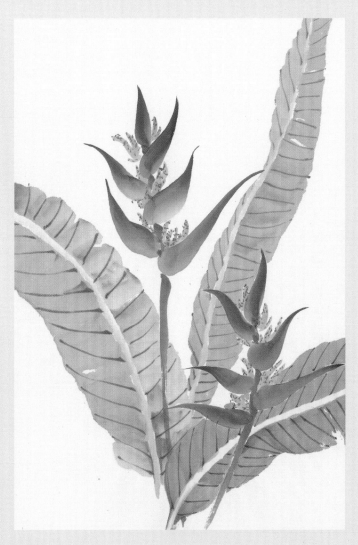

Above By concentrating on various versions of the same flower, you begin to see the subtle variations. The spathes or bracts protect insignificant, small flowers. They are sometimes called lobster claw or parrot flowers.

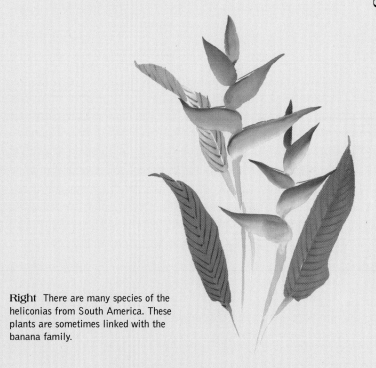

Right There are many species of the heliconias from South America. These plants are sometimes linked with the banana family.

Zantedeschia
(Calla lily)

Calla lilies are currently very fashionable, long-lasting and therefore very rewarding. They are also known as pig lilies, which is rather an insult for such an elegant flower! In this exercise, you should aim to show the prolific growth of the plant, but beware of falling into the trap of having too many leaves and stems crossing each other. Try to show the flowers at differing angles and use varying shades for the leaves. Zantedeschia is usually grown in a pot or tub, but there is no need to illustrate this as long as the stems are growing in a natural form.

1 Mix a suitable colour (these flowers can be white, yellow, orange, pink or the most incredible dark purple). Start your strokes from the top of the highest flower and pull the brush downwards, varying the pressure with each bloom. Then add another stroke to form the other side of the trumpet.

2 Working from the base of the flower, now make a series of thin strokes, moving upwards, towards the flared shape.

3 Using a pale-pink-and-green mixture, stroke gently upwards with the side of the brush to solidify the outside of the tube. Again using green, pull down with a stronger stroke for the stem. Do not make this stroke too long because much of the stem could be hidden by the leaves. If you have not yet finalised your composition, leave the stem strokes until after you have painted the leaves.

4 When painting the leaves, aim for liveliness in their form. Most leaves should be painted from the tip of the leaf to the base, but those turning over towards the viewer should be tackled from base to tip. This is to make the base of the plant of less importance than the flowers themselves. Some of the leaves can be painted with a single stroke, while others are formed from two strokes, with the points of the brushstrokes meeting in the middle.

5. Lastly, add any centres that may be visible. This is an interesting plant because some of the centres just have a large, yellow, spear-like stamen, while others develop into clusters of bright-green berries. As the flowers are rather flamboyant, it should not be necessary to vein the leaves.

Below A variety of leaf arrangements.

Right This diagram shows the directions of the petal strokes.

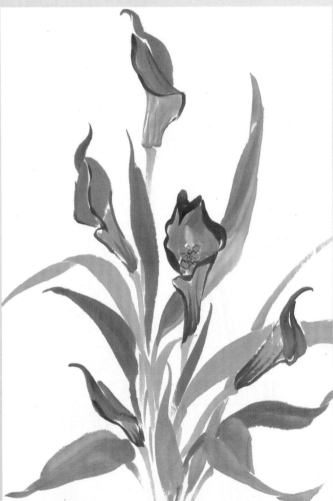

Above Calla lily. This very fashionable flower is known for its long-lasting qualities. When painting it, aim to keep the composition of the stems uncomplicated.

Aristolochia elegans
(Calico flower)

This climber from Brazil can be grown in greenhouses and is an ideal subject for experimenting with different painting techniques. The oddly shaped flowers can be painted using large strokes, with the patterns either being added later or applied in the first instance. Using the former option, you will create a softer effect (with the lines being painted onto the damp strokes), whereas the latter will give a sharper contrast. Try both techniques and see which version you prefer.

1 Once you have taken some time to experiment and have decided which technique you prefer, start with the nearest flower, painting the yellow centre, followed by the black-and-purple tube. Add the outer shape in a pale, thin stroke, then add the pattern directly (or on top of two large, pale, sweeping strokes). Make sure that the reverse of the petals looks different to the face.

2 Paint the buds and closed flowers, including the pale-green inflated tubes, making sure that these are at different angles.

3 Using a variety of strokes (two or three), add the heart-shaped leaves, showing how the leaves of this rampant climber twist and turn in all directions. Notice how every joint between the leaf, flower and main stem has a small, lime-green, circular leaf.

4 Paint the stems with plenty of movement, working from the top downwards.

5 Remember that insects love this plant, so make sure that you add some to your composition.

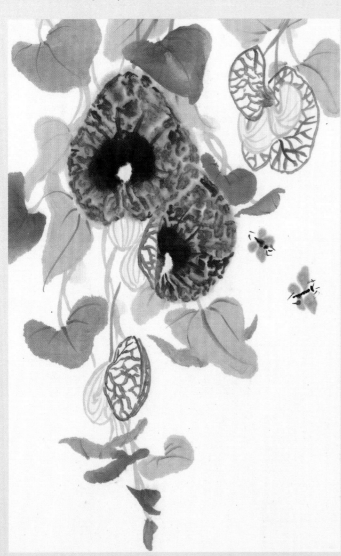

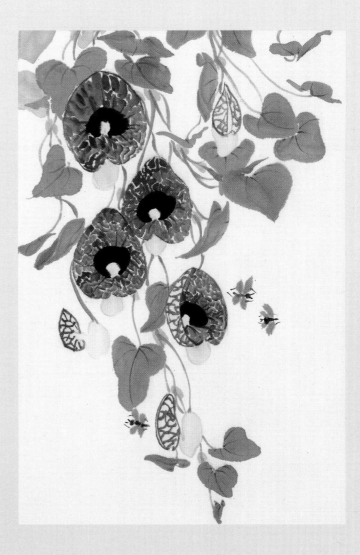

Right and above Two versions of the calico flower. The right-hand version started with the red patterns, followed by a light-yellow wash when dry. On the left you can see the softer effect obtained by painting yellow strokes first, followed by the dark red whilst the flowers were still damp.

Peony

These are the favourite flowers of many artists and are ideal for colour-loading practice. Both the bush and tree type of peony are favoured. Many of the Chinese mountain peonies have unusual colours, such as green or almost black. The bush peony is a symbol of good fortune and affection, while the tree peony represents spring. The red variety, which is often called the 'queen of flowers', is the most admired. There are many combinations of plants that can be painted with the peony, all with auspicious meanings, for example 'riches, reputation and long life' (peony, pine and rock). When painting the peony, try to imagine three bowls of different diameters, one on top of the other. As you paint the petals, visualise the bowls with each layer. Remember to paint the flowers so that they are facing in different directions.

See also the composition of peonies by Sun Ming in the Gallery on page 160.

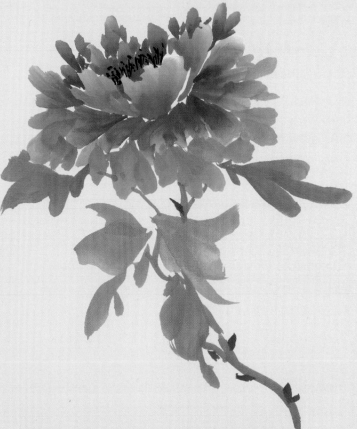

Above A peony showing the difference when the stamens are painted in black.

Below left Stages of the peony flower. Paint the inner cup starting at the front.

Below Gradually add petals to create the whole flower. Paint lines from the outer edge of the petals if required.

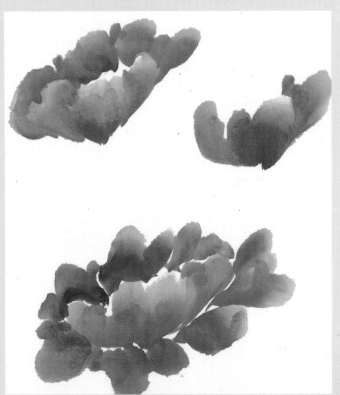

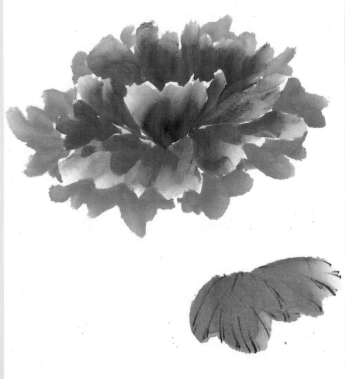

1 Load three shades of red onto your brush, starting with the lightest.

2 Point the tip of the brush into the centre of the flower, then raise and lower the brush while moving it sideways. Each petal is different, and will vary in size (I find that it helps to paint the petal on the near side of the top 'bowl' first, as well as to visualise one layer at a time).

3 Paint the buds with the tip of the brush to the top. The buds are likely to be shorter than, and under the protection of, the leaves and open flowers.

4 Using a variety of greens and the side of the brush, paint the leaves, ensuring that you vary the angles and levels.

5 Load dark green and brown onto a firm brush and paint the stems, using a strong, pushing stroke from the base of the plant. If you have grouped your flowers and leaves appropriately, you should not need many.

6 Add veins to the leaves, then red shoots to the sides of the stems to show new growth points (this also enlivens the stems).

7 Mix some white tube paint with yellow (the white watercolour from solid pans of colour – see page 22 – is not strong enough) and paint the centre of each flower. Make the strokes different heights and densities. An alternative is to use black ink, as in the example shown on the opposite page.

Below Various shapes for the leaves, both young and old. The stems should be lively, with red shoots.

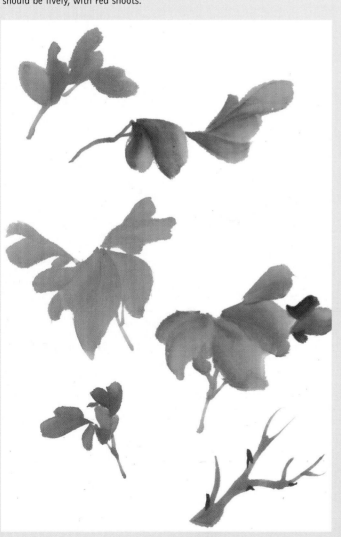

Below A peony composition, painted vertically at a demonstration, showing yellow centres.

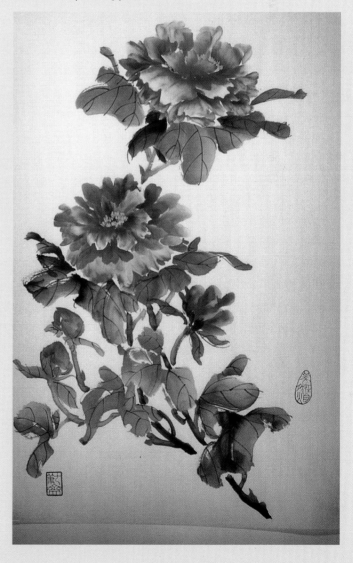

Composition

For flower paintings, it is important to allow the character of the flower to show through. This may be the delicacy of the flower or the leaves; it could be the rampant growth around a contorted branch, as seen in the wisteria in the painting by Chung Chen Sun in the Gallery, page 161; or it could be the stiffness of the plant, as illustrated by Chun Cheng Sun at the top of page 161 (here, small insects emphasise the fragrant nature of the flowers). Decide which aspect of the plant's character is most important to you, then seek to emphasise that element. You can do this by painting it in a darker or lighter colour or by making that element slightly larger so that it dominates everything else.

Look at the bamboo paintings by Qu Lei Lei in the Gallery on pages 161 and 163. In the first painting, you will see some lively new growth sprouting upwards in an energetic fashion. The second composition emphasises the flexibility of the plant as it sways in the wind, with the double curve suggesting a wonderful rhythm to the breeze – almost a song from the bamboo. There is a phrase that is often used: 'When the wind comes, my bamboo laughs', which seems to fit this painting admirably.

Your composition can consist of either the plant on its own (such as a Japanese anemone) in order to show the way it grows, or to emphasise the different stages of its growth, or it can be combined with one or more birds or insects. In the latter case, allow plenty of room for the creatures to fly, and make sure that you do not place them in a position that means that they form lines with the tips of any of the leaves or flowers. Allow the space to flow in and out of your painting, giving an interesting route for the eye to follow.

If you plan to include a bird, decide whether the painting is of a bird, with the flower as an auxiliary subject, or whether the bird itself is the accessory. This will then guide you in deciding the level of importance to place on the various elements and will determine the amount of detail that you need to include. The main item can contain more marks and line work than the minor one. For instance, if a butterfly is an accessory, you could paint it in an outline style, rather than using solid strokes, so that it does not overpower the main subject, the flower.

Other compositions can combine flowers with rocks, again making the most of the juxtaposition of soft and hard, movable and immovable, yin and yang and so on. The painting in the Gallery by Cai Xiaoli on page 163 shows this factor very well, using the outline chrysanthemum as the greatest contrast, bridged by the chrysanthemum leaves and bamboo in solid strokes.

Still-life compositions are popular in China, with flowers often featuring within them. One source of inspiration for still lifes is flower-arranging, either Western or Japanese Ikebana.

Qu Lei Lei painted the profusion of flowers in a glass jug (see Gallery, page 162) in a spontaneous demonstration some time ago. The surface supporting the jug is only hinted at, while the glass and white flowers are greatly enhanced by the blue background (a wash applied afterwards to the back of the painting). This work also shows the grain of the paper very well.

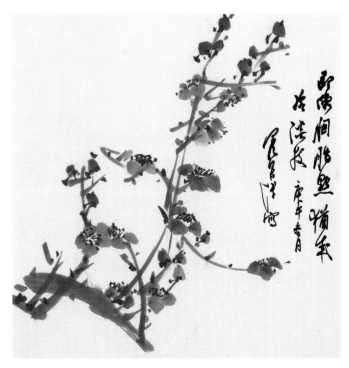

Above A Red plum blossom framing elegant calligraphy by Joseph Lo

Adding calligraphy

When adding calligraphy and seals to your composition (see Completion, pages 139–51), again look at the space left by the marks on your paper. These elements should add to your composition, not detract from it. If you have a delicate orchid, for instance, you would not use a yin seal as this would be too dominant. In the plum painting by Joseph Lo, notice how the plant almost embraces the calligraphy, forming a frame. The style of the calligraphy is very sympathetic to the flowers. The red camellia (see page 50), on the other hand, also by Joseph Lo (see page 38), uses the calligraphy as an extension of the branch, while the hibiscus uses the script as a base to the composition.

Symbolism of flowers and auspicious compositions

Wild apple and magnolias – 'may your house be rich and honourable'

Narcissus, bamboos and rocks – 'the immortals [or fairies] wish you longevity'

Bamboo with plums – marriage

Chrysanthemum and cicada – promotion

Chrysanthemum and pine – long life

Chrysanthemum and nine quail – peacefulness

Chrysanthemum and grasshopper – long success

Cinnamon tree (scented Osmanthus or sweet olive, also known as Osmanthus fragrans or guihua) – success

Cinnamon tree (scented Osmanthus) and peach – great age and honour

Peony and bee – lovers

Two lotus blooms or one bloom and one leaf – shared love

Willow, golden oriole (female) and butterfly (male) – used to evoke love

Plum blossom and bee – long life and beauty

Orchid, wild apple, peony and cinnamon blossom – used to wish a friend well

Let one hundred flowers bloom (many flowers bloom together) – a Communist party slogan, but it goes further back to the 'Book of Odes'

Pine, bamboo and plum – three friends (used for someone on their own)

Bamboo, plum and a rock – three friends (ditto)

Orchid, lily and iris – all called lan

Lotus with bud and leaf – a complete union

Peony, lotus, chrysanthemum and plum – the alternative flowers of the four seasons

Rose in a vase – appropriate for all four seasons (NB for a time there were five seasons in China)

Peony and hibiscus – 'good wishes for richness and flourishing'

Wild camellia and bird – 'long-life wish for the spring'

Flowers in a vase – the vase can add the element of peace to the symbolism of the flower

Plum, peony and crab-apple flowers – three outstanding spring flowers

Plum, pine and Buddha's-hand citron – three purities

Plum and lotus – 'kindness and politeness makes you rich'

Orchid (spring) and chrysanthemum (autumn) – 'each beauty has its own charm'

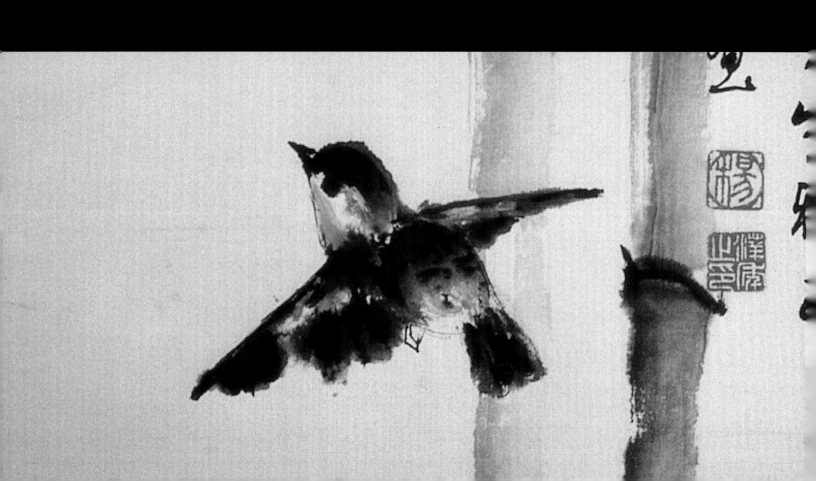

Birds & insects

Birds

Birds were initially shown with flowers (huaniao), and were mostly used as accessories to the rest of the painting rather than as the main subject. Later, such birds as cranes, eagles and peacocks were painted in splendid poses, showing the beauty of their plumage and posture. As freestyle painting gained popularity, so the character of the bird became more important. The background was also chosen to add to the bird's symbolism, for example, cranes were shown with pine (both meaning longevity) or an eagle was depicted on a rock (both indicating strength).

The first thing that you therefore need to do is to decide on the prime subject. Next, look at the positioning of each element. Do not allow your bird to look out of the picture too much – it is much better to include an object of interest (an insect, for example)

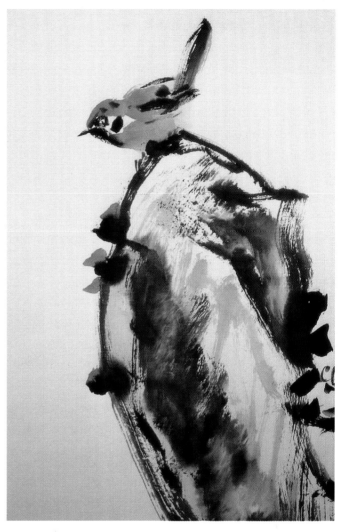

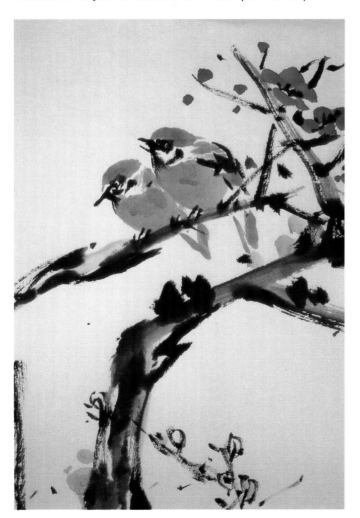

within the boundaries of your painting. Is your bird flying or motionless (such as a toucan sheltering under the protection of branches)? What is the expression in the bird's eye? Also ask yourself how little you need to show for the viewer to know what type of bird and scene you are depicting. The less you have to include, the simpler, and therefore the more dramatic, the work will be. A wonderfully evocative painting of two chicks underneath their parent's stern gaze, by Zoë McMillan, appears on page 163. Although the parent is not shown, you know immediately that the chicks are in 'big trouble'! The composition is excellent, too.

Above A small, cheeky sparrow on a rock, by Chung Chen Sun.

Left Two sparrows on plum blossom. Notice the variation in the poses and the degree of security of the birds on their chosen perches.

Once you have the image in your mind (or a 'master's' painting in front of you), you'll need to decide on the order in which to carry out your painting. For the majority of birds, you can start either with the eye and then the beak or vice versa. These aspects, followed by the top of the bird's head, will usually set the character of your bird. You need surprisingly little in the way of brushstrokes to suggest which species or type of bird you have in mind. However, with some birds, especially those in the Lingnan style (by Zhao Shao An, James Tan and Jane Evans, for example), the breast of the bird is often painted first, or else the back and wings if the bird is turned away from you. Experiment, and you will probably find that one way will suit you better than the others, so make that your way of painting birds. It is usually preferable to finish the bird before adding the branch or rock on which it is

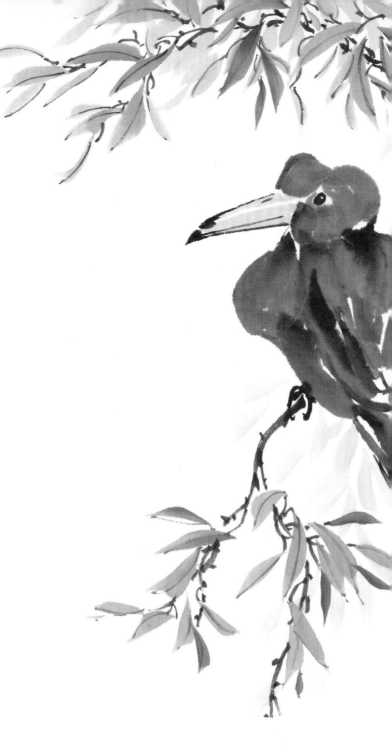

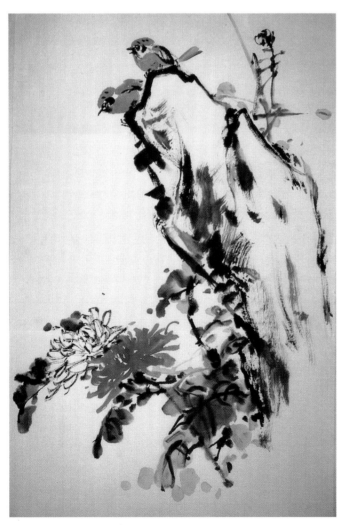

Above There are many types of toucans around the world. Some of their large beaks are all of the colours of the rainbow.

Left This painting of two sparrows on a rock was demonstrated by Chung Chen Sun during a visit to the UK. The rock incorporates many of the basic painting principles, such as light and dark, wet and dry, dense and sparse. The variations in interpretation of the chrysanthemums at the base of the rock add to the qi of the whole painting.

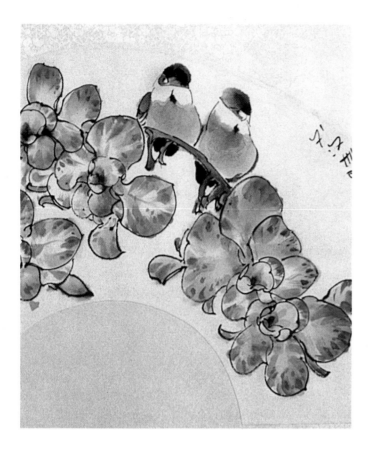

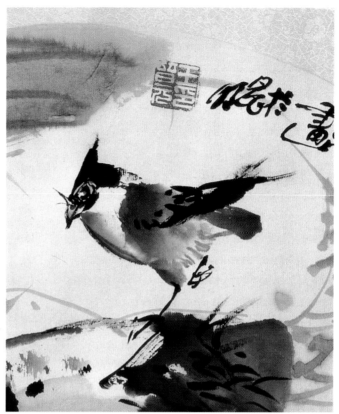

perched. Again, try both ways round so that you can decide for yourself what works best for you. (If you find that you cannot make up your mind, just keep following the instructions.)

Consider what your bird is doing. Is it just sitting? Or is it leaning forward and looking? If it is singing, it will have its beak and wings open, and its tail spread a little. Although you do not need to show any great detail, these small points will help to make your painting look more believable.

In the painting of the small bird with chestnuts (right), the bird is very static, but gives the impression of being hunched up against the cold. Notice how the bird is facing into the main part of the painting. One of

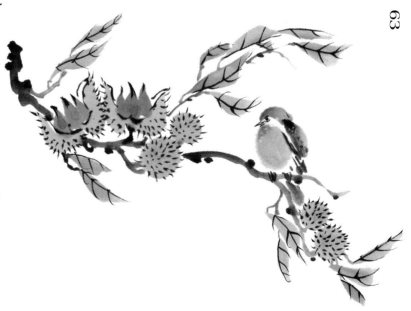

Top left Together, a detail from a charming and colourful fan by Tan Chang Rong. The cheeky, stylised birds contrast so well with the elegant and detailed orchids. Notice the different tones in the petals.

Top right A detail from a fan by Wang Jin Yuan entitled Green Shade. The bird is obviously quite happy exploring under the shade of a banana leaf.

Right A small bird amongst chestnuts. This was painted a number of years ago, after a painting by Sheena Davis.

the owl paintings by Jenny Scott at right is also static, in a typical owl pose. By contrast, the other painting shows the bird stretching its wings (another typical movement). As an artist, you need to learn to be observant at all times and to notice all sorts of details, either from life, photographs or any other reference source.

When painting more than one bird, you need to be aware of the spaces between the birds, and also of the sizes and stages of development of the different birds. The cockerel family below shows these stages of growth and has an interesting composition. Another well-thought-out painting is Gossiping cockatoos, by Jenny Scott (bottom right). A different, but equally effective, approach to the composition is used here.

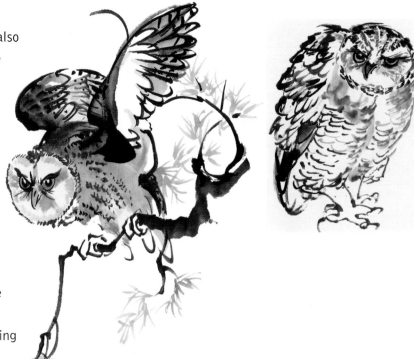

Above and above right A very wise-looking owl by Jenny Scott (above right). The pose is stationary, and the stare intent. The owl on the left, on the other hand, is either flying away or exercising its wings.

Below left Meet the Family, by Jenny Scott. This is a lively composition, with a contrast between outline and solid strokes.

Below Gossiping Cockatoos, by Jenny Scott. This is a compact arrangement, yet has plenty of movement due to the crests of the birds. Jenny has used the foliage to assist in showing the white of the feathers.

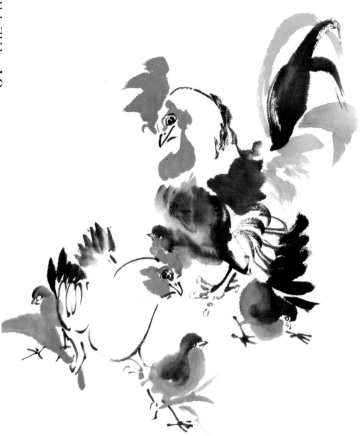

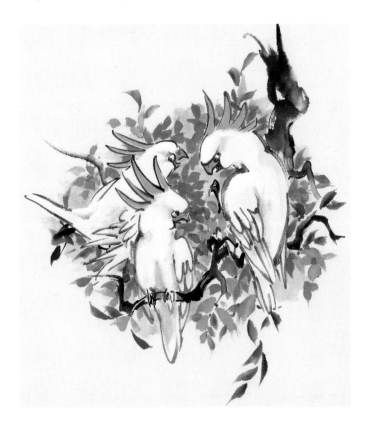

Red-crowned cranes

Freestyle birds are great fun to paint. The strokes must be loose, with varied colour-loading with either ink or colour. The example shown at right is from an idea by Hu Fang, with the red-crowned cranes shown in the background of a lotus painting. Lotuses are symbolic of summer and purity, while the cranes suggest longevity, making the implications of this painting very pleasing. Have fun with the angles of the necks and beaks (after all, in this type of composition, you do not have to worry about the feet!)

1 Paint the beaks first, then the red crowns and the plumes at the back of the heads.

2 Load a soft brush with shades of ink and, using the side of the brush, pull downwards to form the bodies.

3 Using black ink, add extra shading and a few lines to clarify the shapes. Add the legs.

4 For this particular composition, add the lotus flowers, leaves, stems and grasses.

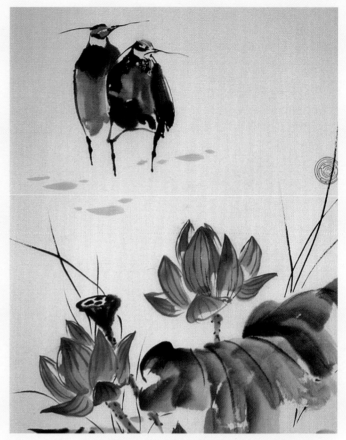

Above Red-crowned cranes in a lotus pond. The birds are shown in a free style that is offset by the detail in the flowers. The seal (carved by Kaili Fu) represents my name, based on tree rings.

White egret

Egrets are beautifully elegant birds, and their white plumage needs to be emphasised. The example shown is painted on dyed Xuan paper, but if you require a varied background, you could put a wash onto standard Xuan paper in advance and allow it to dry, or else add a wash to the back of the painting after completing the egret (see Further techniques, page 129). Remember that both a wash and the commercial dyeing process will affect the absorbency of the paper.

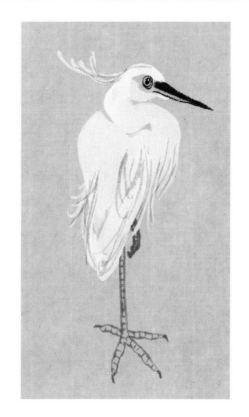

Right A white egret, a bird that has been haunting the local watercress beds for some months. This is painted on coloured Xuan paper.

Golden orioles

As with all bird paintings, you will need to decide whether the bird has priority. You will see from the examples here that the oriole on a fig branch is the prime subject, whereas the oriole with the willow and butterfly is part of a more complex composition. In both instances, start painting the bird first; you can then arrange the rest of the composition around it.

Right Another variety of oriole is the main subject of this composition. Fig trees are known as 'the fruit with no flower' in China.

Below A golden oriole in a willow tree with a butterfly. The tree plays an important role in this painting.

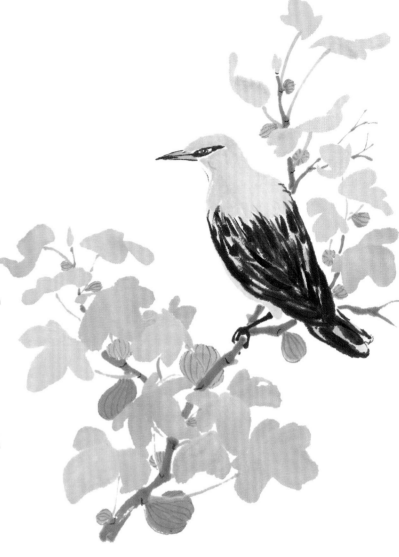

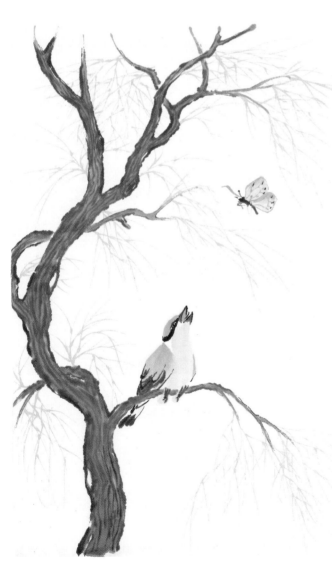

1 Paint the eye, the beak and the black markings around the eye (note that the two birds depicted here look slightly different).

2 Add the main head stroke, working from the beak backwards.

3 Put in the breast or shoulders, followed by the wings (make sure that your strokes are strong).

4 Position the tail feathers so that your bird is secure on the branch. If appropriate, insert some yellow for the undercarriage.

5 Add the legs and feet.

6 For the fig tree, paint the leaves, then the branches, stems and fruit. Now add the markings.

7 For the willow, paint the tree, then add the foliage (I have shown spring foliage here). Finally, paint the butterfly).

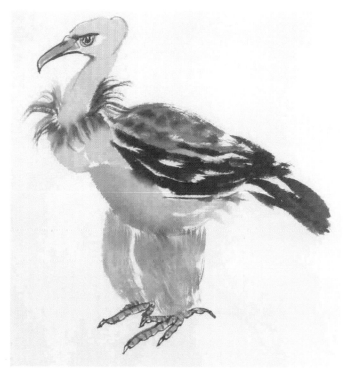

Above Not all birds are pretty! This vulture is fun, though, and gives an opportunity for a lot of variation in expression.

Improving and developing your technique

As you gain confidence and experience with each subject, it is essential that you avoid remaining stuck at one level. Do not be content with simply copying other people's paintings, but try to develop your own work. One way of advancing is to take one or more paintings that you have already painted of the same subject (especially if the compositions are different) and try to change the arrangement or to amalgamate them. I had painted two versions of the male and female pheasants shown on this page and then decided to try a different pose. I drew in simple brush lines, the male from one and the female from the other, both on separate pieces of paper, which I then cut around so that I could overlap them. By experimenting with gradual movements – up and down, left and right – I eventually arrived at a composition that I was reasonably happy with. (I found that the most difficult thing to get right was the position of the male's head, which was initially 'getting lost' against the body of the female.) This method allows you to sort out many problems before tackling 'the masterpiece' itself.

Once you are ready to move away from the 'copying-to-learn' process, and onwards towards creating your own work, there are various approaches that can help you.

1 Browse through art books (both past and present), making notes and sketches.

2 Try painting different arrangements, moving one or two elements at a time.

3 Cover a previously painted picture with a piece of plastic (to avoid damaging the work). Using a brush and ink, trace the main structure of the bird or other subject on a thin piece of paper (e.g., grass paper). Assemble a selection of these sketches and move them around your proposed picture, carefully examining the shapes and spaces.

4 Once you have painted your picture, check carefully to see if there is anything that you can improve. By working in this way you will gradually develop an eye for compositions that are appropriate, and will get to know which types of compositions you prefer.

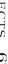

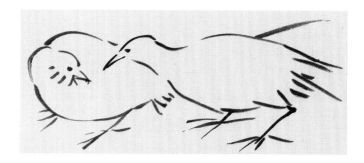

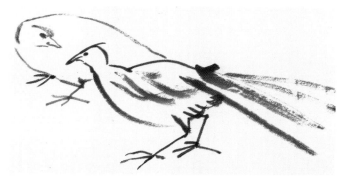

Top Be prepared, by the use of sketches and so on, to try various options. A few simple brushstrokes, even if they are only in ink, are sufficient to experiment with different groupings.

Above Not every version will work well. Here the male's head is confused against the body of the female. I think that the final version, shown overleaf, is better.

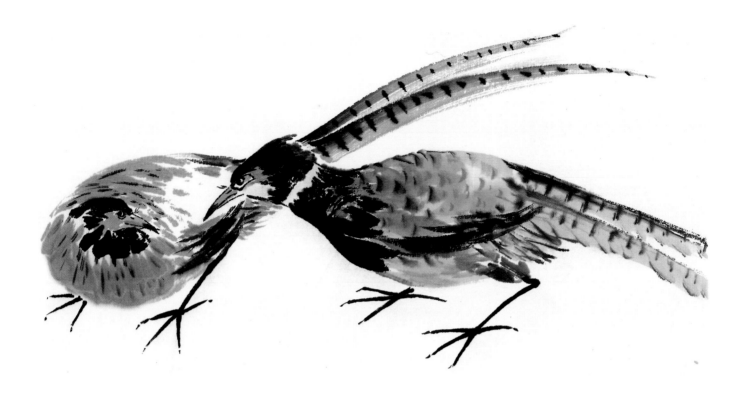

Above Pheasant composition. When working on a new project, try many different arrangements and options.

Below A detail from Chattering in the Wood, a fan by Liang Shi Min, showing four of the five birds in this humorous and skilful painting.

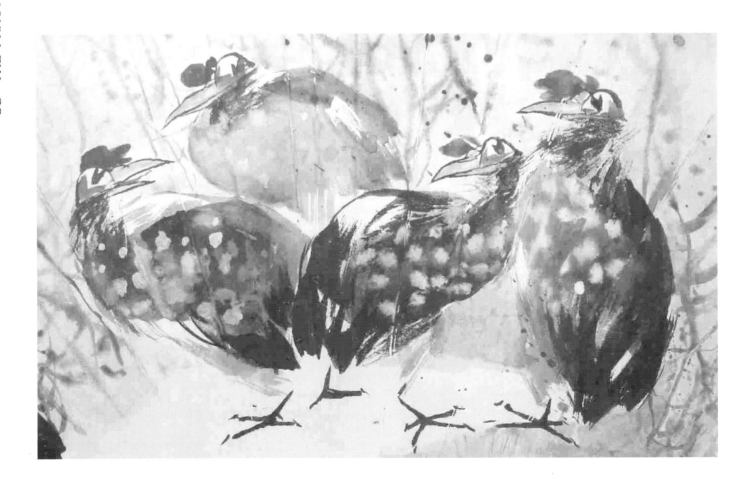

Insects

When adding an insect to a painting, there are several tips to help you. If your main subject is complex or detailed, keep your insect sketchy or simplified. On the other hand, if your flower or fruit is simple, your insect can be meticulous or detailed. In the lupins with bees shown below, it is very easy to get the balance wrong. It is not necessary to paint an exact representation of a bee or wasp because this is not important here. It is the overall impression that you are trying to convey – maybe of fragrance (or the reverse), or maybe a feeling of summer heat. Of course, if you are including your insects in a meticulous-style work, then all of the details should be precise.

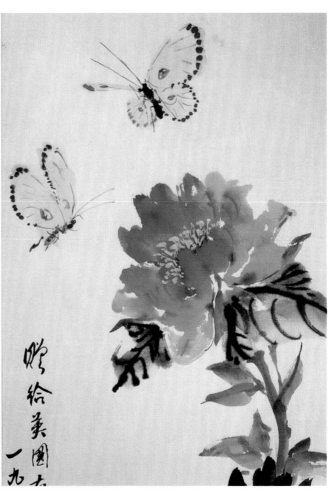

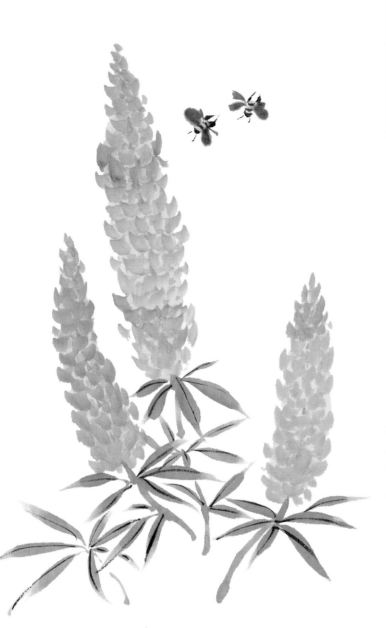

Left Lupins make an ideal partner for these bees.

Top Butterflies attracted by a peony (from a scroll dated 1980). Notice how the views of these insects are from different angles to add interest.

Above This butterfly consists of a few xieyi strokes.

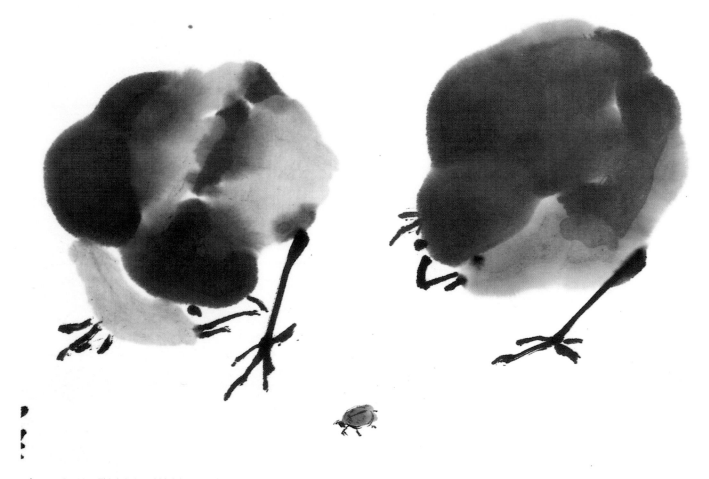

Above Do You Think it is Edible? by Joseph Lo. The element of space plays an important role, combined with the few strokes forming the chicks.

It is also a very good idea to gather together a file of different views of as many insects as you can. Think of it as a database of possibilities. Do you want a side view, a three-quarter view or a full-on aspect? At some point you are sure to want to consider all of these options. If you were including several butterflies around a flower composition, for instance, you would certainly want to vary the angle of each butterfly. (A word of warning, however: always beware of adding too many insects and thus overloading your work.)

Think carefully before adding any extra creature to your painting. If you paint a rough impression of the creature on a spare piece of paper, you can then move it about on your painting to make sure that it would not 'square off' your composition, or create a duality anywhere. A small amount of time spent doing this will pay dividends in the long run.

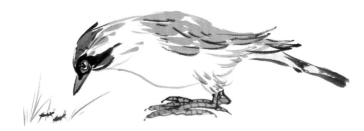

Above This green woodpecker is clearly trying to decide if the ants are worth eating. Notice how balanced the bird appears, but how the shape of its legs and feet are more suited to tree-dwelling than to standing on the grass.

Always ask yourself, 'Is the addition of this insect necessary?' If you cannot answer positively, leave it out. A small creature can often add humour or interest, depending on your composition. However, if you do include one, make sure that it is appropriate, and if you are adding it to a painting of a bird or animal (for example, the two chicks by Joseph Lo and the green woodpecker shown opposite), make sure that you place it in the main subject's line of sight.

Check that your addition is in proportion to the rest of your picture. You may be surprised by how easy it is to include something that is too large. Using a mock-up on some practice paper can again help you to overcome this problem (and this technique can also be used when adding calligraphy or a seal to your work).

Finally, another factor to consider in your composition is is the creature appropriate? It is no good including a dragonfly in your picture if the nearest pond or water source is obviously miles away. Bees and wasps are summer creatures, so do not make the mistake of including them in a winter scene. Butterflies are delicate, so although you could include them in a painting containing both fragile and strong contextual images, you do need to be cautious.

With all of these points, an element of research is required. But that is half the fun, and I find that it adds additional interest. It is amazing how many facts you can uncover, and how much you will find out about Chinese and Oriental culture at the same time.

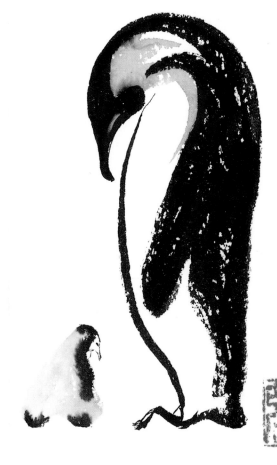

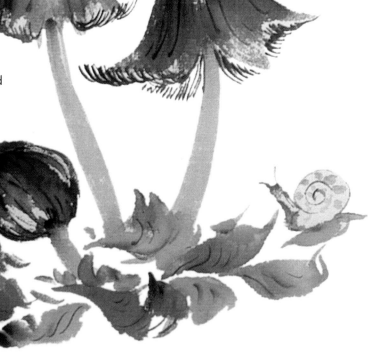

Above This penguin and chick by Mike Williams illustrates what a few strokes on sized paper can achieve. The seal rather dominates this small composition.

Right Fungi with a Beetle and Snail, by Maggie Cross. Having the snail in outline and on the top of the leaf contrasts with the beetle against the toadstool's colour.

Right A different approach to a snail, with this one appearing less ethereal than the woodland snail by Maggie Cross on page 71.

Below Kingfisher with Bulrushes, a composition by Zoë McMillan. The bird is both beautiful and a good contrast to the bulrush shapes. He seems to have arrived too late to catch any fish, though!

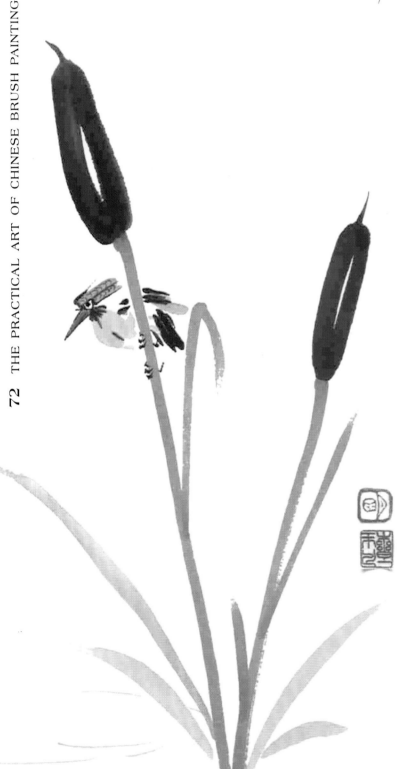

Symbolism of birds and insects

Azalea and cuckoo – linked in Sichuan lore. The azalea is sometimes called 'cuckoo flower'

Eagle on a rock in the water – a man (hero) who fights alone

Crane plus pine – long life

Crane plus stone – long life

Crane plus peach – long life

Magpie standing on lotus seed head and eating seeds – continual success in exams

Magpie on a Paulownia or wutong tree – shared joys

Boy of the White Crane – attendant of the gods

Two cranes flying upwards – promotion

Two wild geese – wedding wishes

Mandarin duck, goose or phoenix – marital bliss

Hen with five chicks – harmony between parents and offspring

Heron with lotus – 'may you go ever upwards'

Doves with flowers – fidelity

Four friends of flowers – butterfly, swallow, oriole and bee

Cricket – fighting spirit

Magpie(s), bamboo and plum – friendship and happiness

Phoenix and peony – 'happy life'

fruit & vegetables

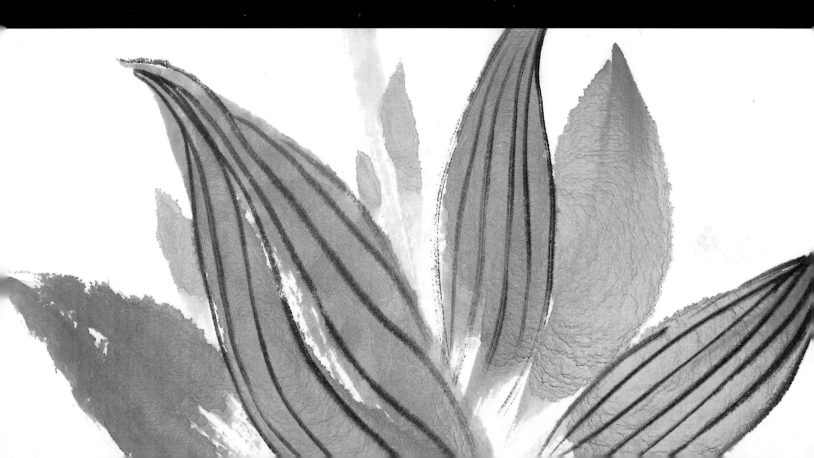

Fruit and vegetables

In an agrarian society, the fruits of the earth are always important. In China, with so many people to feed, the Chinese attach great importance to natural sources of food. Over the centuries, symbolism has been given to various fruits, grains and vegetables (possibly more so in the south of China than in the north). The natural products in an area – based on its latitude, climate and soil – will often dictate the people's diet, clothing and building materials.

During the Imperial Academy period, butterflies and birds were often portrayed with fruit. At various other times the fruit depicted has been far from fresh, with plenty of insects around. Some varieties of vegetables, fruit and grain are shown in still-life situations, with beautiful bowls or ancient bronze vessels, painted in great detail. Sometimes the grouping of items in the composition almost suggests a meal, with fish or fowl shown hanging from the top of the painting and fruit or vegetables below, or to one side.

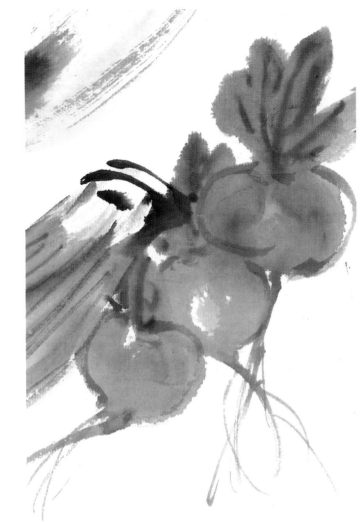

Above Section of Still Life by Joseph Lo.

Above Lotus root and water chestnuts. The lotus is used for many nutritional and medicinal purposes. In this painting, it contrasts well with the bat-like shape of the chestnuts.

Painting fruit

When painting fruit, it is advisable to think of bountiful harvests and the rich meanings behind the various subjects. Fruit can be painted either on the plant or with containers or artefacts, which gives plenty of scope for variation. There are, of course, seasonal variations and traditional subjects for different times of the year (persimmons or oranges at New Year, for example) and for specific occasions (such as pomegranates, denoting many children, for weddings). This approach can be adopted by the Western artist, allowing you to give additional meaning to your work.

First, decide on the style and degree of detail that you wish to include. Many artists have their own stylistic preferences, but this does not mean that the style needs to be consistent over all subjects. Many fruits are symbolic in that they contain many seeds and therefore suggest wealth and harvest. Now that Oriental and other unusual fruit are becoming increasingly available in the West, we tend to be more familiar with many of these interesting and exotic shapes and forms. However, do consider the way in which you are planning to combine them. Are they appropriate to put together? We tend to think of fruit as sweet and vegetables as savoury, but these groupings may work very differently for other cultures.

Right Iris foetidus, the stinking iris. As the pods burst open, they expose wonderful seeds. Gardeners grow them for the autumnal colour of the seeds rather than for the flowers.

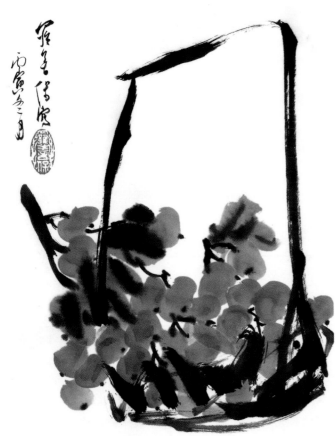

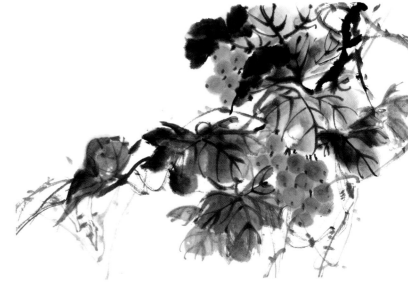

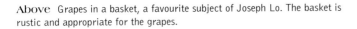

Above Grapes in a basket, a favourite subject of Joseph Lo. The basket is rustic and appropriate for the grapes.

Above Grapes on the vine, showing the tangle of leaves and tendrils.

Below Grapes and a watermelon slice in a bowl, painted on silk. The colours complement each other, adding excitement.

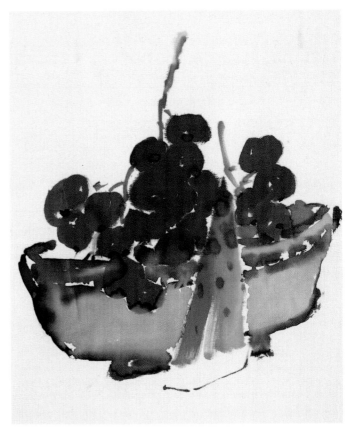

In the examples shown above and right, both the basket and bowl with grapes by Joseph Lo show instances in which the fruit is enhanced by suitable containers. In addition, the slice of watermelon echoes the colour of the Chinese bowl, the richness of the colouring being further enhanced by the silk medium on which it is painted. The grapevine (above right), on the other hand, shows the effect of painting the profusion of colour and leaves, the result of studying the natural growth of the plant. Altering the colours of the leaves and painting them one above the other exaggerates the feeling of protection afforded to the fruit.

The grape painting opposite has an interesting story behind it. At a workshop with Fu Hua, we were told to produce a painting for him to comment on and alter. I – rather tongue-in-cheek – produced a very boring bunch of grapes. There was no comment, just a twinkle in his eye! After many additions, paint of many colours

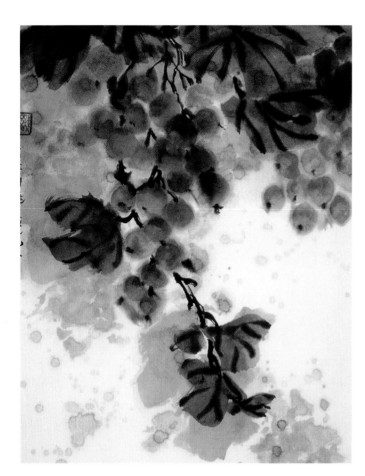

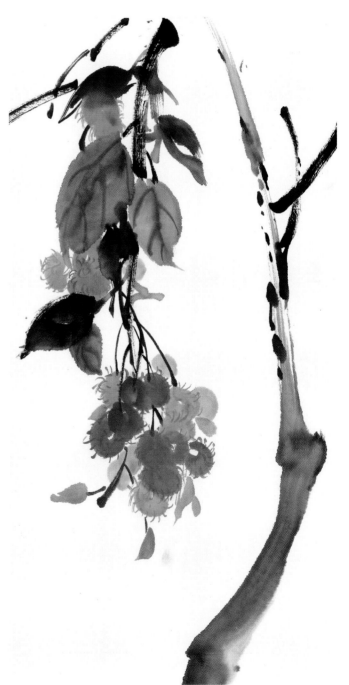

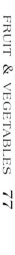

Left A grape painting initially created by the author, with massive improvements later being made by Fu Hua!

Below Rambutans, by Jenny Scott, with bold stems and luscious fruit.

being dropped onto the paper, and more grapes being added, the magical result that you see here was produced. The calligraphy says 'Meeting of the masters', and the seal 'Weaving dreams'! But you can see how even a regimented painting can still be wonderfully altered by a master using colour and marks freely.

The rambutans hanging in profusion (right), by Jenny Scott, suggest luxuriant growth, the exotic colour being offset by the use of ink for the foliage. Shades of ink can be substituted for any colour, but ink is more often used for leaves than anything else.

The Buddha's-hand citron and bitter gourd (see overleaf) are both associated with offerings. (The bitter gourd is sometimes found in the West, and can be used in salads or curries, but beware: it is an acquired taste!) The shapes involved are rather unusual and very interesting to paint. They each have deep meanings: the Buddha's-hand citron is indicative of grasping wealth,

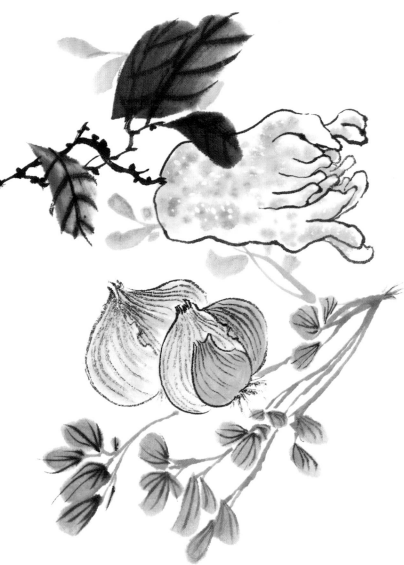

as well as being in the style of the hands of Buddhist statues, while the gourd, which consists of many elements, is symbolic of countless blessings. They are often painted with bronze containers, reflecting their use for scenting rooms.

An unusual combination is the Rosa rubifolia and Michelmas daisies (opposite left). With their complementary colourings, together they convey a wonderful image of autumn. The contrast in the foliage shapes and colouring adds to the interest of this composition. You would also need to suggest the differing growth patterns, and to consider the roundness and robustness of the rose hips in contrast to the fragility of the daisies.

Fruit is often combined with flowers, but it is unusual to see both flowers and fruit, beans or seeds on the same plant. The jack, lab lab or seven sons bean is an example of a plant in which the flowers and beans can both be seen at the same time. (The reason for one of its names is derived from the idea that if you grow this prolific bean in your garden, you can feed a family of seven strapping boys!) This bean, along with others, is a joy to paint. There are several bean techniques to choose from: you can paint the individual beans first with a light colour or paint the pod and then add large dots for the beans while the paint is still damp.

Above The homely onion with the exotic Buddha's-hand citron and some fresh herbs to tie the composition together. Note that the leaves behind do not have veins.

Right Turnip, bitter gourd (or melon) and spring onions – useful ingredients for a curry! The bitter gourd is attractive, but an acquired taste.

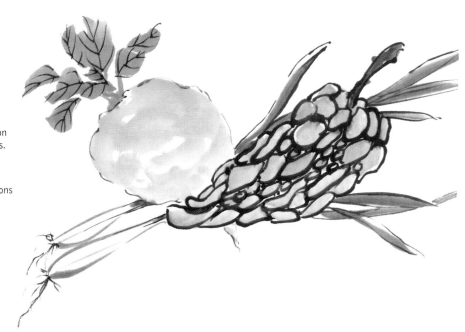

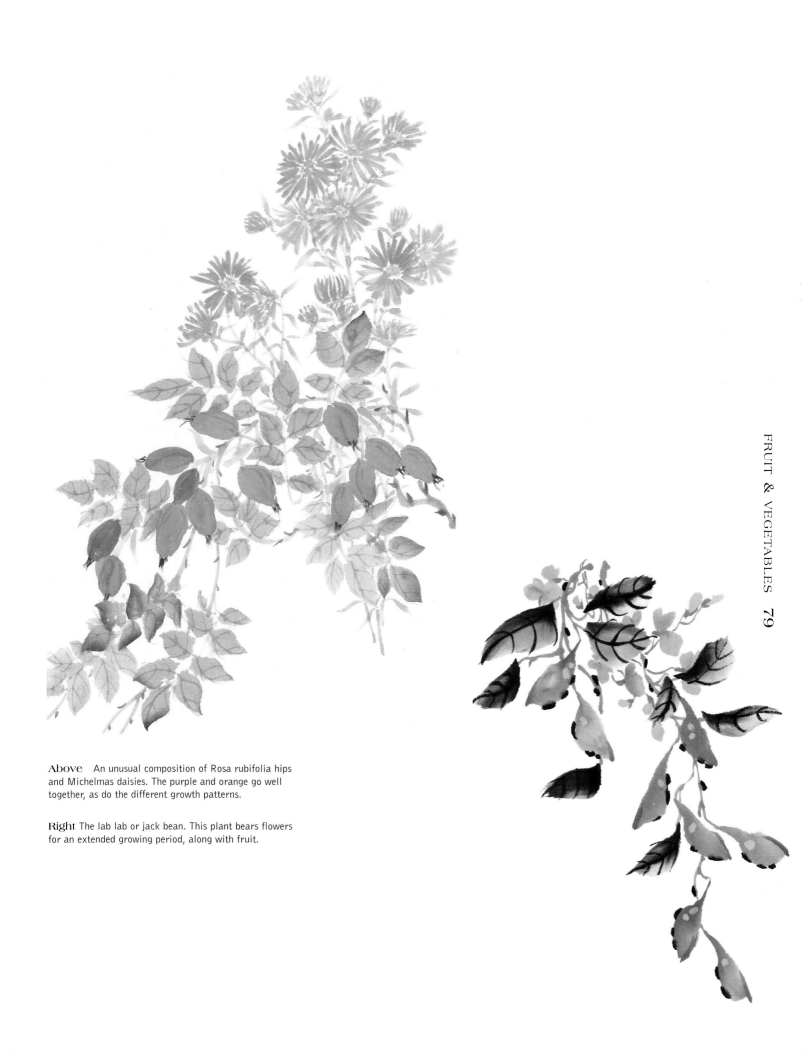

Above An unusual composition of Rosa rubifolia hips
and Michelmas daisies. The purple and orange go well
together, as do the different growth patterns.

Right The lab lab or jack bean. This plant bears flowers
for an extended growing period, along with fruit.

Painting vegetables

The Chinese artist never loses sight of the high regard in which food is held in China. There is a deep respect for it that is rare in the West. This attitude is bound to affect both the content and composition of any painting.

Here again, I have taken a subject in detail to show some of the variations, especially in deciding upon a composition. The homely onion (along with its relatives, the spring onion and scallion) plays an important part in many types of cuisine around the world. Firstly, it is shown below with spring onions, carrots and a bowl, using the colour of the interior of the Chinese bowl to add excitement. The onion is painted in a free outline, and the colour added in minimal strokes afterwards. For both the spring onions and the carrots, bold sweeps of the brush are necessary. Notice the varied brush-loading on the latter. The bowl is painted starting with the rim, followed by the side and feet, with the inside colour being added last of all.

The second version (right) simply focuses on the contrast in shape and strokes used for the onions and spring onions. It is painted in a similar order to the previous example. The third composition (below right) is by Zoë McMillan, and shows the ingredients for a more complex dish. I would commence with the sweetcorn and then fit the onions behind. The onions

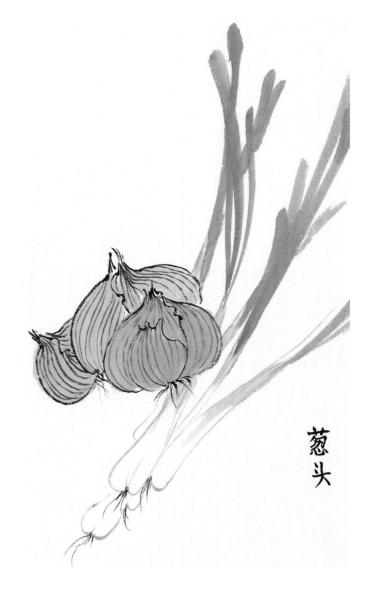

Above Onions and spring onions. The varied techniques express the bulbs and shoots against the older onions.

Left The carrots dominate this composition, with the onions and spring onions behind. The colour of the Chinese bowl complements the orange.

Below Ingredients for a superb dish! This is a composition by Zoë McMillan, incorporating a variety of shapes and techniques.

are shown in two views, using solid strokes. The mushrooms and chillies are arranged in a pleasing distribution of numbers, complemented by the sweetcorn. This illustrates how even the most mundane of vegetables or fruits can be made interesting. An important factor is the clever use of the intriguing shape of the chillies to set off the roundness of the onions. You will notice that there is just enough line added to the various elements to strengthen their outline without making the lines too numerous, continuous or heavy.

Aside from wheat (in the north) and rice (in the south), another staple Chinese food is millet. This can be shown in arching sprays, often tied together, symbolic of the harvest. For this, you paint a yellow or beige circle (similar to painting a fruit) and then add small, darker dots while the paint is still damp. Afterwards, you can add the stems and any method of tying. If growing millet is depicted, as in the example shown at right, it will often be pale green in colour.

Above Millet is one of the staple foods in many parts of the world. It is often shown to indicate plenty (because it consists of many small seeds). Qi Baishi often painted the more 'ordinary' things of life, and millet was one of his subjects.

Left Taro roots. These are used in many Chinese paintings, as well as in traditional medicine throughout the East. The bright-cerise shoots contrast well with the shades of ink.

Below Fungi, by Maggie Cross.

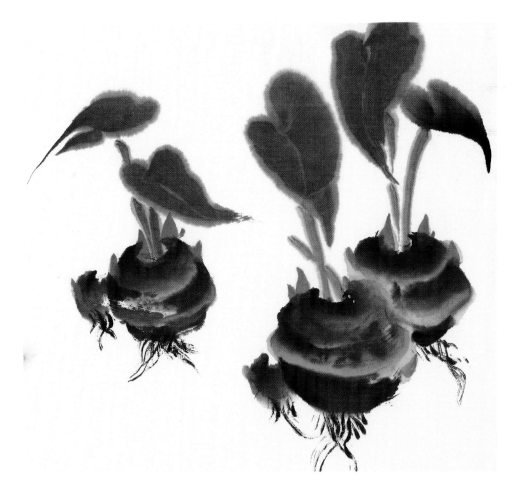

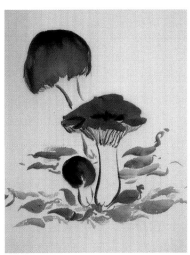

Left Cardoons, with their long, flowing leaves and thistle-like heads. These are delightful to paint.

an artichoke-shaped head (the plants are related), which changes from a beautiful stone or mineral green to shades of brown each autumn. The shape of the head is like a thistle, with purple petals. The leaves are also ice green, but quickly change and become less attractive as they are constantly exposed to water and frost. In some respects they are similar to large poppy leaves. When the leaves are in their prime, the long, flowing strokes needed present quite a challenge: you need to use long strokes with the side of your brush and to overlap them to achieve the ragged edges.

Of course, wild plants like fungi can be painted, too. Study the version on page 81 by Maggie Cross. Using just a few strokes, she has set the background so well, with its crisp, brown litter of leaves.

The taro (Colocasia esculenta) is a vegetable that I have seen for years in Chinese paintings, many of them by master painters, although I have never been able to discover the English name for it. It is a root tuber (a little like a potato in texture and colour) that is used a lot in Asian cooking, especially Thai. It can also be used as a plaster in alternative medicine. Taro can be found in other parts of the world, too, often under a different name. In order to paint this vegetable (see page 81), you need to keep in mind its hairy nature and large leaves. Although they are often shown as being pointed, in other descriptions they are likened to rhubarb leaves, and, with their bright-cerise shoots, are a delight to paint. The lotus is a plant of many uses, and on page 74 the rhizome is shown with water chestnuts. The latter are reminiscent of bats, although I have never seen mention of this fact.

To paint a more exotic subject, such plants as the cardoon (see above) can be included. The cadoon has

Symbolism of fruit and vegetables

Oranges and catfish (often displayed in a basket) – 'may every year be happy'

Chestnut – good manners

Chinese date (jujube tree) and lychee – 'may you soon have sons'

Chinese date and cinnamon tree – 'may your sons prosper'

Buddha's-hand citron with butterfly – long life

Peach, pomegranate and Buddha's-hand citron – peace, many sons and long life

Persimmon (Chinese date or fig), lily and fungi – 'may your affairs prosper'

Persimmon and tangerine – 'good fortune in your plans'

Persimmon, pine and an orange – 'good luck in one hundred undertakings'

Persimmon and lychee – 'may your markets profit'

fish, reptiles & amphibians

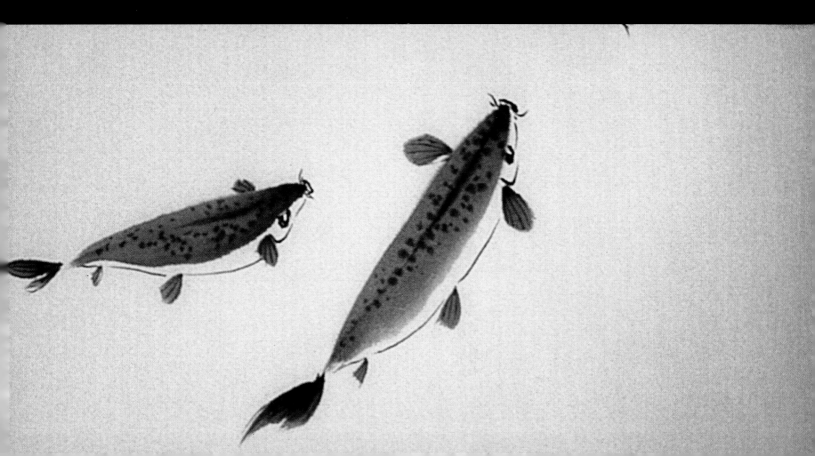

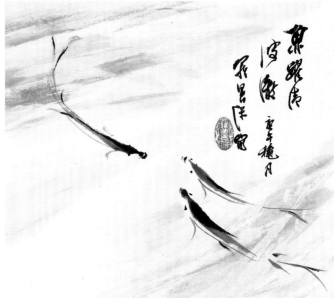

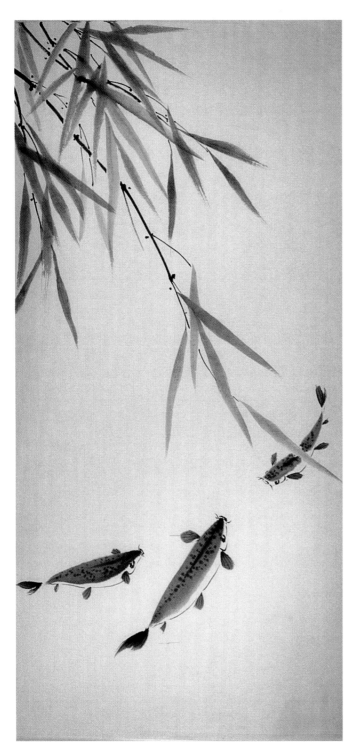

Above Fish meeting underneath an overhanging bamboo. You do not need to show the water, provided that your fish are swimming naturally.

Above right A Conversation, elegant, thin fish by Joseph Lo, giving an impression of interrupted movement.

Fish

Fish are painted for their fluidity and flexibility. They have been admired for centuries, and the Chinese have bred them into fantastic shapes and sizes. There is a great love of Chinese gardens, of which the fish pools within them are a major element. The viewer looks down on the fish, and this is the way in which they were usually painted. The bowls once used to hold fish in Chinese homes are often used as plant-holders today, but would originally have been made from porcelain, giving a view of the fish exactly as though they were in a garden pool. It is therefore reasonable to assume that any painting that shows the fish side on is likely to be of a more recent date.

The most popular fish painted are carp — leaping, twisting and turning — but there is no reason why other types cannot be used. Indeed, there is a wide variety of fish, especially if saltwater varieties are considered. Many of the tropical species come from Asian rivers and streams anyway (their bright colours are often due to the muddy nature of their natural habitat and are nature's way of giving guidelines by using colour). The angelfish painted within the fan format (opposite) show an excellent composition by Zhang De Jun. The contrast between the fish and the background is full of excitement, even though the fish indicate stillness or

slow movement. On the other hand, the small, tropical fish depicted at right scurry around within the weeds, hurrying from one area of cover to another.

By contrast, the fish depicted by Wei Yi in a scroll presented to me by the late Alec Bates (see Gallery, page 169) has a wonderful, curving stroke 86 cm (34 in) long that says it all. The addition of a paler stroke for the mouth and whiskers, plus two further, diluted strokes for the tail, completes the story. Take note of where the calligraphy and seals are placed. One of the seals is a very attractive fish design.

Another version of fish-painting can be found in Further techniques, page 134, where the small, busy fish by Sun Ming are painted with the fingers rather than using the elegance of simple brushstrokes.

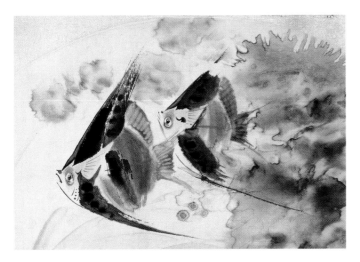

The streamlined fish by Joseph Lo (opposite right), complete with his beautiful calligraphy, create a different environment, one of peace and restfulness. Another painting suggesting a moment of time is the small fan on peach-coloured glitter paper overleaf. You get the feeling that the blossom has just landed on the surface of the water. At the extreme end of the scale is the still life on page 87 by Joseph Lo, in which bamboo shoots and radishes flank the plump fish. The bamboo shoots complement the fish and echo the fish's tail.

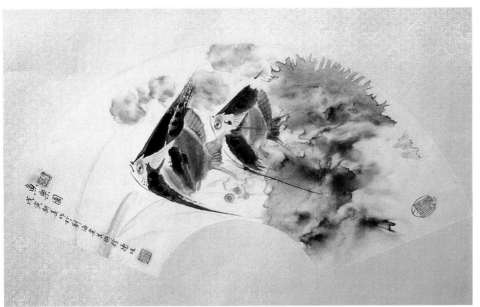

Above Small, tropical fish scurry through the water. Their safety against predators is often dependent on their speed of movement.

Above left A detail of the Angelfish fan by Zhang De Jun. The artist has used the bold shape of the fish to contrast with the suggestion of the background.

Left The whole design of Zhang De Jun's Angelfish fan.

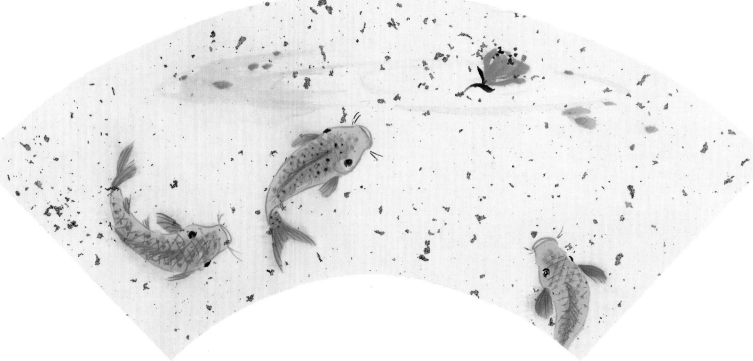

Above A fan portraying inquisitive fish. There is the impression that the blossom has just hit the water's surface.

The goldfish painting at right, by the same artist, suggests infinite water and depth. You get the feeling that the two fish are merely suspended in a far greater scheme of things. The angles of the fish ensure plenty of interest in the composition.

When painting fish, it is important to decide on the character of the subject and the composition. Consider whether you are going to create an exotic version or a take a more practical approach. You will also need to consider the background. Water subjects provide a good opportunity for you to experiment with backgrounds (try out some of the possibilities from the Further techniques section, pages 122–38). They can be definite statements or merely suggestions, and can consist of one or many colours. Fish paintings are often very atmospheric, and for that reason are often associated with wash techniques. You can experiment with colours, light and dark and dense and sparse strokes or marks in this type of painting. It is only by

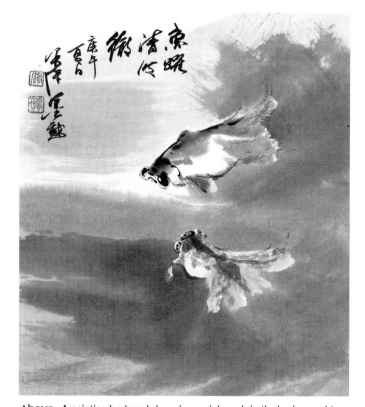

Above A painting by Joseph Lo using an ink wash in the background to suggest the bottom of the pond and maybe some vegetation.

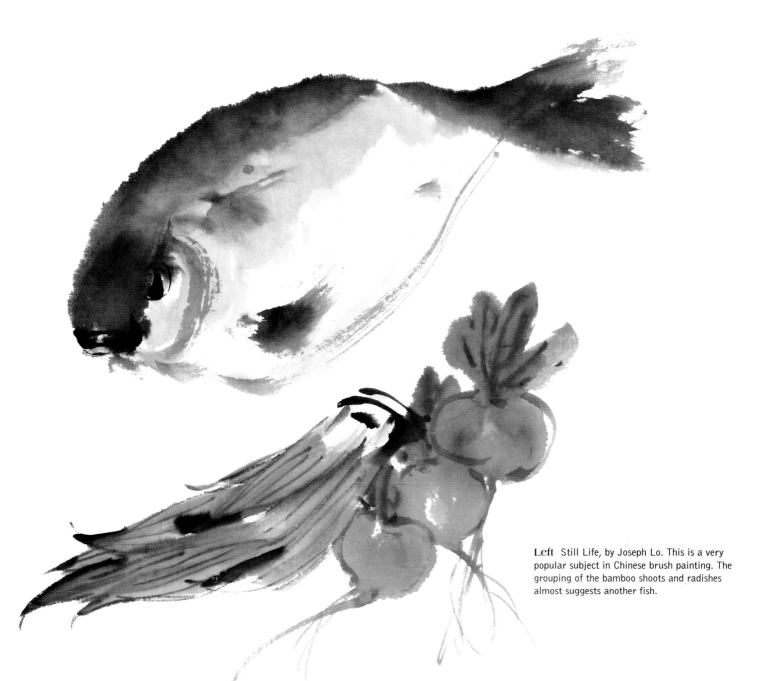

Left Still Life, by Joseph Lo. This is a very popular subject in Chinese brush painting. The grouping of the bamboo shoots and radishes almost suggests another fish.

trying out different possibilities that you will be able to develop your technique. Beware of making your painting too technicolour, though, because this would not in be the traditional Chinese style.

However, in order to depict the brightness of, for instance, Siamese fighting fish and guppies, you will need to show some boldness in the colouring. You then need to think about the background and decide whether you actually need to show one at all. It is obviously easier when you are familiar with certain creatures (I used to keep tropical fish) because then you know how they twist and turn. For me, the fighting fish is rather

stiff and stately when compared with the guppy, which is full of fluttering skirts. Attention to detail is useful as you should not show two male fighting fish together (their behaviour gives them their name). So if you want more than one specimen in your composition, you will need to make sure that the fish are female. The other factor to bear in mind in your painting is that fighting fish are air-breathers, so you may wish to show one angling itself up towards the surface. Again, it is the background research, thought and preparation in Chinese painting that can add so much interest, even before you put brush to paper!

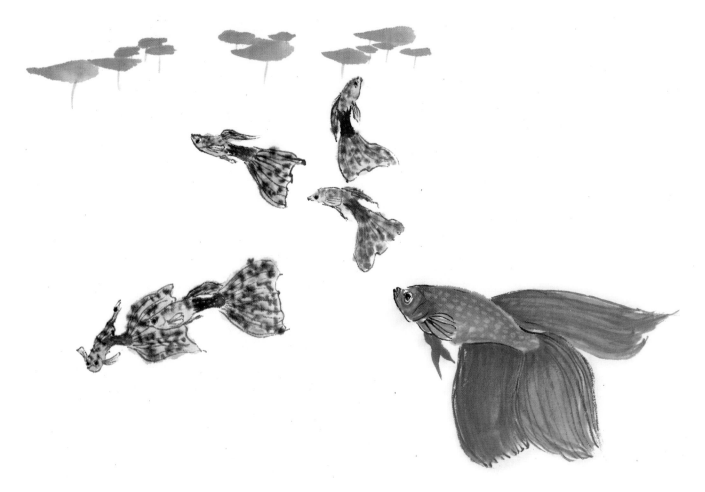

Above The slow-moving male fighting fish always pursues the male guppies. The dominant colour of the fighter shows its strength, and the indistinct treatment of the guppies helps to suggest the fluttering nature of their fins and movements.

Fighting fish

1 Paint the fighting fish, starting with the eye and mouth.

2 Use bold strokes for the body; two should give you the required shape.

3 For the fin, load your brush with colour, tip in a darker version, then lay the brush along the line of the back and sweep the brush upwards and away from the body. Starting initially with most of the brush in contact with the paper, aim to have only the tip of the brush in contact by the end of the stroke.

4 Repeat similar strokes for the lower fin and another two strokes for the tail.

5 When adding the fin lines, remember to imagine them opening like a fan. On such dramatic fish, a few dots are all that are necessary to indicate the scales. To do more could well be too much.

6 For the guppy, use a pale colour for the body and fins, having first painted the eye and mouth to give the scale.

7 When the paint is only slightly damp, add the markings in both ink and colour.

8 Lastly, add a few lines to emphasise the shape. As a contrast to the larger fish, you could paint this small fish using the outline technique, but you need to be careful not to draw!

Composition

When composing a fish painting, there are several factors to consider. Firstly, do you want to create an impression of tranquillity or drama, gentleness or aggression? Next you need to decide how many fish you wish to portray: one, two or an entire shoal. (This decision will depend partly on the breed of fish that you have chosen.) If you have two fish swimming in the same direction, it could be too boring; in opposite directions, too confrontational and regular. One going each way, but at different angles, is much better and more interesting. If you have a larger group and they are all going towards each other, you will have a stiff and unnatural formation. If they are travelling away from the centre in pairs, there will be no link between the elements. Choosing to have three going one way and one the other, for example, would give you a far more interesting arrangement.

Fish with flowers introduce a different experience, and the fish may be above or below the vegetation. In general, however, it is easier to incorporate fish below, say, a banana leaf than to paint carp above a lotus. Either way, you do not need to show the water, but just make it clear that the fish are swimming.

The cinnabar red crab (below) is a delightful composition. The curves of the plant material, combined with the shape and juxtaposition of the legs of the crab, ensure that there is lots of interest within the painting. The addition of the black ink for the eyes of the crab and the veins of the leaf is just enough to give that excitement of light and dark, large and small.

Below A vermilion red crab with a seed head, by Joseph Lo. The angles of the crab's body contrast with the curves of the plant material.

Above Fish with lotus. Because the fish have white undersides, and as an alternative to a wash, I backed this painting with green-dyed Xuan paper to show the white in a more subtle way.

Reptiles and amphibians

Out of all of the possible species of reptiles and amphibians, the two most popular for painting purposes must be the dragon and the frog. There is a resemblance between them in terms of their skin texture, but otherwise they are very different. The dragon is a mythical creature, and, as such, can be painted in any way that you please. The cheeky dragon embellishing the fan below is painted on gold glitter paper – a Xuan paper that had flecks of gold incorporated into it during the manufacturing process. (Do be prepared for some of these pieces of gold to come free of the paper during storage, painting or backing.) For such a subject, this type of paper increases the sense of the dragon's flamboyant nature. (The method for cutting several fans from a sheet of paper is given in Further techniques, pages 122–38.)

Above right A very free version of a dragon by Jenny Scott. Most of the painting is just suggestion, but it is very effective and leaves the viewer in no doubt of the dragon's fiery nature.

Below This cheeky dragon is dancing across the firmament. The paper is appropriate, and an oval seal has been used instead of painting its 'pearl of wisdom'. Carved by Qu Lei Lei, it says 'The cloud is carefree'.

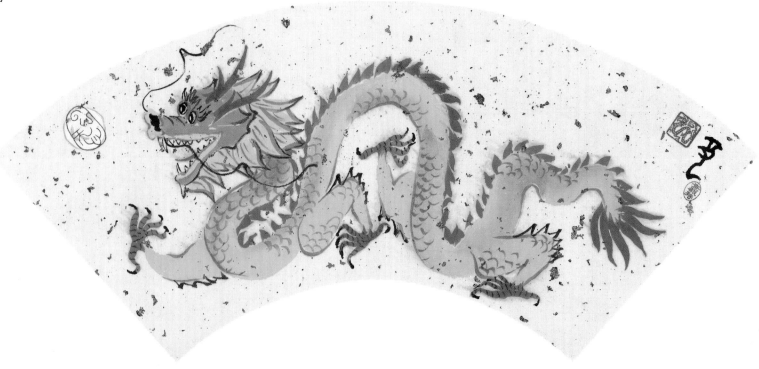

Below This cheeky tree frog was inspired by a magazine photograph. Note that the leaf strokes follow the direction of the leaf. For the blotches on the body, I dropped spots of water onto the green strokes while they were still wet.

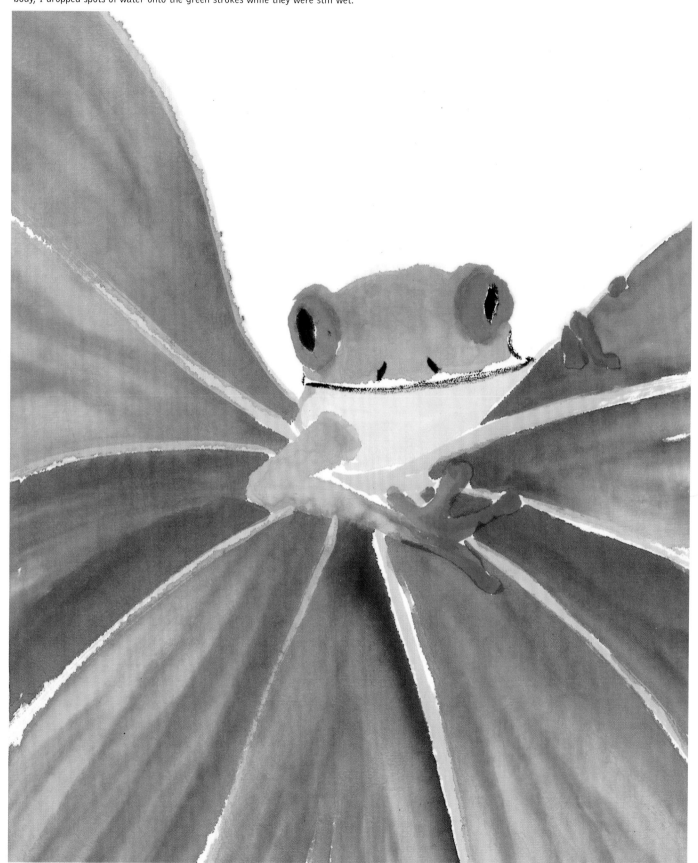

An ideal time to try out the method used to paint the blue-dragon painting by Jenny Scott on page 90 may be if you find that you have accidentally used two sheets of paper together. The sheet underneath often has just a hint of the top painting, and you may well find that you like it better than your intended version.

When searching for ideas for subjects to combine, try looking in books on Chinese symbolism. There you will find associations that you may not otherwise have considered. (These paintings can make appropriate gifts.) Viewers are usually very interested when there is a deeper meaning behind an apparently random choice of subjects.

The tree frog portrayed on page 91 was taken from a magazine cover brought to a course by a student (I hope that the unknown photographer approves!) The composition immediately took my eye, and the possible use of brushstrokes to show the structure of the leaf certainly appealed. The tree frog conveys the element of surprise that occurs when frogs suddenly pop up and startle you, making your heart race.

The lazing lizard below is from the opposite end of the scale to the frog. These creatures may make our pulse rate change, but in general they are very slow-moving. Consider whether you could find a way of showing this. Lizards need heat in order to function, and like to bask in the sun or a warm place. I used broad brushstrokes to start with, and then added the markings as necessary. The foliage around the lizard suggests its desire for cover, to hide from predators.

Symbolism of fish and reptiles

Carp, child and lotus – 'continuing wealth'

Fisherman selling carp to a mother with a child – good income and social advancement

Carp and lotus – 'a happy and wealthy life'

Dragon with longans – the fruit is called 'dragon eyes'

Frog or toad looking at the moon – longevity.

Below A lizard stops within the shelter of some foliage, waiting until it seems safe to move again. This painting has a quality of stillness.

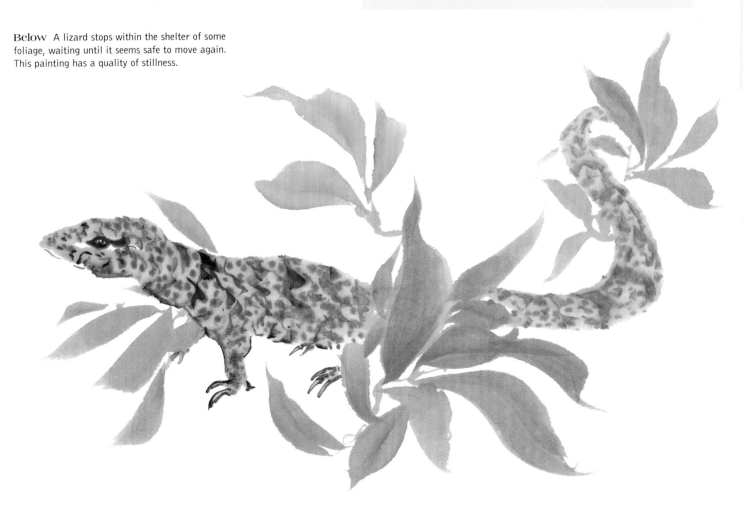

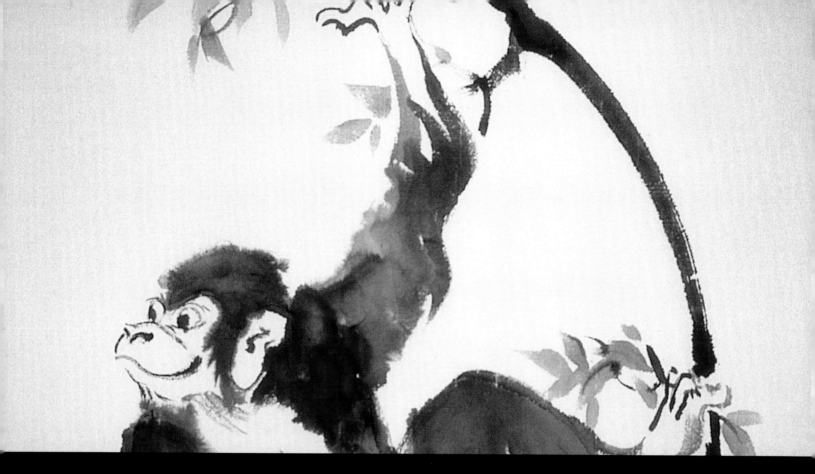
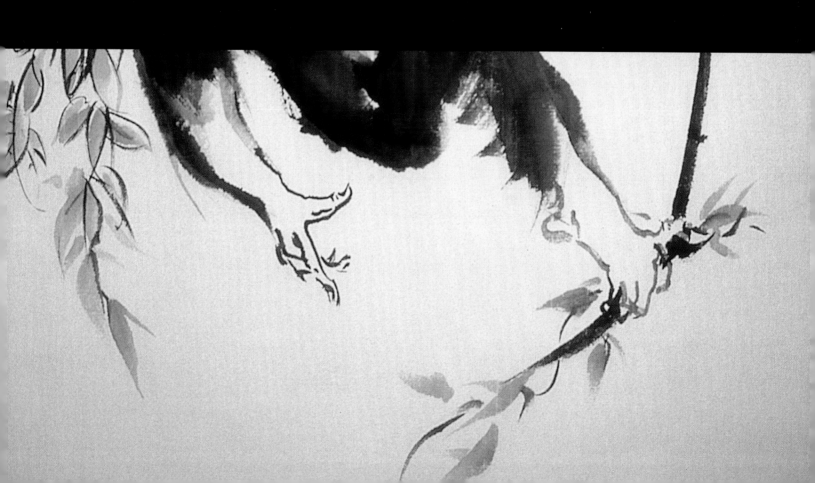

Animals

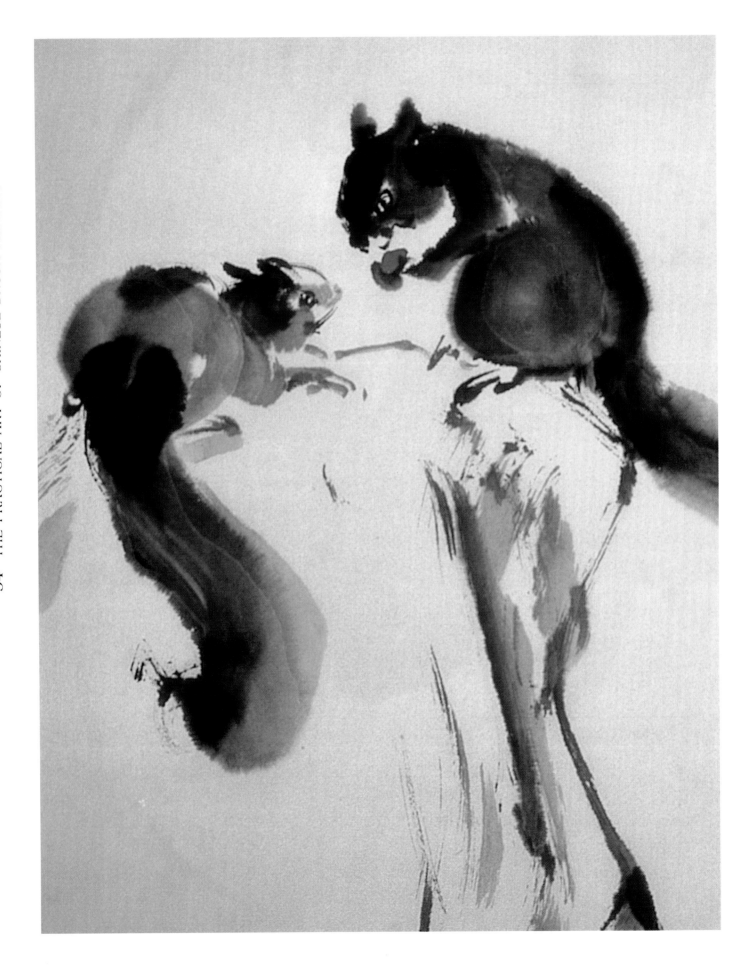

Animals

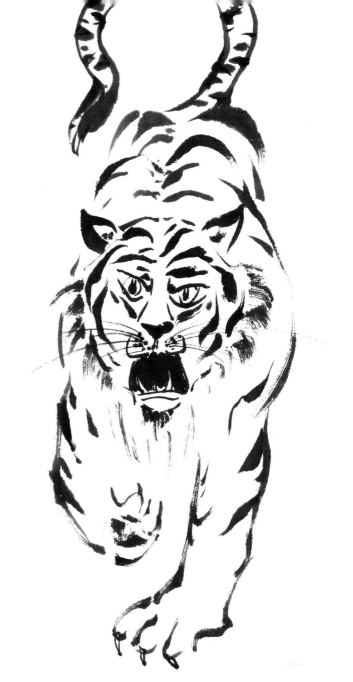

Animals were usually featured as possessions in older paintings. Five thousand years ago they were used for decorating masks, pottery and, in stylised form, bronze utensils and ritual vessels. Horses in particular (along with tributes of tigers and camels) featured in silk and paper scrolls dating from the 4th to 8th centuries showing the court and the manner in which the emperor and his entourage conducted their lives. The horses were bred from steppe ponies and were rather portly, with deep, barrel chests indicating their perseverance and stamina. Later, other breeds were incorporated into the Chinese horse. Early artworks show the horse as a fighting animal, and it was the aggression of the invaders' horses and riders that shaped much of China's history. The innate character of these animals later attracted artists to paint them, and such qualities as strength, loyalty and perseverance were illustrated, with the animals being shown in suitable poses.

Today, many more animals are depicted, but often just the essential element of each is portrayed. You will sometimes see the description 'One hundred horses [or butterflies, birds and so on]'. This merely means there are many of them. If you were to count, you would maybe find 89 or 111, but not necessarily one hundred. This type of painting allows the artist to paint the creature from every angle, a skill that requires much observation and attention to detail (even if it is not obvious in the final painting).

Above right A tiger with a lot to say. This animal was painted very quickly, with as few strokes as possible. It worked!

Left Please Share it With Me, freestyle squirrels by Chung Chen Sun, part of a larger demonstration painting. Notice the difference in posture of the animals, and the varying space in and around them. Also note how securely they are perched on the rock.

Animals can have different meanings for different people. If you own a pet, then that animal will mean more to you than to someone else. You will have an affinity with it and will also understand it better. So in this case, the first part of your research is already done. Some animals are familiar to us, while others are strangers. When you try to paint them, they often become friends – but not always! As I have advised before, if your painting does not go well, just think, 'It is not my day for painting [whatever you have tried to paint]'. Another day it will be better – I promise! Sometimes your mood will allow you to paint tigers,

another day it will allow you to paint leopards. It is that simple. Just keep on trying until you achieve what you are hoping for.

First, consider at your mood and requirements. Do you want to create a tranquil painting or a rip-roaringly powerful one? Do you want a single subject or multiple subjects? Do you want to link the animal kingdom with man or to explore it in all of its wild glory? In time, once you have developed beyond just copying previous works and are creating your own compositions, you will need to make these decisions.

Below An elegant giraffe. The bold strokes were carried out first, followed by the dots and the few lines to complete the shape.

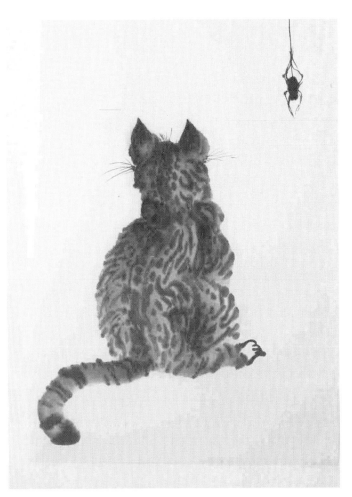

Above Mack Elliott, not looking too sure about the spider! Varied brush-loading is important here.

Will your painting show a wild animal (fierce and energetic) or a domestic creature (timid, frightened or shy)? Is it the creature's energy or its soft, cuddly nature that you want to show? Whatever you want to convey, there are various factors that you will need to bear in mind along the way. If aggression is what you're aiming for, then your brushstrokes will need to be sharp and forceful. If it is the animal's soft, cuddly nature, then you will need a responsive paper to suggest its softness. It will help enormously if you examine lots of paintings and books to get to know which style attracts you. The Lingnan school will appeal to many prospective Chinese brush painters, but we are not all capable of achieving those kinds of results. However, your own results will vary from time to time, and will probably depend partly on your mood. Just try to retain an open mind and experiment with different styles and techniques.

The two monkey paintings in the Gallery on page 164 are very different. The rhesus monkey (top) is wistful and pensive, while the monkey by Jenny Scott (bottom) is up to no good at all! He has obviously got his eye on something and is about to grab it. This is the inherent qi that all Chinese brush painters try to achieve, which varies from artist to artist and from viewer to viewer. It is that special 'something' that brings the whole subject to life.

For mood, the two tiger-and-man paintings (Gallery, page 159), also by Jenny Scott, say it all. These are based on a legend about a scholar who had a pet tiger. Because of this he was made an Immortal, yet there does not seem to be a name for him. In the painting at left, the mood is one of sleepiness. In the painting at right, there is a connection between the two, a dialogue that is silent, as far as the painting is concerned, leaving the viewer to supplement his or her own.

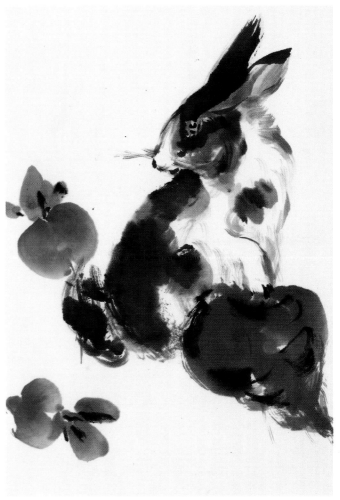

Above Rabbit, by Joseph Lo. This creature would certainly not be popular with a farmer.

The rabbit with the turnip and radishes above is by Joseph Lo. The rabbit is looking rather guilty about the appropriating that it is about to do. On the other hand, Mack Elliott (opposite right), Tessa and Trevor's cat, is very interested in what he is looking at! The original photo showed Mack looking at a whale on a television set – hardly the stuff of a Chinese brush painting! Sarah's whippet, Mowli (page 99), was quietly sleeping in class when I decided to start painting. Although I am not an 'animal person', I certainly enjoyed achieving those few strokes to show the fineness and delicacy of Mowli's limbs. It was definitely the afternoon for a whippet, as far as I was concerned!

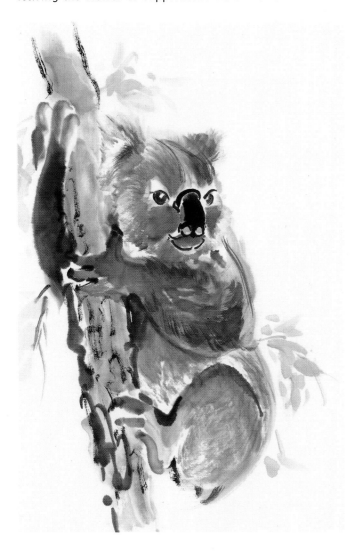

Left This koala bear by Jenny Scott demonstrates how well it can cling to a tree. There is just enough background shown to complete the picture.

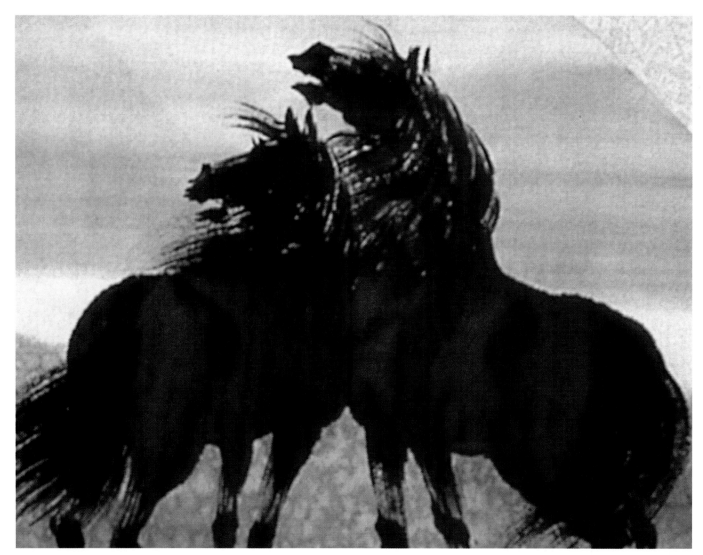

A detail from a fan painting by Cao Xiao Qin (above), entitled Fresh Wind on the River Bank, shows that it is not always important to paint every hoof. The atmosphere of the painting conveys the chilly, breezy feeling of the early dawn. By contrast, the koala bear from Tasmania, by Jennifer Scott (see page 97), is appealing, cuddly, warm and comfortable. The giraffe on page 96 was based on a larger composition by Win Turner showing a giraffe and its young, and although it is appealing, it is not as cuddly, nor on the same scale, as the koala bear. These paintings all contain the basic principles of dark and light, wet and dry and large and small. The horse at right is very gentle, and not as lively as some from the Han Dynasty! It is placidly trotting along, displaying the loyal characteristics that we expect from the noble horse.

Above A wonderful fan painting, a detail of a painting by Cao Xiao Qin. The techniques used here could be achieved by sprinkling salt on wet paper, just as in Western silk painting. The answer is to experiment.

Below A rather gentle horse, showing its noble characteristics rather than its fighting nature.

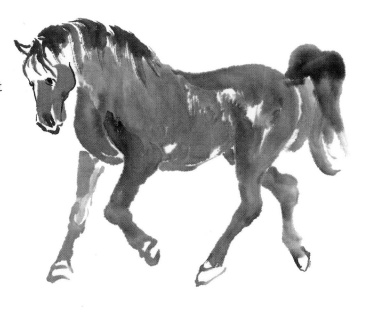

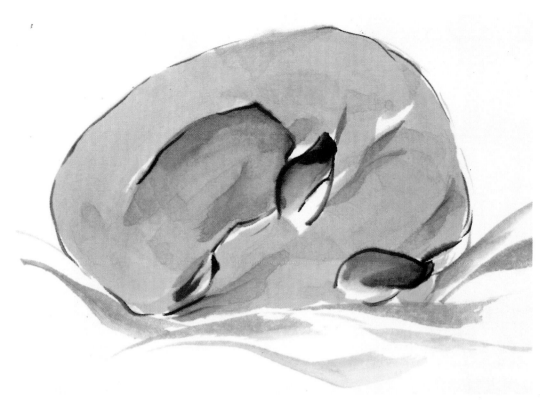

Left and below Two views of Mowli. It is the fine bones of the whippet that are important here. Some of the brush-loading worked successfully and depicts the limbs very well.

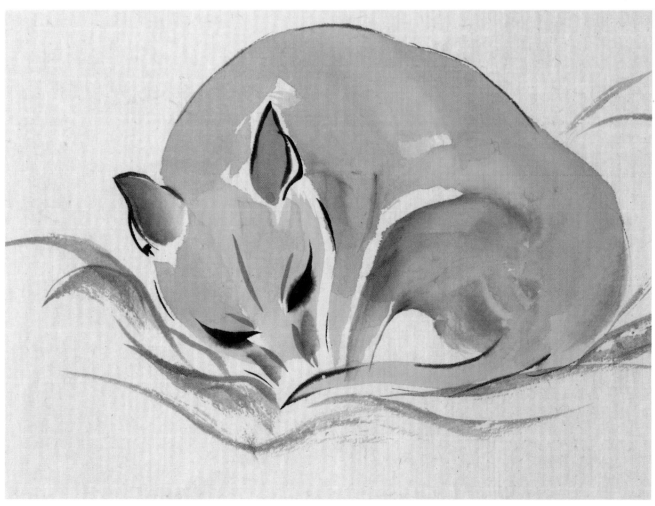

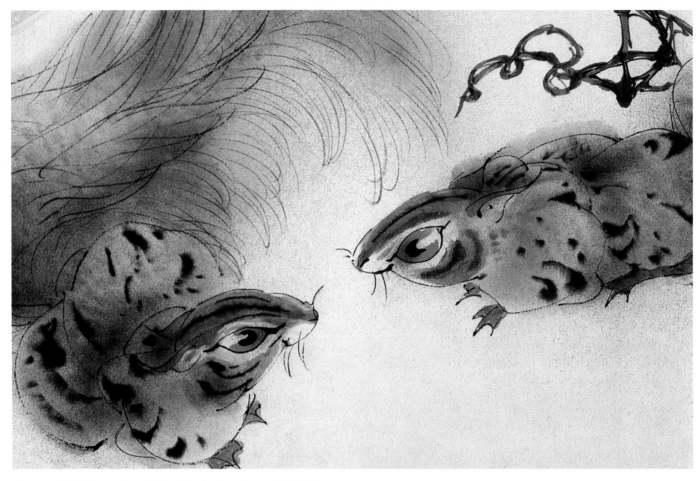

Above A detail from a fan painting of squirrels and grapes by Tan Chang Rong. This uses a mist-spray technique and wonderful brushwork to give the feeling of soft fur.

The various squirrels illustrated here show how different the styles of painting may be. Look at the difference in acquisitiveness, gentleness and liveliness in the xieyi freestyle by Chung Chen Sun (page 94), the neater version in the style of Liu Chi Yu's squirrel painted by Tessa Elliott (opposite) and the wonderful detail from a fan painting by Tan Chang Rong (above).

Right A squirrel by Jenny Scott.

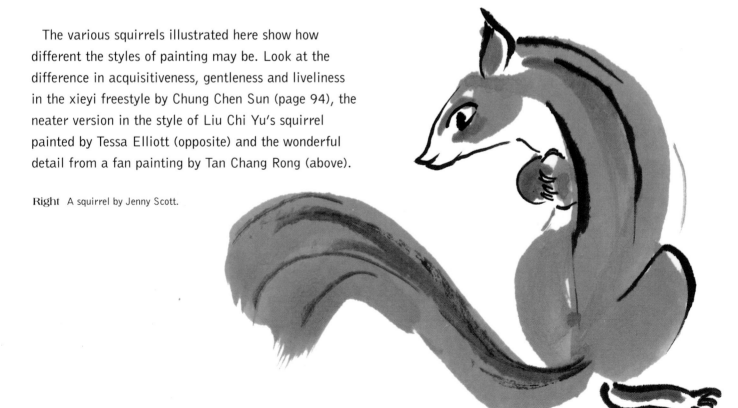

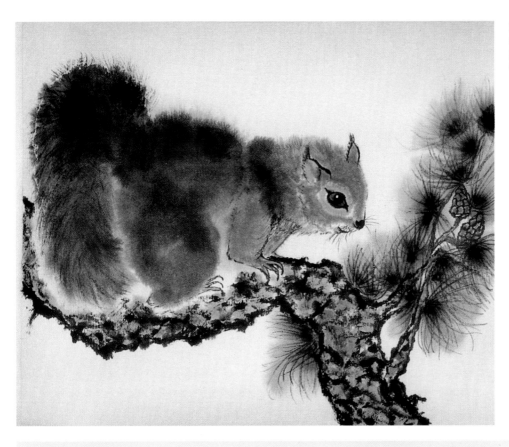

Left This painting by Tessa Elliott used one of Liu Chi Yu's animals as a starting point, but has ended up as a painting with quite a different feel to it.

Symbolism of animals and auspicious compositions and subjects

Animals were divided up into groups:

The five classes – feathered (phoenix), furry (unicorn), scaly (dragon), shelled (tortoise) and naked (man). The first four also represent the four directions (N, S, E, W)

Five or six domestic and edible animals – horse, ox, pig, dog, sheep and chicken

Five noxious creatures – snake, lizard (or gecko), scorpion, centipede and toad

Cat, bamboos and plum – 'ripe old age'

Monkey in a maple tree with bees

Cat looking at a peony – 'may you be rich'

'Mountain cat' (hare)

Panther and magpie – 'joy to come'

Tiger with bamboo – bravery

Cinnamon tree with a hare and a toad – for newlyweds

Badger and magpie – 'joy in the air and on the earth'

Cat and butterfly – 'may you reach seventy to eighty years of age'

Monkey and bee – 'gaining advancement'

Monkey on a horse – advancement

Deer – riches and longevity

Dog with rice or millet – plenty (southern China)

Child on an elephant – happiness

figures

太上老君

Figures

The first painted figures were used for murals and were often religious figures, sages or emperors. In the north of China are murals at such sites as Dunhuang Caves. Buddhism had a great influence throughout China. When the capital moved to Nanjing, great progress was made in figure painting. Many works illustrated Confucian teachings, such as The Admonitions Scroll, setting out how ladies of the court should behave. At this time, the 'centre-tip brush' was very important (also called the 'iron-wire stroke').

One very striking painting, frequently illustrated and a favourite of mine, is a fan-shaped album leaf dated 1210 showing the 'knick-knack pedlar' demonstrating his wares to a mother and her children. This is from the Imperial Academy era. It has a note saying that there are five hundred items in his baskets (it will be around that figure rather than exact). It is certainly a wonderful painting. Of course, this is meticulously painted, but many figure paintings are in the xieyi style. With just a few strokes, the attitude, character and movement of the figure can be realised.

Above A painting by Ben Xong, based on a poem by Li Qing Zhao (1081–1141).

Below The Palace Concert, a fan painting by Li Xing Wu. Seven elegant ladies are playing various traditional instruments. Notice how the faces are rather similar, although the clothing and hairstyle details vary.

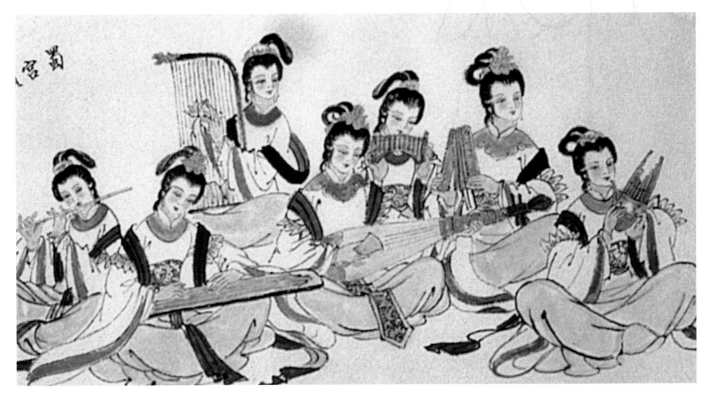

Above A detail from a painting that was brought from China for me: saluting the moon with a drink! The robes are underplayed.

Left A painting based on a figure of a Bodhisattva.

for some paintings of monks or legendary characters (such as the pondering Buddha), in order to suggest a cumbersome or comic nature.

It is therefore necessary to decide what character you wish your painting to have and the painting style that you will follow. Will your figure be the prime subject or an accessory? Works by many current Chinese artists show not only historical figures or beautiful ladies, but also industrial or agricultural workers. Once you have decided on the character of your painting, you can then practise the strokes, aiming to reduce the number necessary to achieve a lively work. Of course, some artists find figure painting easier than others. Most of us can achieve satisfactory results with enough practice, however.

Paintings of beautiful young ladies appear in the Gallery on page 165. One of the paintings (bottom) is rather scholarly, with books and scrolls in the background. The painting of the lady in green (top right) suggests a dancer, and it is only the face that has any detail. Yet this painting is full of soulful movement, while the other is far more static. The painting of the younger sister with a figure reminiscent of Zhong Kui (top left) is a wonderful work of contrast, with his size and hairiness contrasting with her delicacy.

The Asian figure is of a different proportion to the Western one. In many European art-instruction books, the figure is shown split into seven sections, whereas the Oriental figure, being a smaller frame, is divided into eight. The head section is therefore smaller (unlike the Bodhisattva above, although I was pleased with the rest). In the case of beautiful ladies, this is emphasised to give a delicate appearance. The reverse is often used

Left A musician, taken from a figurine. Make sure that you have contrasts within your painting, such as the outline and solid areas of colour and ink.

Right A lady musician. Again look at the various strokes and areas of colour. When working from 'ivory' statues, keep to a limited palette.

Two musicians

To paint the two musicians above, I used a pair of figures purchased for flower-arranging, which gave me a starting point. I decided on the colouring (the figurines were made of 'ivory') and set off from there.
1 Start with the faces, using burnt sienna and just a hint of green. With a reasonable-sized brush, paint in the 'T' shape, the brow, cheeks, chin and so on. Using a fingernail to indent the paper, work out the position of the hands and paint in each finger and thumb. At this point, you will find adding the instruments helpful.
2 Being aware of the areas of wet paint, start to add the clothing, working the strokes in the direction of the folds. Only add line work where necessary.
3 Taking care around the areas of flesh, paint the hair, ornaments, beard and so on, along with any details required for the face (using medium ink).
4 Lastly, add belts, lapels and other such details.

Trio of scholars

Some of the poses for the trio of scholars shown below were based on small, cheap figurines. In today's environment of digital cameras and scanners, you can assemble a scene with which to work. You should adjust and experiment to gain the best composition.

1 Once you have achieved a satisfactory grouping, paint the face and hands of the single figure to the left, followed by those of the other two characters. Use your fingernail or the end of a brush to indent the paper so that you know where you are. You will see from the additional example at right that you can choose to be freer if you wish.

2 Add the robes, keeping to the traditional colours of the period. (You can assess these by looking at various books and publications, even story books.)

3 Using your imagination, add any rocks or other resting accessories. One of the characters was originally resting on a wine jar.

Above This robe illustration shows more freedom and less detail than the painting below. Consider which version you want to achieve.

Below Three scholars having a discussion. Be careful not to include too much detail in the robes.

The expression of your painting can depend on your own mood, as well as that of the subject. Maitreya – the laughing Buddha – is portrayed at right in a thoughtful mood, with as few strokes as possible added once the areas of flesh had been painted. By contrast, the painting based on a Bodhisattva carving on page 104 (left) uses many strokes to show the robes. Although the gentleman with the cranes (page 109, left) has a pensive expression, the one with the wine cup on page 104, top right, is definitely enjoying himself! (The latter two paintings are thought to be by the same artist.)

The painting below of small boys squabbling was inspired by a work by Li E-sheng showing a group of five boys underneath a grapevine. The boys formed only a small part of that painting. I have made the boys the main element, split the

Above right A pensive pose, but because the figure is the 'laughing Buddha', there is a hint of mischief in the face. The fleshy areas of the figure are dominant.

Below A fight over a kite inspired by a painting by Li E–sheng. The blue side seems to be getting the worst of it!

group into two plus two, moved them around, altered the position of arms and hands, changed the colours and added the kite for the back two to squabble over. The painting is now also in a landscape format, with the paper turned on its side, instead of the original portrait format. When you develop a work, you need to sketch, experiment and try out different ideas in order to get the composition to your liking.

The meticulous painting by Zhang Shi-wei on page 108 (bottom right) is all about space. The monk looks deep in thought, maybe influenced by the incense. The fan painting of the ladies playing music for the court at the bottom of page 103 is also in the meticulous style. The faces are similar to each other, but the figures, clothes and instruments are pleasingly arranged. Although these paintings are skilled in execution, I find the livelier xieyi paintings more appealing and fun.

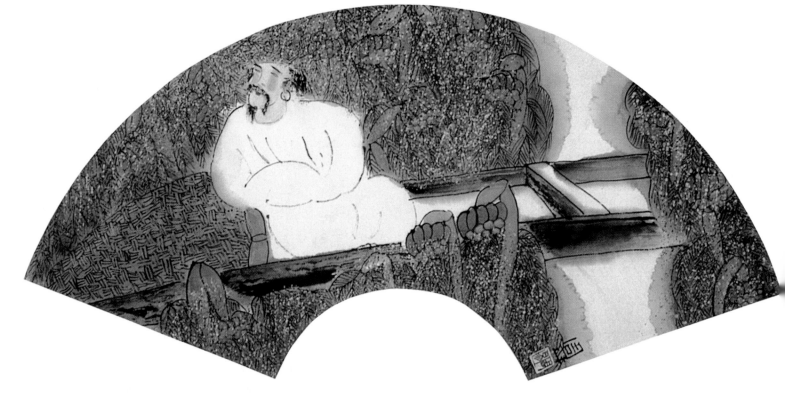

In the fan painting Enjoying the Lotus Scene (above and left), the gentleman in the punt looks as deep in thought as the monk below. The amazing textures in the lotus plants and the unusual composition gives the whole picture a different impression, however.

The paintings of the scholar with his tiger, mentioned on page 97 and shown on page 159, take a historical story as their source. Another good example of one of the many stories told in paintings and based on legends – a rich source for subjects and compositions – is the painting of the lively boy with the toad on his shoulder by Jenny Scott (opposite, bottom).

Above and top Enjoying the Lotus Scene. This figure is perfectly at rest in a punt-like boat, just listening and looking, and maybe even smelling the fragrance of the flowers. The white scholar's robe is merely suggested and provides a foil for the pattern and density of the method of depicting the vegetation in this fan painting.

Right A more realistic painting, this time of a monk deep in thought. Notice the generous space in this painting by Zhang Shi–wei.

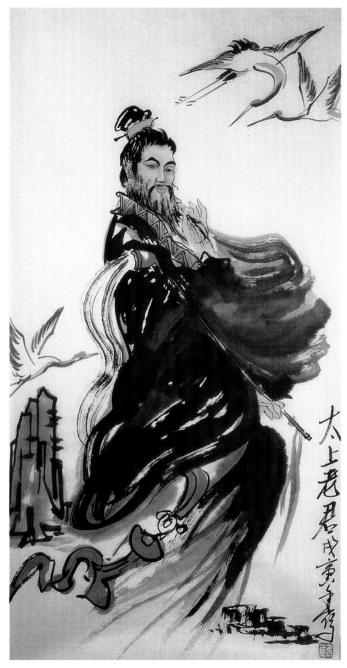

Symbolism of figures and auspicious compositions

Girl with flowers, pomegranates, gourds, orchids, peonies, peach blossom or plums

Girl with a frog, parrot or horse

Children playing with bamboo firecrackers – 'may there be peace'

Fat-bellied Buddha (seated, usually shown with children playing)

Child with fish – 'many prosperous sons'

A lady, her maid and two children near a lotus pond with fish – good fortune year after year

Lao Zi and a water buffalo or ox

Child flying a kite and riding an ox

Above The most exalted Lord Lao (a Daoist deity identified with Lao Zi), shown with cranes symbolising longevity. This painting was brought for me from China as a present.

Right Jenny Scott achieves wonderful expressions and wordless dialogue in her paintings.

Landscapes

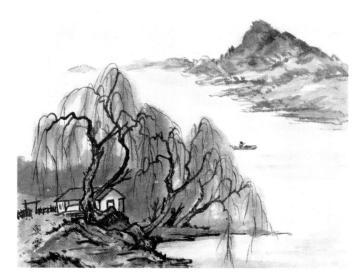

Above Waterside buildings with willows, by an unknown artist.

Landscapes

Landscapes were not one of the earliest subjects of Chinese brush painting, but started more as a reaction against the meticulous, academy style of flower and bird painting. Wang Wei (AD 699–759) was one of the earliest exponents of this subject, completely ignoring all of the compositional conventions of the time. The literati favoured only ink work, producing emotional paintings: 'The picture created a poem, and the poem prompted a painting'. In around AD 600, the green-blue landscape came into use, followed by the gold-green. The bone-style (kufa) strokes for landscapes became popular at this time, too. Many paintings were large, elaborate landscapes.

As Confucianism, Daoism and Buddhism came into popularity in China during various periods, so the style of painting developed with the change in beliefs. The use of 'ink and light colour' came from Confucian ideals; the importance of nature (and the insignificance of man) came from Buddhism. Daoism was a reaction to the severity of the previous beliefs.

During the Song Dynasty, the boneless style (free, solid strokes) was commonly used. Landscapes became a subject in their own right, and the paintings often reflected the feelings of the artists against the current regime. With the Yuan Dynasty, water-ink painting was the main technique. The first canon was used throughout all aspects of Chinese brush painting. The blue-green landscapes were still being produced up to 1550. During the Ming Dynasty, it was felt that there was a loss of freedom due to the importance given to copying the works of ancient masters.

It is said that if you wish to learn landscape painting, you should first paint summer and winter scenes and then move on to spring and autumn scenes. In order to learn, you should produce the exact lines and dots and then aim to convey the spirit and character of the original painting.

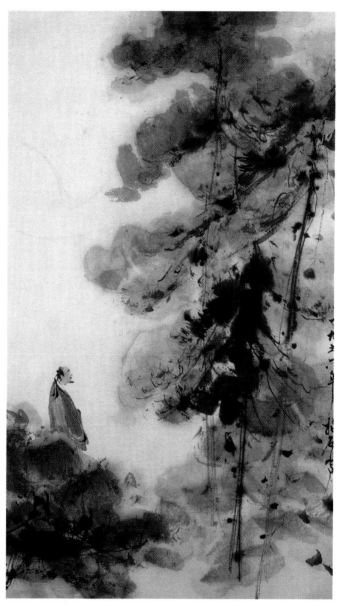

Above A scholar studying a pine tree, by Joseph Lo. This painting has a lovely, peaceful quality about it. The scholar creates an interesting series of spaces to the left of the picture.

As your painting skills develop, and you experiment more, it will be necessary to study as many sources as you can. Try to be more observant. From the examples given, you should note the difference in rock structure, the construction of tree trunks and the suitability of elements for a scene. To include strokes indicating water may add more liveliness, but will not increase the feeling of tranquillity. Which effect do you want to include in this particular piece of work? Study the different ways of showing pine-tree foliage. Which do you like, or which best illustrates the subject that you are painting? You may find that you change your preference after a while, which is all part of developing your own style.

Think about your composition and the distribution of its elements. Consider the appropriateness of the building, bridge or figure for the scene that you are painting. In this section, you will find a wide variety of styles and techniques for your consideration.

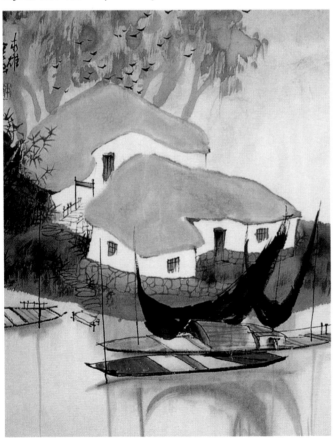

Above One of my favourite paintings. The boats and cinnabar-red fences suggest to me that this could be southern China. The blue mineral colour lifts this painting.

Small Boats Floating in the Evening Light

This section describes the techniques used by the artist, Eric Ng, to achieve the landscape painting opposite.

1 Eric started this painting with the rocks to the left-hand side of the waterfall, using Xuan paper and a goat brush. He built up the structure of the mountains, working to each side and towards the back, until that middle 'level' was complete in form.

2 Next, he painted the larger rock to the right, followed by the smaller rock in front. Many of the trees at the base of these mountains were painted at the same time.

3 At this point, the range of mountains at top left was added, then the misty ones at top right. The rocky outcrop at the base of the waterfall was followed by the detail of the shoreline, including more trees, the suggestion of some arable land and the roofs of the small houses.

4 Using a fine water spray, Eric dampened areas of the painting where the rocks had mist over them, such as the top and bottom of the waterfall. Dilute, wet ink was then added to these areas, gradually spraying further as required.

5 The small boats were added carefully, again with the goat brush.

6 Mist was added at this point, after spraying a larger area of the painting. A hake brush was used, with only half (or less) of the brush being loaded with dilute ink. This process cannot be hurried, and it is best to proceed carefully. The 'water' side of the brush must be towards the cloud, rather than the rocks, in order to give a soft edge. Eric used first the 'ink' corner of the brush, then the 'water' corner. By alternating these corners of the brush, he achieved the softness of the mist. This part of the painting took nearly one hour.

7 After the ink painting had dried, it was ready for the colour. The painting was sprayed with water. Using burnt sienna and a hint of vermilion, Eric painted the tops of the mountains, gradually softening the colour towards the base of each rock.

8 Mixing indigo and rattan yellow to obtain green, Eric then added this colour to the lower slopes and shoreline. He also added some stone green to this colour for the roofs and some of the misty areas, keeping the painting damp with the spray to gain softness of colour.

9 For the distant misty areas, Eric used rattan yellow as a pale wash. The painting was allowed to dry for a while (ten minutes), after which some of the areas of colour were accentuated (you can use two washes, but not more as the transparency is often lost). At the end of this colour stage (which took about 40 minutes), he checked the tones of the ink work (because colour can change the effect of the ink).

10 Lastly, the calligraphy and name seals were added.

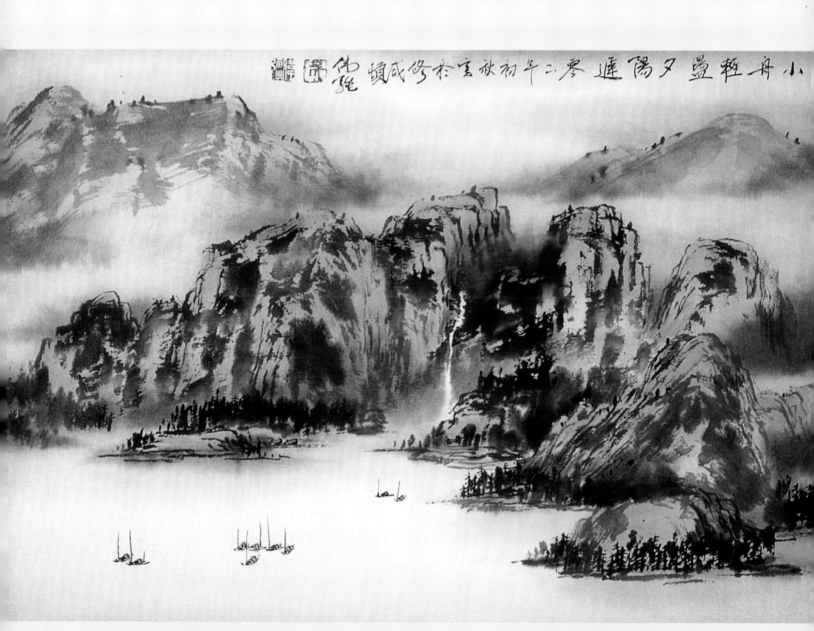

Above A wonderful demonstration painting by Eric Ng. Read through the description of the artist's techniques (left and above), and you will see that this was not painted 'in one breath'!

FOLIAGE AND TREES

Pepper dots Rice dots Vertical dots Scoop dots Bowed-head dots Grouped dots

SOLID DOTS

FEATHER SHAPES

Outline and solid

BRANCHES

Deer horn Crab's claw

PINES

Various methods of showing pine trees, using an oblique brush, a split brush and three different styles of needles

TREES

Scales

Vertical lines

Scales

Twists

Hidden roots

Horizontal

Exposed roots

ROCKS

Rounded rocks Flat-topped rocks

Lotus-vein rocks

Tall-fissured rocks

Sharp rocks

BUILDINGS

When including buildings, you should decide on the character of the area. Is it rural or urban, a garden or a temple enclosure? Study as many paintings as possible and decide which you require

WATER

Various techniques for showing water. Many Chinese brush paintings do not define mists, lakes, rivers or waterfalls

PEOPLE

People in landscapes look livelier if they are depicted going about their daily lives: maybe meditating, discussing, running errands, farming, preparing tea or travelling.

BOATS

Boats usually imply a nearby habitation like a village. They can also give the impression that travel by other means maybe difficult, perhaps due to impassable terrain. Bridges may hint at a town scene rather than a hamlet.

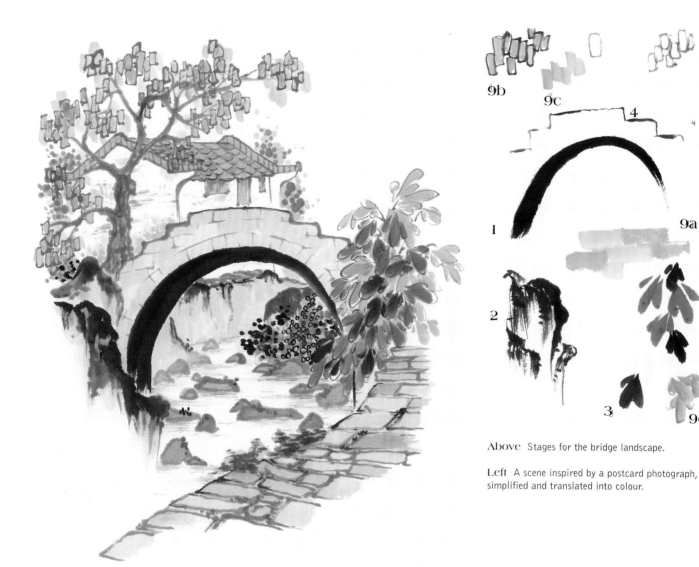

9b 9c 4

9a

1

2

3 9d

Above Stages for the bridge landscape.

Left A scene inspired by a postcard photograph, simplified and translated into colour.

Landscape

The landscape shown above, by the author, was developed from a rather old, poor-quality, black-and-white Chinese postcard.

1 First, paint the underside of the bridge in one stroke with dark ink.

2 Add the rocks, using dry brushwork.

3 Paint in the foliage with diluted ink, varying the size of the leaves.

4 Put in the rest of the bridge's structure.

5 Gradually add the flagstones to the foreground, working to achieve a variety of sizes and shapes.

6 Paint the tree to the left, again paying attention to the varying foliage.

7 Insert the building and the banks on each side of the stream.

8 Put in details as necessary.

9 Lastly, add colour, along with the lines around some of the foliage.

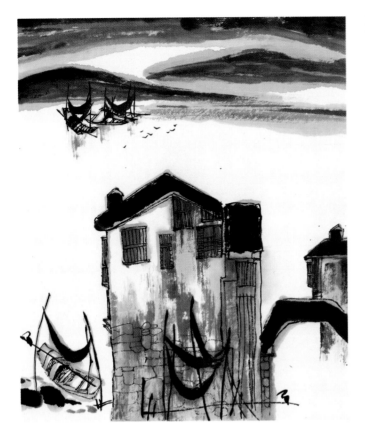

Left Waterside buildings in southern China, after Hu Fang. Do not make the building strokes too regular or continuous.

Below A preliminary painting of one of the banks of the Li river. I intend to develop this idea further.

Hu Fang has been an inspiration to many would-be Chinese-brush-painting artists in the UK. Her exciting landscapes have influenced many of us. Few 'outsiders' realise the variations in style between northern and southern China, where the light, scenery and surroundings will obviously inspire artists in different ways. The riverside scene at left was painted from one of her paintings. You do not need to obtain straight lines for buildings (this was one of the elements that my colleagues and I found difficult, due to our professional training, causing endless amusement to Hu Fang!) The sense of nets drying in the foreground while the fishing fleet is at anchor in the distance gives great depth. The distant hills are only suggested. Many of Hu Fang's scenes portray southern China.

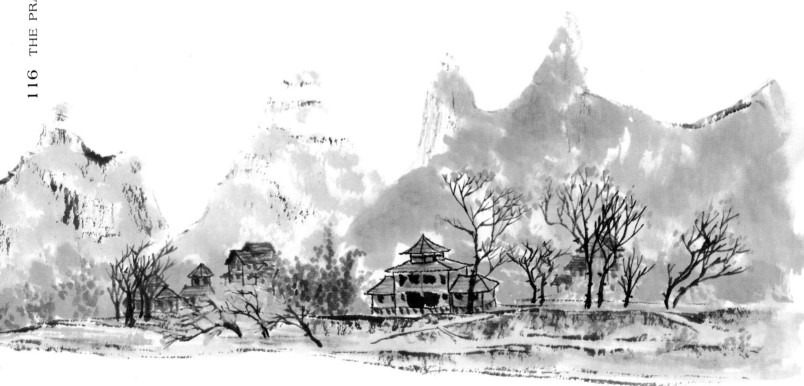

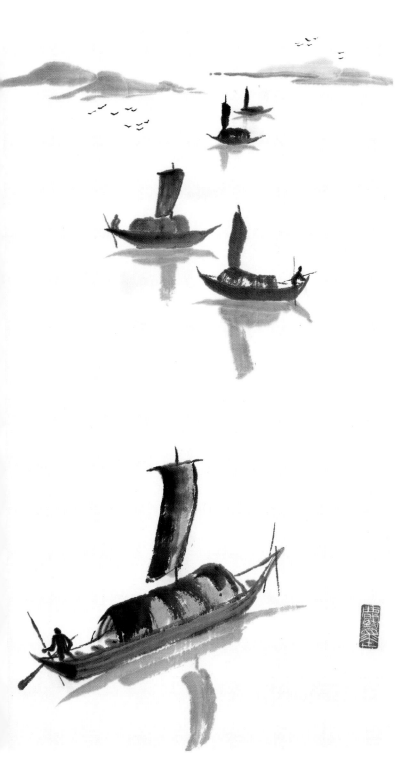

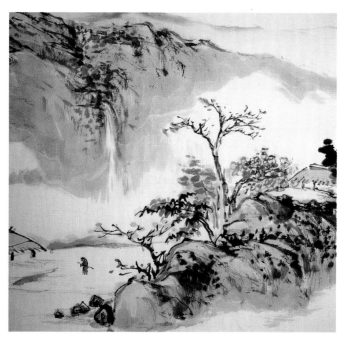

The riverside scene opposite (bottom) is based on a photograph of the Li river. It was only a first attempt, but gives a possible starting point for another painting. One of the difficulties is getting the right degree of mist while still showing buildings on the bank.

By contrast, the painting of becalmed fishing boats at left is literally 'playing with ink'. Without colour, the viewer has to think about the time of day, which could be early morning or evening (the latter is likely because there would probably be mist in the morning).

Above Fishing boats becalmed. The seal says 'Playing with ink'.

Above right Here you can see part of a painting by Chung Chen Sun, showing rocks, trees and a small rural building in traditional style. There is a wide variety of foliage strokes, giving a very natural setting.

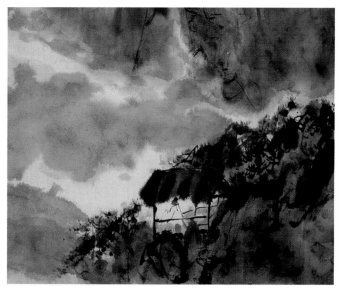

Above A figure in a viewing retreat (by Joseph Lo), looking out down a valley.

A rock is like a box (top and two sides).

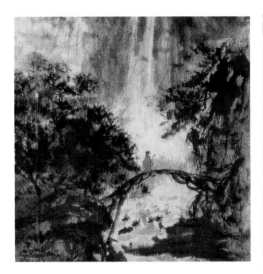

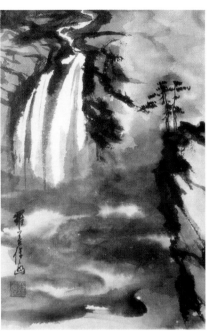

Left A figure on a bridge (by Joseph Lo). He appears to be listening (to the waterfall or a bird?)

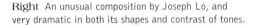

Right An unusual composition by Joseph Lo, and very dramatic in both its shapes and contrast of tones.

Of a different nature entirely is the painting by Chung Chen Sun on page 117 (right). The group of trees shows traditional strokes and arrangements. The trees' roots are hidden behind rocks, which follow the 'three-sides-to-a-rock' thinking illustrated above. The small building does not intrude on the overall scheme, but merges with nature. A demonstration landscape by Chung Chen Sun (Gallery, page 166, left) is again painted in a vertical position. From the ancient pine trees through to the mountains at the top, there is great depth, which is accentuated by the strokes, ink work and choice of colour. Examine the spaces that suggest mist and sky, and see how they vary in shape and size. The effect of the waterfall creates a wonderful atmosphere of shan sui (mountain and water), the Chinese for 'landscape'. The small, rustic viewing hut with the blossoming plum tree is typical of this type of painting.

Joseph Lo loved to experiment: with different types of paintings, with papers, with inks and with colour, but especially with landscapes, and some examples of his work are shown on these pages. They either have a watercourse, a tree or a figure as the leading element. The spaces without information are always an interesting balance or shape. One or two of the paintings appear to be on sized paper, leading to some interesting brush marks. The larger pine tree with birds (page 121, left) is very dramatic, and the trails of the skeins of birds across the sky are an important element in the composition.

Another pine tree, shown in the Gallery on page 166, right, this time by Ya Min, is depicted with its rocky support. This is a powerful painting, with a feeling of strength within the old pine tree. We see many landscapes with rocks and trees in the distance, so that

Left A slim cascade by Joseph Lo, showing rocks and pine in the spray zone.

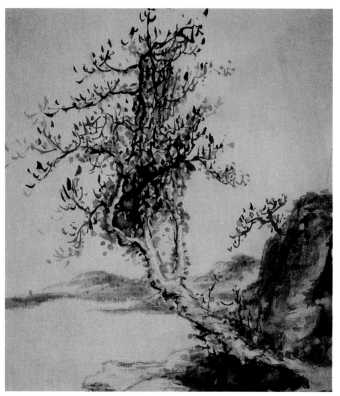

Left A delightful composition by Joseph Lo, showing some different trees.

Below Note how the use of mineral blue lifts this tree and rock landscape by Joseph Lo.

when they are brought closer, as in this painting, the impact can be rather dramatic.

A further example by Hu Fang (in the Gallery on page 172) is more traditional, with mountains and waterfalls. Note how the detail and weight are at the top of the painting, while the major element of space is at the bottom. The seals are placed at the base of the waterfall, adding to the cascade. Hu Fang's painting featuring a red sun (see Gallery, page 167, bottom right) is more contemporary, and demonstrates an interplay between the shapes of the natural elements and the colours. As with much of her work, there is some communication between the elements, the bushes and so on. It is a very lively painting.

The water village, by contrast, has a totally different feel. Here man's interference plays a greater part, with the water being almost totally overshadowed by the buildings. However, the balance of the painted areas is comfortable, with lots to interest the viewer.

In the waterside village shown at the top of page 120, I have based my painting on one by Kaili Fu, who based hers on a painting by Song Wen Zhi. Each version thus expresses something about the present artist, and no doubt retains something of the original one, too. A friend of Joseph Lo probably painted the third water-village painting, with its thatched roofs and blue boats (see page 112). It has a depth and distance that is not immediately noticeable. The southern China-based painting, by Sun Ming, indicates the atmosphere and watery nature of that area. The colours are pure and the vegetation plentiful.

Painting a landscape in a fan shape can be an interesting exercise because a major decision has to be made. Do you keep the horizon straight or curve it to match the traditional fan shape? In most cases, I tend to keep the horizon straight, as illustrated by the beautiful blue-green version by Yao Ye Hong in the Gallery at the bottom of page 171. The small ox herd

and his charges are dwarfed by the massive grandeur around him (see the detail below). The sense of space is dramatically increased by the use of cloud and mist.

Qu Lei Lei's ink painting (Gallery, page 167, bottom left) takes advantage of the dramatic quality of the ink. Look at the painting, and then look again: you will start to see small bridges, different layers of rock, pathways and a hut or two. There is a great deal of information in this work, but it is truly a case of 'You should feel as if you can walk straight into a landscape' and 'You should feel as if you can live in a painting'. The representation of rocks and trees is traditional.

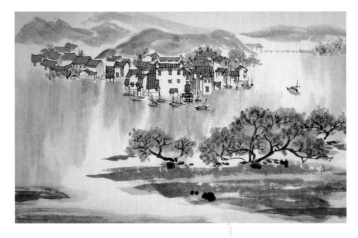

Above A waterside village, after Kaili Fu, in turn after Song Wen Zhi.

Below Detail of the fan in the Gallery at the bottom of page 171 by Yao Ye Hong, showing the small ox herd with his beasts.

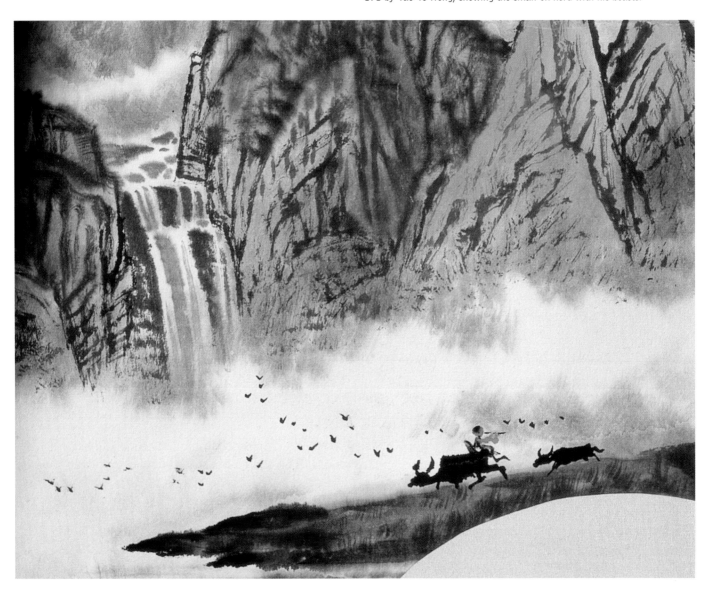

Eric Ng's large landscapes (see pages 113 and 168), on the other hand, offer far more in the way of suggestion, with areas leading you from one part of the painting to another without necessarily having much to say by themselves. The overall effect is just as spectacular, however. Some of his work is very large.

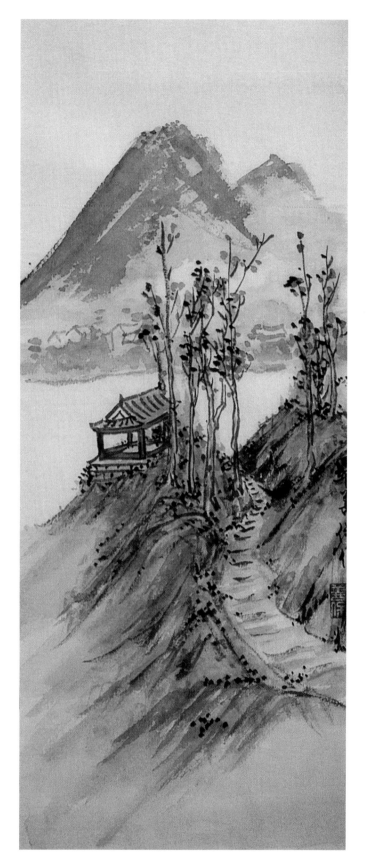

Above Pine trees and flocks of birds by Joseph Lo. If you study the birds, they appear to move after a while.

Above A small landscape painted freestyle on sized paper by Joseph Lo. Observe the sharp edges to the strokes of the mountains.

Further Techniques

Meticulous work

As was mentioned previously in this book, meticulous work has been popular since early times. This technique uses either sized silk or paper. You can either purchase sized silk or paper or produce your own using an alum-and-water solution. But beware: it is very difficult to get the sizing even, and I would much rather spend my time painting! There are particular skills to be learnt for working on silk, most of all the initial brushwork. This is painted using shades of ink, which need to vary to show the difference between flower and leaf, flesh and fabric and so on. Once you have completed the outline work, several ink washes are added to give depth. These stages should not be hurried. Only at this point should you add colour if it is desirable or necessary.

The colour wash is added in several layers, with each 'start-and-stop' point being staggered to avoid lines or marks. There could be nine or more layers of colour in order to get the desired intensity and to add interest. Another colour can be added to the back of the painting to alter its appearance. This may be white behind faces to add highlights to the skin, or else another colour is often used to change the one in front (this cannot be seen once the painting is backed, of course). Many would-be meticulous painters have given up by this stage! It does take a great deal of time and patience. (The process is similar for sized paper, but does not allow so much movement of the washes.) Meticulous paintings tend to be busier in composition than other styles, with greater detail.

Above right A horse and groom from a Tang Dynasty painting. This meticulous painting by Jane Dwight is on specially prepared silk. Horses were bred for their strength, and originally came from the steppes. They were later interbred with Arab strains and became slimmer.

Centre right Another meticulous painting on sized silk by Jane Dwight. This picture is from a very wide landscape in the blue-green (powdered-mineral colours) style. It is after Wang Xi Meng, of the Sung Dynasty, an era that was a highspot for meticulous painting of this style. This landscape by Jane is not yet complete, and requires several more layers, both on the back and the front, being still in its unmounted state. Once it has been backed with paper, there will still be more layers to add to the front.

Bottom right The Chinese scholar Tao Yi Ming. This beautiful copy of a Ming Dynasty painting by Chen Yung Sho is again on sized silk by Jane Dwight.

Prepared silk

When using prepared silk, you need to follow a particular sequence of steps.

1 Sketch out your composition on a piece of paper, making sure that the line is dark enough to show through the sized silk when it is placed on top. With a gongbi, or fine-line, brush, trace the painting, ensuring that your line work is lively. Use a 'centre-tip' brushstroke for these lines, and differentiate between flowers and leaves, flesh and clothes and so on by controlling the shades of ink. Make sure that you are aware of any parts that are in front of, and therefore masking, others. Feather off the 'back' lines.

2 Using pale ink washes, two white-cloud brushes and varying the beginning and end points of all of the strokes, gradually build up areas of ink to show the different levels of the painting. The ink is used to 'warm' a colour. Do not rush this stage, and make sure that you let the ink dry between washes. (You can always have more than one painting in progress to allow for drying time.)

3 Next, use cold colours (such as indigo) to show dark areas behind and underneath, and then contrast them with warm colours (such as burnt sienna) for the highlighted areas. Build up colours gradually so that there are no hard lines. This is a very therapeutic technique, but do not expect to complete it speedily! To quote Cai Xiaoli, 'Quick to start and slow to finish'.

4 Use stone blue or green on the back of a painting to change a colour (usually a cold one), and rattan or pale yellow on the back to lift any brown colours.

5 When painting white or pale flowers, gradually build them up at the same time, both on the front and on the back. Ensure that you keep the front of the painting subtle.

6 When you think that you have a sufficient depth of colour, add a few layers of the leaf colour, for instance, over the top. For a bird painting, you may wish to add a layer (over the whole area of the bird's body, for example) to amalgamate the shape rather than have too much detail.

7 Last of all, paste-mount your picture, and when it is dry, leave it on the board and add some more washes to the front, especially if it looks flat. To obtain merged strokes, use a damp brush on the silk before adding more colour. When it is completed and dry, remove the backing board.

Figure painting

1 Follow steps 1 to 3 above.

2 Detail the faces in rouge red (the two cheeks, forehead, nose and chin – the 'five points') and then add a layer of flat colour over the top. Paint the back of the flesh with white or a pale colour.

3 Point the brush into the crevices and onto the top surface for sleeves, and then wash out to the centre of the fabric.

4 Use rouge red on the back of the painting for coldness and cinnabar for warmth. If the initial washes are dark, cover them with a light colour and vice versa. If the front colour is dark, back it with a light colour, maybe even white.

5 Complete by backing and more work, if necessary, as described above and right for flowers.

Lotus flower

3 Using ink washes and two mixed-fibre brushes, start to model the painting with ink where the 'cold' areas of the painting occur.

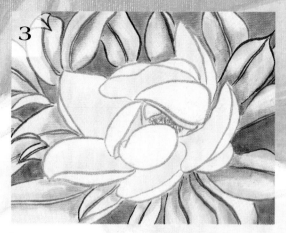

4 Use indigo to add to the 'cold' areas and burnt sienna to add to the highlighted or 'warm' areas. Work the yellow of the flower from the centre outwards, and the white inwards from the outer petal edges.

1 Sketch the flower on a piece of practice paper.

2 Transfer the design to sized silk, and then, using a 'centre-tip' brush, paint it in shades of pink ink.

5 Having built up several layers, consider adding rattan yellow to the back of the burnt sienna and stone green behind some of the indigo. Finally add a green wash over the whole leaf and background area.

Do not make your silk paintings too small, and do not lose the interesting bits! It is easy to do too little, but equally easy to overdo it. I have included a rough example of the process used for flowers, plus some examples painted by generous colleagues. If you can attend a course with a Chinese artist on this style of painting, you will find it of great benefit.

Should you wish to paint a landscape (they are mainly great or small blue-green style), you will require many more hours of work and practice. Many of the traditional works use mineral colours. Powder pigments can be used on the front of the painting, where they will have the most impact, but use tube colours on the reverse, which will be hidden by the backing. You can see an example of this by Jane Dwight on page 123, centre right.

Using sized paper

Besides using a sized Xuan paper for meticulous work, you can use this paper for achieving other effects. There is a variety of subjects to experiment with. However, there are a number of factors that you need to take into account, too. For example, instead of the 33 per cent fading factor for colour as the pigment dries, it is closer to 50 per cent with sized paper or silk, which means that you need to work with stronger colours and ink to allow for this.

The results are also less predictable. As the pigment and ink are drying, the liquid is able to move (or can be moved by you, either with a brush or by angling the painting surface), so that a wide variety of effects can be produced once your work is dry. There are several ideas for you to try. You can either take note of the stages that you followed and the results, or just accept what comes!

To produce different trees, you need to have ascertained the main characteristics of the branches and stems of each type. Examine how the side branches leave the main one, for example: are there any distinctive patterns (in a silver birch, for instance) Dilute the ink to a pale grey. Paint the main shape of the tree in this ink, working quickly. While it is still wet, add ink and colour of varying shades. (You can also add drops of water that will push the colours around.) You must be careful not to use small, fussy strokes or too many colours. Make sure that you keep the outline of the branch simple as well; if the edge is

Above and left A lotus leaf (above) and flower (left), using sized paper for a freestyle (xieyi) technique.

ragged, there will be too much to look at. You could add a few judicious marks with dark ink and a fine brush to give definition, but be careful not to overdo it.

This technique can also be used to paint large, dramatic leaves, such as lotus leaves. After painting the main elements of the leaf in water or light ink, add a suitable colour, plus darker ink. (Consider whether you wish to show the veins. If so, avoid dark colours to enable the veins to be seen.) Again, keep the rest of the painting simple to offset the complexity of the colour and texture achieved by this method.

Using illustrations of Chinese vases and pots, paint a shape onto sized paper. Then add ink and colour as before. You may like to add a distinctive pattern around it, obtaining a softer effect by doing so while your work is still wet or damp. (This technique is best used with dramatic flowers, not small blossoms.)

The above methods all use the movement of wet paint or ink using a brush. You can also achieve interesting effects by lifting the paper and tilting it to allow the pigment to run and leave trails across the paper. Some Chinese artists experiment with thicker sized paper and bright pigments to excellent effect.

Below Branch, leaves and vase, using sized paper and imagination.

Methods for painting the sun or moon

For the sun, you need to use warm colours for any clouds or a bright-blue sky. For the moon, use either ink shades or a cold colour, such as indigo blue. Various papers will change the effect, and you will need to experiment until you achieve what you are looking for. The list below gives methods for obtaining shapes and effects for both sun and moon painting.

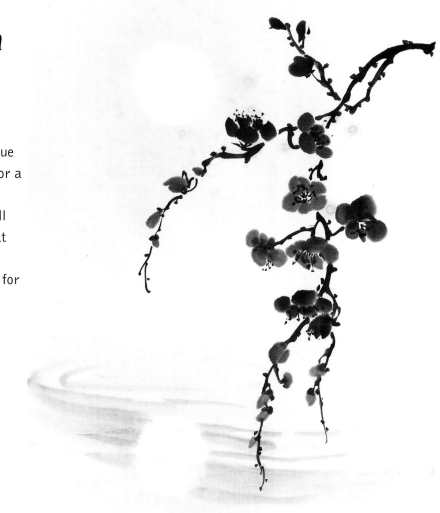

Right Different techniques (1 and 3 below, for example) can be combined when creating the moon and its reflection.

1 With a vertical brush, paint a circle in outline. If the sky is being shown, the brush should be used on its side, around the circle, travelling away to the edges of the paper.

2 Select a dish, bottle cap or similarly round shape. Then, using either a spray bottle or folding fixative spray, blow ink or colour around the shape.

3 Using a clean, wet brush, paint a circular shape onto Xuan paper, pushing any alum or size in the paper to the edge of the shape. You can then follow this with clouds or sky, working around and over the wet shape.

4 Tear (or cut) a piece of paper into a circle, wet it and apply it to the surface of the painting. Then paint the sky over the top and remove the paper shape.

5 Other techniques include using alum solution or white paint for the circular shape, followed by a wash over the back of the painting. You can achieve a variation of this effect by allowing the alum to dry thoroughly before applying the wash, or can obtain a softer effect by doing it while the circle is still damp.

You may want to combine two of these techniques, if, for example, you are showing both the moon and its reflection in water.

Bamboo in moonlight

Traditionally, the first bamboo was painted from shadows cast onto a tent or paper screen. Bamboo is often shown with a moon in the composition. The leaves are painted over the top of each other rather than broken (if they are behind others), such as orchid leaves. Here are some hints for success.

Below A bamboo painting, with a moon created by spraying light ink over a mask.

1 Make sure that your bamboo is strong and bending only gradually along its length.

2 Place the joints on adjacent stems at different levels to each other.

3 Paint the leaves in a lively fashion (and not like wet washing or a bunch of bananas!)

4 Vary the shades of ink, both in the stems and the leaf groups.

5 Ensure that any side shoots only appear on alternate sides, not opposite sides.

6 Leave some spaces within the composition.

7 Avoid parallel stems.

8 Remember the maxims 'dense and sparse' and 'large and small'.

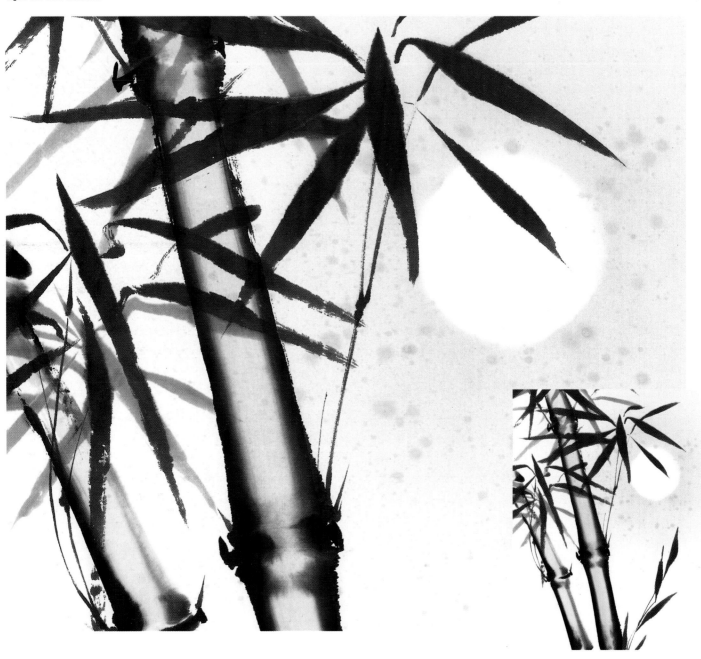

Right A varied wash on dampened paper.

Far right Top half: a horizontal wash on dry paper. Lower half: a vertical wash on dry paper.

Reflections

For many centuries, the effects of light falling on objects, shadows and reflections were ignored by the Chinese as being non-essential to a painting. A few paintings, influenced by the advent of missionaries in China, began to include the occasional reflection, but these were in the minority. During the 20th century, however, some artists included this effect when it was relevant to the tranquillity of the scene depicted.

In order to paint a reflection, you need to decide how much impact it should have on your planned work. It may be a dramatic statement (as with the sails of boats) or merely an addition to the colour or stillness (illustrated by a lakeside village). Of course, the obvious method is to reverse your brushstrokes, making the lower shapes shorter and less distinct. Another technique is to paint the shoreline in sections, and to fold your paper each time, blotting it with a brush, tissue or the side of your hand. This will work better on very absorbent paper, but you will need to work quickly to obtain a good effect.

If you want to paint a reflection to emphasise a shoreline or boat, experiment, or consider using a horizontal or vertical stroke, or maybe a mixture of the two, within the composition. The use of horizontal strokes will bring the subject nearer; vertical strokes will push the shore further away, and will also give greater stillness to the water.

Washes

Washes can be used to add atmosphere or additional colour to your painting. You will need to choose between an even and an uneven wash. Do you want a wash over the whole of the painting or only part of it? Once you know which you want, you can plan your process.

To add colour to an area of water in a landscape, for example, you should probably work on dry paper, stopping and starting the wash areas to allow for patches of 'light' on the water. If you require a background, you will need to dampen the paper first, then carefully wash in the colour using even strokes, pausing to spread the wash with a damp brush. (Hake brushes will give good results.) Any variation of colour can be added while the colour is still very wet. (An old, woollen blanket is best for this process.) All of this should be carried out after painting. If you colour-wash the paper first, you will alter the absorbency of the paper, partially sizing it. Your subsequent painting will therefore be less free.

Washes can give different effects. They can be even or irregular, and need not be applied to the whole painting. For a landscape (such as water), you may want to give the impression of tranquillity or calmness. Vertical and horizontal strokes will give differing results, and horizontal strokes used in the background can add to the impression of distance.

Paper-wrinkling

By creasing, or wrinkling, paper, either randomly or deliberately (by 'painting with your fingertips'), many interesting effects can be achieved. This technique can be used in conjunction with others, too. It can be used for backgrounds, for distant mountains, or for rocks and gorges.

By pinching the paper together with your fingertips, forming 'peaks and troughs', you can create areas relating to your composition. For a background, it may be required over all of the paper, but remember to include 'dense and sparse' areas. Paper with some size in it will work best, giving a pronounced crease. Very absorbent paper will give a softer effect, which maybe appropriate for a background for fish, for instance.

Top right Trees wrinkled using grass paper (this gives a crisp fold).

Bottom right Another tree.

Below Wrinkled mountains.

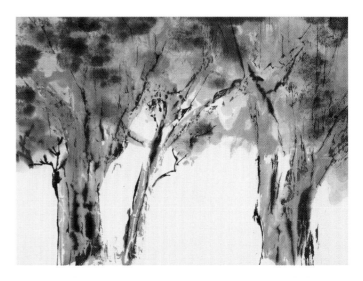

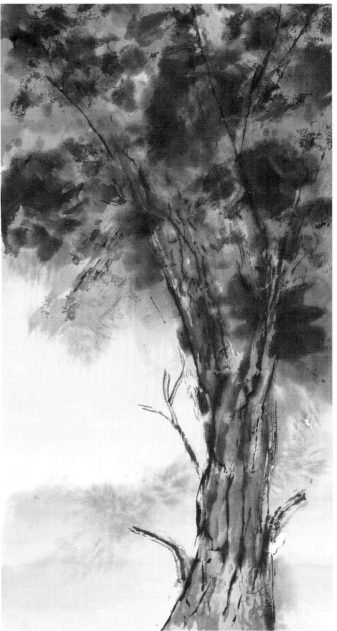

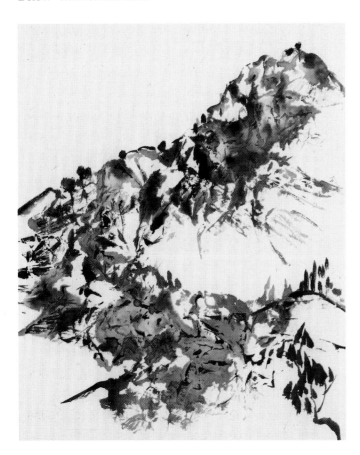

Using various shades of ink, gently drag a brush across the tops of the creases to create 'light and dark', 'wet and dry' and other contrasts. You may want to add some wetter brushstrokes to soften certain areas and give a varied effect. When this stage is dry, add colour if appropriate, plus any required detail. To flatten your work, simply spray it with a water spray, stroke it out with a soft brush and leave it to dry. Further work can be added before backing it in the normal way for framing.

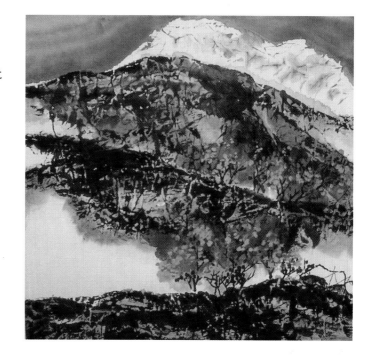

Right My version of a painting by Hu Fang, using wrinkles to obtain the rocky formations.

Below A wonderfully evocative scene. In this painting by Hu Fang, the sea has been created using the wrinkle technique.

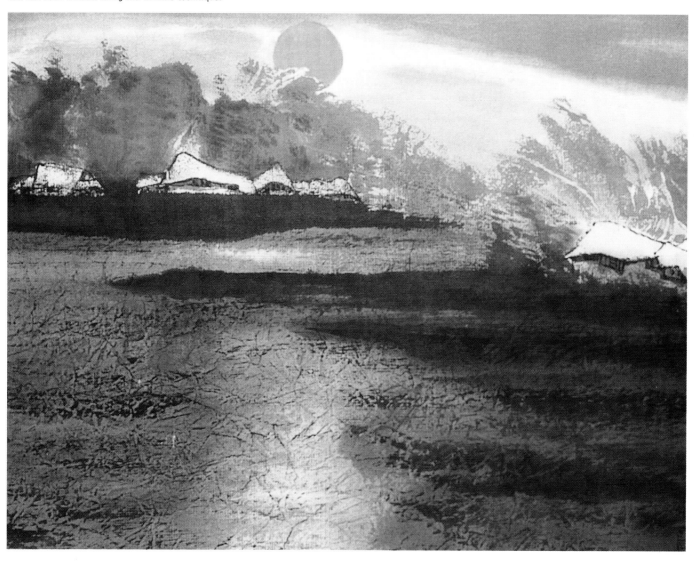

Resist techniques

materials that you are using and how to manipulate them.

At the appropriate time of year, experiment with snow on branches and pine trees. Incorporate variations by allowing some resist strokes to dry more than others. Always remember the principles of composition, even when experimenting in this way.

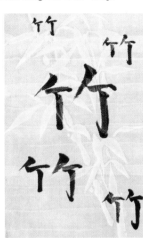

Left Bamboo, created with a resist technique, with a deliberately mottled wash for the background.

Right An exercise for resist bamboo, with the calligraphy for 'bamboo' repeated for practice.

Below A similar exercise carried out for an orchid.

In order to produce a variety of interesting effects, a resist technique can be employed using alum or milk. Alum comes in white-powder form, and is mixed with water to give a clear liquid. It is also used to size paper and silk to enable meticulous work to be carried out on absorbent surfaces. Milk is only found in certain parts of China, but other fat-containing liquids can be used. It gives a slightly different effect to alum, and can also be used in conjunction with it.

The resist methods can be used for waterfalls and snow, and also for creating layered work. They are especially good for innovative work with calligraphy and washes. Variations can be achieved by layering immediately (while the resist is wet or damp) or by allowing the resist to dry. If it is left to dry first, the end result will be sharper.

Experiment using a resist or a flower subject. Wash a colour or ink over the paper, then add calligraphy for the subject in ink. Next, try the reverse, adding the calligraphy first, followed by the wash, and see the difference. This is a fun way of practising both your calligraphy and wash skills. You will also learn about the

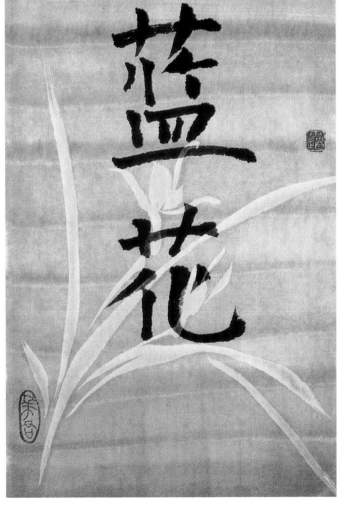

Blotting

The blotting technique can be used for several subjects. It makes an effective background, yet can be used to express rocks, too. Random marks can also be made on a sheet of paper and a scene or subject superimposed after careful consideration.

The ink or colour (or both) is brushed or dropped onto a board or rough, plastic sheet (polythene and glass are too smooth, allowing droplets to form). A piece of highly absorbent paper is then lowered onto the ink or colour and brushed with the side of the hand or a stiff brush. You should avoid creating hand prints or any recognisable shapes. Study the results and decide what you want your painting to be. If it is a landscape, add trees, define rocks and boats and so on. If it is a background, you may wish to add a wash or some blending strokes to avoid creating too much texture.

The Chinese artist Hu Fang uses blotting to great effect. She used both ink and colour for the initial blot, working green and brown into the ink (right). When doing similar work, remember to allow for the drying-out of both colour and ink, which gives a lighter result.

Blotting can also be used to great advantage to achieve the results shown by Zoë McMillan (below). Having used this technique to produce landscape work, I suggested to students that they used different

Left Ink- and colour-blotting for a water subject.

Centre Ink-blotting for a landscape.

colourings and thought about lotus leaves, water and so on. As you can see, these paintings (left and centre) are quite different in style, and show what can be achieved with additional brushstrokes and some imagination. However, you do need to know when to stop! Be prepared for failure because not all of your efforts will be successful. You must allow for the pigments to dry out lighter, by approximately a third.

This method allows you to take advantage of the properties of the Chinese materials – absorbent paper is best for this – and can also help to create more freedom in your work, so experiment using different colours and varying the degree of opacity. Keep a note of the paper and pigments that you used so that you can produce a similar effect another time. This is an excellent way of learning more about the properties of both paper and ink or colour.

Right A landscape by Hu Fang using the blotting technique. As you can see, you have to be bold!

Far right Freestyle blotting of a lotus pond (complete with frog) by Zoë McMillan.

Finger- and thumb-painting

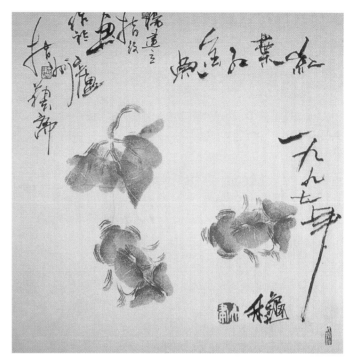

Although brushes are used for Chinese brush painting, there are also techniques for using your fingers and thumbs, along with sponges, rolled-up paper and so on. Marks were originally made with burnt sticks, and artists have experimented with other ways of making marks at various times.

A variety of finger and thumb impressions can be made to depict flowers, birds and animals, as well as to create elements of the landscape. The example illustrated below shows plum blossom created using the fingers (different fingers can give differing sizes of petals). These marks are best combined with brushstrokes for the rest of the composition.

The fish and chicks (top right and right) by Sun Ming show the variety of marks that can be made with the hands. Indeed, some 'finger artists' in China produce the most wonderful landscapes completely

Top Finger-painted fish by Sun Ming.

Above Finger-painted chicks by Sun Ming.

Left Finger-painted plum blossom.

Right Finger-painted berries. A mixture of finger marks and brushstrokes were used to create this painting.

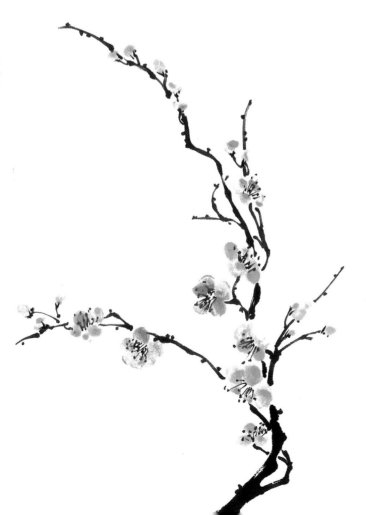

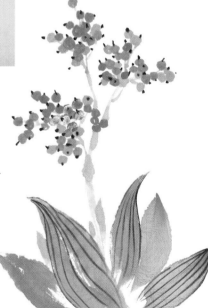

without brushes. Experiment with the examples shown here, but when using these methods for your painting, remember that you still need to consider including some plain marks to complement them.

Fans

To produce a xieyi (freestyle) painting on a fan, you will need to cut out the shape first. This can be done with the help of a template (see the diagrams on the following pages) or by using a simple folding exercise (right). Chinese painting paper is often produced in rectangular sheets approximately 137 x 68.5 mm (5.5" x 2.7") in size (a double square). A single sheet will produce eight fan-shaped shapes and two circular (moon-shaped) versions. You could otherwise use a square sheet of painting paper to produce four fans and one circle. (See diagram - right).

Take a square of paper and fold it in half diagonally. Fold it in half again from the folded edge to the point, and again from the folded tip to the centre of the edge side. Fold it in half yet again, bringing the folded sides together to produce a long, thin triangle.

Hold a piece of string in your fingertips at the point, and hold the other end of the string and a pencil in your other hand. Draw an arc at the point where all of the thicknesses of paper are present. Move your hand approximately 200 mm (8 in) away from the top and draw a second arc. Cut out the shape carefully while keeping the paper folded. Open it out twice and cut the two single folds, then the double fold. You will now have four fan shapes and one moon shape to paint.

If you wish to paint a more meticulous fan, it is possible to buy a prefolded construction, with pockets between the pasted layers to take finely tapered bamboo sticks. The painting is carried out with the fan held as flat as possible, yet accepting marks made by the brush running over the creases. The surface of these fans will be sized by their fabrication techniques, and care is needed because the ink and paint will remain wet for some time. After completion, you can place your painting on a board and display it flat in a frame instead of folding it.

750 mm (29½ in)

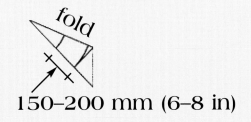

150–200 mm (6–8 in)

enlarge by 80%

enlarge by 50%

enlarge by 50%

enlarge by 50%

enlarge by 58%

enlarge by 58%

Completion

Completion

Once your painting is finished and ready for completion, there are still several stages to be done. The first is the addition of some calligraphy (you should, of course, be considering this during the painting stage). One thing to learn, and then practise, is writing your name. There are several books available in Chinatown areas, or in Western publications in which names are featured. The date is another option (see pages 142 to 145). Lastly, there is the inclusion of a seal. To ensure that your composition is correct, move samples of your calligraphy and seal around the painting until you are happy with the composition. Then add the calligraphy and apply the seal.

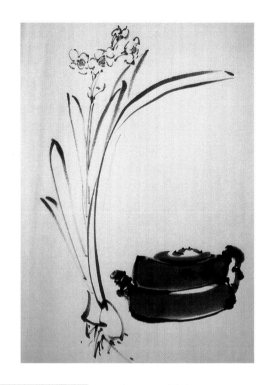

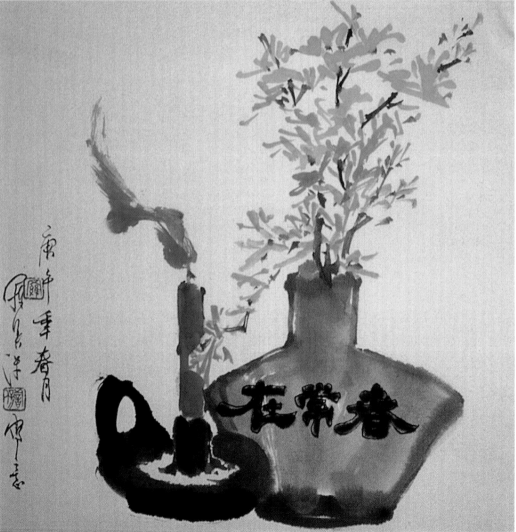

Above and left Two ways of practising your calligraphy! Any accessory can be 'decorated' with a suitable character or two.

Calligraphy

The Chinese way of writing has no alphabet, but is based on pictograms or symbols, often showing what the item consists of – wood or water, for example – plus a phonetic sound. In many ways, the written character is like a picture, prompting the saying 'To write a painting'. The presentation of a piece of calligraphy in China often occurs on the same occasions on which people in the West give flowers or chocolates. Couplets are popular, and are frequently produced at Chinese New Year, being pasted onto gates and doorways. They are only temporary, however.

Good calligraphy was more revered by scholars than a good painting, and was the deciding factor for success in the imperial exams. A humble scholar could rise to a high position if his calligraphy was very good. A piece of work was carried out for respect and honour rather than money.

Calligraphy paintings are judged on their line and brushwork in the same manner as writing. A Western audience can appreciate calligraphy as an art form, but it is so much better when you can understand the meaning! Nowadays, due to the growth of computers, calligraphy as an art form is less practised in China, but a wider (and more informed) audience is now to be found in the West.

Apart from the decorative bone-shell and bronze scripts, Chinese calligraphy started with the seal forms (zhuan) of the great and small seals. It progressed over centuries, becoming more abstract, to Han official, then on to standard (Kai Shu, for textbooks) and cursive or running (Cao Shu, for letters). During this time, the materials changed more than the basic forms. In recent years, some simplification of the characters has taken place, but this form is rarely used on paintings.

The best way to learn Chinese calligraphy is to find good examples and practise them. Three main forms of Kai Shu have been respected: Ou form (by Ou Yang Xun during the 7th century), Liu form (by Liu Gong

Above Calligraphy, by Xuzhuang Li, of a poem by Jia Dao of the Tang Dynasty. 'I went into a deep mountain to visit a hermit friend, but he was out. I asked a boy under a pine tree, and he said his master was picking herbs in the mountains. As the clouds were so deep, he did not know where his master was.' (In other words, his master did not want to be disturbed!)

Quan during the 8th century) and Yan form (by Yan Zhen Qing during the 8th century), and famous essays by these calligraphers have been used as examples.

To begin with, trace some examples of calligraphy and then compare the original with your finished copy. Next, choose a piece of calligraphy and study it carefully, trying to see the hidden meaning rather than the outer form. Finally, practise painting the calligraphy symbols over and over again.

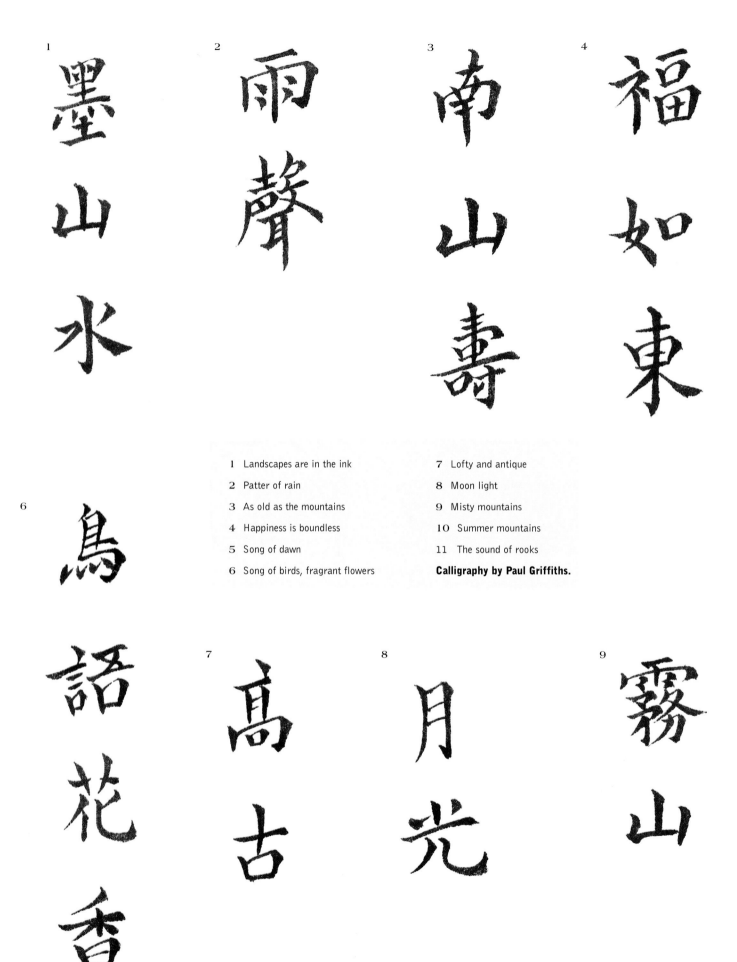

1 墨山水

2 雨聲

3 南山壽

4 福如東

6 鳥語花香

7 高古

8 月光

9 霧山

1 Landscapes are in the ink

2 Patter of rain

3 As old as the mountains

4 Happiness is boundless

5 Song of dawn

6 Song of birds, fragrant flowers

7 Lofty and antique

8 Moon light

9 Misty mountains

10 Summer mountains

11 The sound of rooks

Calligraphy by Paul Griffiths.

5

10

11

The sixty-year cycle

This is a method of dating used by scholars and artists for centuries. Each year is given a name, which contains elements from the 'ten heavenly stems and the twelve earthly branches', which repeats itself in a cycle. In the table overleaf, the names of the years are listed both for the past and future. When investigating the age of a painting, you may have to choose between 1919 or 1979, for instance, depending on the dates when the artist was active. The Wade Giles names (the pre-Pinyin versions, which you will find in older books) are given in brackets.

 An alternative way for you to date your own painting is also good practice for you. The year names are used with nian (year) at the end, as in the example given for 2003, below.

Above Guiwei year, 2003.

The sixty-year cycle

Calligraphy		Years			Name	
甲子	1	1864	1924	1984	Jiazi	(Chia Tzu)
乙丑	2	1865	1925	1985	Yichou	(Yi Ch'ou)
丙寅	3	1866	1926	1986	Bingyin	(Ping Yin)
丁卯	4	1867	1927	1987	Dingmao	(Ting Mao)
戊辰	5	1868	1928	1988	Wuchen	(Wu Ch'en)
己巳	6	1869	1929	1989	Jisi	(Chi Szu)
庚午	7	1870	1930	1990	Gengwu	(Keng Wu)
辛未	8	1871	1931	1991	Xinwei	(Hsin Wei)
壬申	9	1872	1932	1992	Renshen	(Jen Shen)
癸酉	10	1873	1933	1993	Guiyou	(Kuei Yu)
甲戌	11	1874	1934	1994	Jiaxu	(Chia Hsu)
乙亥	12	1875	1935	1995	Yihai	(Yi Hai)
丙子	13	1876	1936	1996	Bingzi	(Ping Tzu)
丁丑	14	1877	1937	1997	Dingchou	(Ting Ch'ou)
戊寅	15	1878	1938	1998	Wuyin	(Wu Yin)
己卯	16	1879	1939	1999	Jimao	(Chi Mao)
庚辰	17	1880	1940	2000	Gengchen	(Keng Ch'en)
辛巳	18	1881	1941	2001	Xinsi	(Hsin Szu)
壬午	19	1882	1942	2002	Renwu	(Jen Wu)
癸未	20	1883	1943	2003	Guiwei	(Kuei Wei)
甲申	21	1884	1944	2004	Jiashen	(Chia Shen)
乙酉	22	1885	1945	2005	Yiyou	(Yi Yu)
丙戌	23	1886	1946	2006	Bingxu	(Ping Hsu)
丁亥	24	1887	1947	2007	Dinghai	(Ting Hai)
戊子	25	1888	1948	2008	Wuzi	(Wu Tzu)
己丑	26	1889	1949	2009	Jichou	(Chi Ch'ou)
庚寅	27	1890	1950	2010	Gengyin	(Keng Yin)
辛卯	28	1891	1951	2011	Xinmao	(Hsin Mao)
壬辰	29	1892	1952	2012	Renchen	(Jen Ch'en)
癸巳	30	1893	1953	2013	Guisi	(Kuei Szu)

Calligraphy		Years			Name	
甲午	31	1894	1954	2014	Jiawu	(Chia Wu)
乙未	32	1895	1955	2015	Yiwei	(Yi Wei)
丙申	33	1896	1956	2016	Bingshen	(Ping Shen)
丁酉	34	1897	1957	2017	Dingyou	(Ting Yu)
戊戌	35	1898	1958	2018	Wuxu	(Wu Hsu)
己亥	36	1899	1959	2019	Jihai	(Chi Hai)
庚子	37	1900	1960	2020	Gengzi	(Keng Tzu)
辛丑	38	1901	1961	2021	Xinchou	(Hsin Ch'ou)
壬寅	39	1902	1962	2022	Renyin	(Jen Yin)
癸卯	40	1903	1963	2023	Guimao	(Kuei Mao)
甲辰	41	1904	1964	2024	Jiachen	(Chia Ch'en)
乙巳	42	1905	1965	2025	Yisi	(Yi Szu)
丙午	43	1906	1966	2026	Bingwu	(Ping Wu)
丁未	44	1907	1967	2027	Dingwei	(Ting Wei)
戊申	45	1908	1968	2028	Wushen	(Wu Shen)

Calligraphy		Years			Name	
己酉	46	1909	1969	2029	Jiyou	(Chi Yu)
庚戌	47	1910	1970	2030	Gengxu	(Keng Hsu)
辛亥	48	1911	1971	2031	Xinhai	(Hsin Hai)
壬子	49	1912	1972	2032	Renzi	(Jen Tzu)
癸丑	50	1913	1973	2033	Guichou	(Kuei Ch'ou)
甲寅	51	1914	1974	2034	Jiayin	(Chia Yin)
乙卯	52	1915	1975	2035	Yimao	(Yi Mao)
丙辰	53	1916	1976	2036	Bingchen	(Ping Che'en)
丁巳	54	1917	1977	2037	Dingsi	(Ting Szu)
戊午	55	1918	1978	2038	Wuwu	(Wu Wu)
己未	56	1919	1979	2039	Jiwei	(Chi Wei)
庚申	57	1920	1980	2040	Gengshen	(Keng Shen)
辛酉	58	1921	1981	2041	Xinyou	(Hsin Yu)
壬戌	59	1922	1982	2042	Renxu	(Jen Hsu)
癸亥	60	1923	1983	2043	Guihai	(Kuei Hai)

Seals

The three visual arts are painting, calligraphy and sculpture. Because seal-carving comes under the latter description, many artists are involved in all three arts. Seals were originally made from clay, and then cast bronze, being used to give legal authenticity in the same way as the West once used sealing wax with a fob seal or ring. Some early seals were made from gold or jade, with popular decorations, such as horses, tortoises, dragons or camels. Many seals at that time had a cord through the top to enable them to be worn around the neck. Most seals of the Han period were of a recessed design.

Seals and inscriptions were not affixed to paintings until the Tang Dynasty. During the Song period, the artist hid the seal amongst rocks and trees. Later, a single-line inscription was included to show where and when the painting was carried out. There was a variety of ways to 'sign' a painting, such as the artist's family name, given name, studio name and so on.

During the Yuan Dynasty (the Mongols), artists started to carve their own seals from stone rather than bronze or ivory, and 'leisure' seals (a poem or saying) were first used. In around 1500, it became fashionable to include the carver's name, together with a poem or phrase, carved onto the side of a seal. Later, flowers or figures were included.

From 1900, many ancient examples of both calligraphy and seals were excavated, and seal-engraving took on a new momentum. Seal-making is really an extension of calligraphy, with the specialist working on metal or stone rather than paper.

When seals are used in conjunction with an inscription, they should be about the same size as a character. Care should be taken with larger seals. You should leave the positioning of such seals until the end of your work. Metal seals are more difficult to use and to obtain a clear imprint. You can have a seal carved with your name, but if you just want to convey a pleasant message, some rubber-moulded versions are available for a fraction of the cost.

1

2a

3

2b

4

6a

7

Spring

6b

Summer

5

6c

Autumn

Illustrations

1 Eight characters, reading downwards: (top right) objects, beautiful, heaven, treasure; (top centre) the people, the best, the land; (top left) intelligent sprite.

2a Bird/insect/fish zhuan (script) around BCE/CE (before common era/common era) – The one who records history' (bronze seal).

2b 'It's always good for our descendants.' (For a collection.)

3 'Have a lot of joy from [within] it.'

4 'Happy New Year.'

5 'What a lovely way to enjoy life!'

6a Another bronze seal: '[name] in charge of the area west of the Great Wall'.

6b 'Infinitely happy.'

6c 'Asking the plum blossom for information.'

7 These four seals are part of two sets of seasonal seals, one set being square and the second of an irregular shape.

Winter

Mounting and framing

When you have completed your painting, you will need to back or mount it. This involves a pasting process, which is described in many publications. Prior to this, you will have to decide upon which format you wish to use. Your work can be framed directly, placed behind an aperture mount, silk- or paper-trimmed or scroll-mounted.

These methods all follow the same sequence of steps.

1 Back the painting with another piece of paper of the same, or similar, type.

2 Now either frame your painting directly, aperture-mount it or move on to stage 3.

3 Use paper-backed silk, or back your own, and paste the borders onto your painting. (Until you gain more confidence, you could use paper with a brocade pattern to it.)

4 Place the painting in the frame or go on to stage 5.

5 Make the painting into a scroll.

Opposite page A calligraphy collage by Qu Lei Lei, a beautiful piece of work showing the variation in style, size and ink colour that can be achieved. The red of the seal impressions adds to the muted palette.

Left An alternative to making a scroll is to use a fancy border (rather than an aperture mount). Top to bottom: brocade-patterned paper, dyed Xuan paper, silk overlapping painting and a gutter border adding an additional modelling line. After backing your picture, add the sides, followed by the top and bottom borders, and then paste-mount another sheet over the back of both painting and borders.

Tips on framing

Keep your framing material simple. One method is to use a frame and mount of a similar tone to the painting itself. You may be tempted to use a bamboo-shaped moulding, but this can be too overpowering for the delicacy of the watercolour, although a painting or piece of calligraphy with a lot of powerful ink strokes can stand a heavier frame.

Above Three different methods of attaching the hanging cords and tie ribbons. These ribbons can be woven (brown and white/black) or made from a piece of silk sewn into a ribbon shape (yellow). Notice the variation using beige inset stripes on the open scroll.

Below To make scrolls, you will need either silk or special paper. This can be plain (like the blue silk) or patterned, usually with a brocade design. The colour and degree of pattern should be appropriate to the painting, and not too heavy.

Scrolls

To make a scroll to hang vertically, or a hand scroll to unwind on a flat surface, it is necessary to have a large working area and a great deal of patience. You also need some special brocaded silk, which can be obtained with a paper backing. The process is explained on page 151, but is too specialised for most people. If your home is centrally heated, it is perhaps preferable to frame your work (or to protect your investment) behind glass.

Here is a brief description of a demonstration by Pak Tin Li, given in London, on how to make a scroll. As you will see, it is quite involved, and many famous Chinese artists go to a mounting expert, such as Pak Tin Li, to complete their work. For most mounting tasks, especially scrolls, you will need a large working area and plenty of space for the drying processes.

1 Back your painting (either by pasting the back of the painting or by pasting the backing sheet).

2 Back your silk, or use a prebacked version (you could also use a brocade-decorated paper, but this is not as attractive as silk).

3 Cut the silk to size using age-old proportions – (where there is more mount space above the painting than below, and narrow sides).

4 Attach the silk borders to your painting, maybe with a separating strip.

5 Back the whole composite area with more paper.

6 When dry, polish the back of the scroll with a large pebble and wax.

7 Prepare the wooden rollers and supports and attach them to the scroll.

8 Complete the scroll with cords, a label and title.

Top left Three methods of overlapping for both scrolls and borders. From left to right: a) the painting and surround are separated by a small gutter feature, enabling easy remounting; b) the painting overlaps the sides, while the surround overlaps the painting at the top and bottom; c) the painting overlaps the surround on all edges.

Top right A selection of dowels, quadrants and half-circular pieces of wood are required, along with special ends for the bottom rollers. The ends of the dowels have to be carved or drilled to accept the hardwood knobs.

Below Fancy (centre) and plain (top) trimmings at the back of scrolls. The lower scroll shows a label on the outside that enables the contents to be recognised.

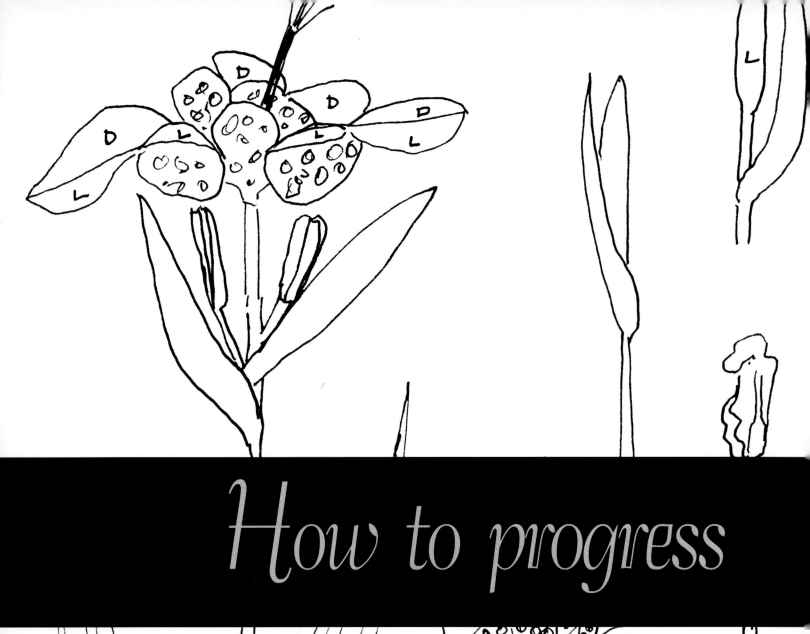

How to progress

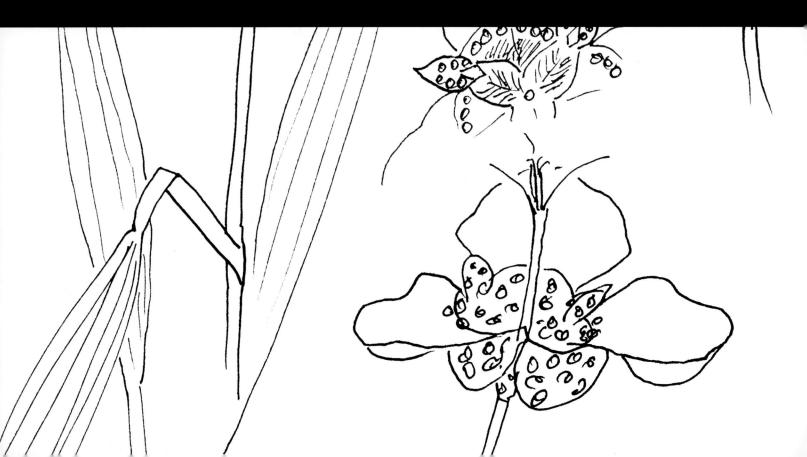

Inspiration

As you develop, you will want to move away from the 'copying-to-learn' process and onwards, towards creating your own work. There are various ways to do this. Photographs, paintings or sketches can inspire you. Keeping copyright in mind, use any of these as a starting point: choose one, study it well, maybe make notes, and then put the items or elements that make the greatest impact onto paper. Get down your own impression of the subject, not the other person's view. Individual artists will have favourite subjects, not just flowers or landscapes, but maybe poppies or peonies, waterfalls or birds. What we like is very often what we do best; what we do best, we like.

Use a previously painted picture (covered with a piece of plastic to avoid damaging the work) and, on a thin piece of paper (grass paper, for example), make a brush-and-ink sketch of the main structure of the bird or other subject. Assemble a selection of these sketches and move them around your proposed picture, carefully examining the shapes and spaces.

I often work from life or a photograph, which I place behind me so that I can turn back to the painting and concentrate on the strokes, shapes and spaces. Some artists work by painting many examples; others prefer to work on one version in order to get it right as soon as possible. Find out which method is best for you.

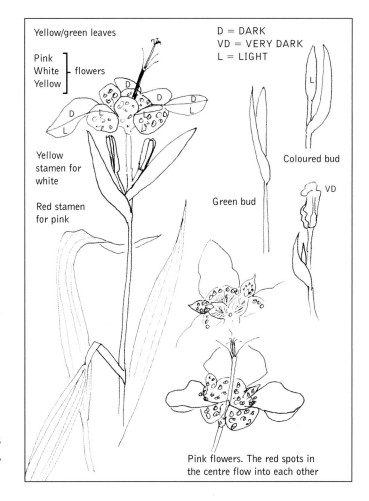

Right Study the subject, and then mark, or draw, the light and dark areas, the direction of the veins and other details.

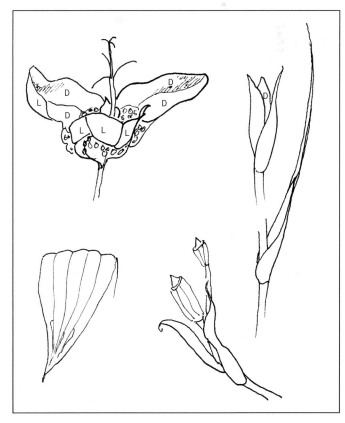

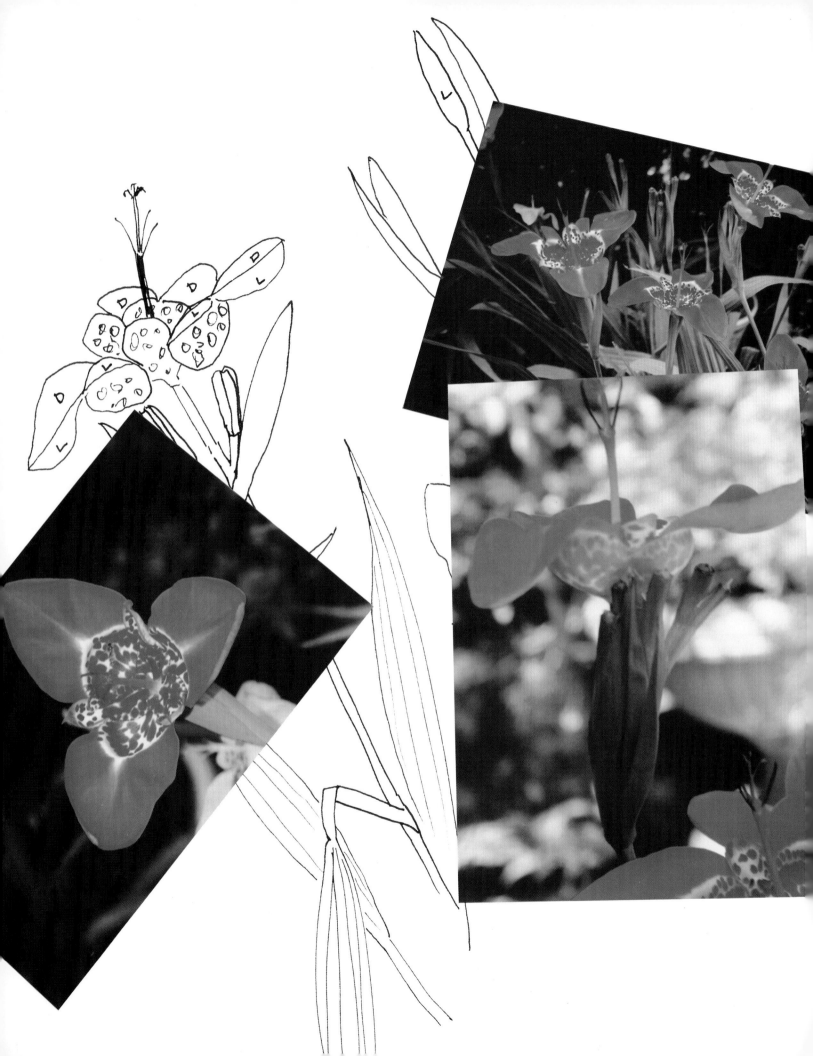

Creating new flowers and plants

Walk around a garden, greenhouse or park, or browse through some gardening books and seed catalogues. If possible, take photographs from several angles, showing the junctions of the leaves and flowers, as well as any buds or seed heads. You can also make sketches, not in a Western, botanical fashion, but working out where the strokes will go (see the examples of the tiger lily on these pages). For your future reference, assemble all of this information in a scrapbook or keep it in files or envelopes. The idea is to be able to find it when you want it again.

Now that you have the shapes, colours and botanical details of the plant, you can plan your painting. You need to capture the essence rather than the reality. If you already practise botanical painting, it can be quite difficult to leave realism behind. Do not paint 'every leaf'. Sometimes you will create the effect that you want immediately; at other times you will need to make several attempts. The secret is to learn when to keep going and when to leave it to another day rather than pursue a task that is not working for you at the moment.

Try another version of the same plant, or another colour, variety or close relative. Paint the same subject using another technique, maybe both contour and freestyle, or even paint it in gongbi and meticulous style.

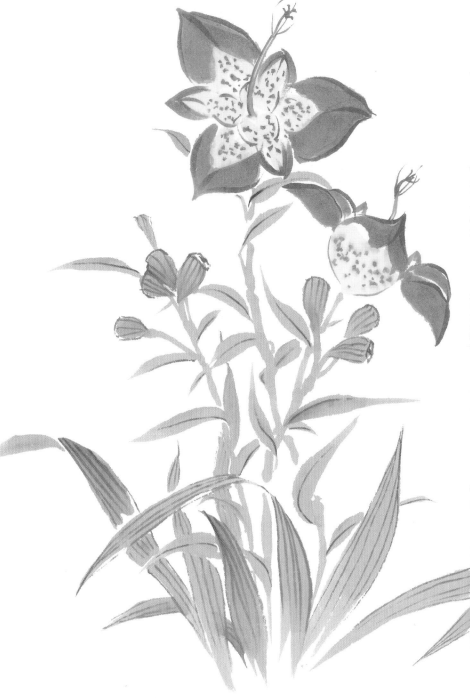

Left Use photographs and sketches to build up reference material. It is a good idea to keep that material with a copy of your results for future reference.

Right A tiger-lily painting, the result of sketches.

Creating new figures

Y ou may have bought, or been given, an Oriental figurine. Sketch it (with a brush) from different angles. Alter the angle of the head or hands maybe; change the mood of the figure; or make it look up, instead of down. When you have a collection of brush sketches, put one or more into a pleasing composition, still using the brush. Look at the work of established artists and decide what appeals to you. Never be afraid to acknowledge any of your sources.

Once you are happy to start painting, do some research on the colours used in the period that you are illustrating. Try to tell a story in your painting, either creating your own or using a myth or legend. When you are searching for ideas of subjects to combine, remember that books on Chinese symbolism can be very inspirational. There you will find associations that you may not otherwise have considered.

Once you have completed some paintings, ask yourself whether any strokes or information could be left out. Try to leave something to the viewer's imagination to add more interest. If the complete story is told, a painting may be less appealing.

Below Moon Goddess, detail (see page 165).

Creating new landscapes

Consider a scene that can be changed with the seasons. You could paint a screen, for example, with an identical view for each of the four seasons. Some scenes will work better than others, so weed out the ones that, in your opinion, have not worked. If you are working on a large landscape painting, you can use photocopies or sketches to help you to work out the composition. You may wish to add a bird or boat, for instance, in which case get into the habit of using a small sketch of your intended addition to hold over the painting to test the position, size and so on (remember that this technique works with seals and calligraphy, too). At the final stage of your hard work, you do not want to spoil it with the incorrect placement of such finishing touches.

Working this way will allow you gradually to develop an eye for compositions that are appropriate and that suit you. 'Capturing the essence' of your intended subject is also about enjoying your painting, so make sure that you do so!

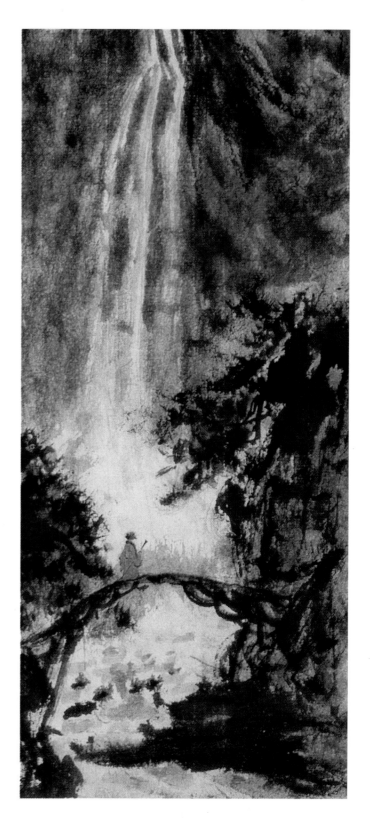

Above Figure on a Bridge, by Joseph Lo. The figure appears to be listening – to the waterfall or a bird, maybe?

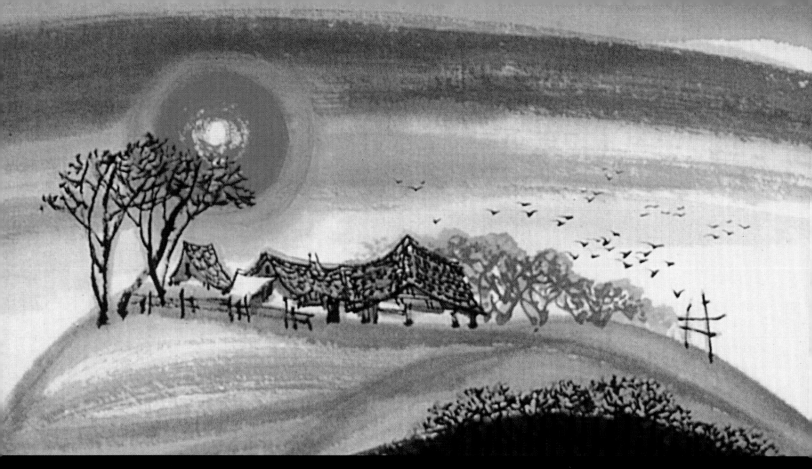

Gallery

Right A waterside village in southern China, by Hu Fang. The water is expressed with brushstrokes, while the cormorants on the net rack above the boats give a geographical location. The composition of this painting is exciting and interesting, but not necessarily conventional.

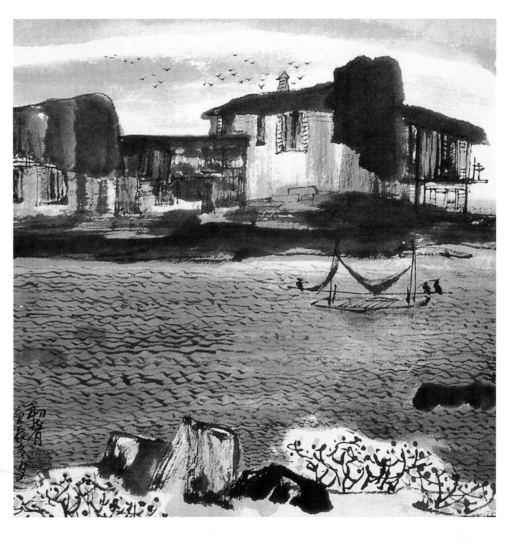

Below left and right These two paintings by Jennifer Scott beautifully illustrate the importance of deciding on a mood for your painting. Both show a scholar with his pet tiger, one depicting them sleeping (below left), the other 'in conversation' (below right). According to legend, the scholar was raised to the status of an Immortal due to his unusual pet. He certainly does not seem to be worrying about the Zen saying 'Laugh at the man reaching for the tiger's whiskers'.

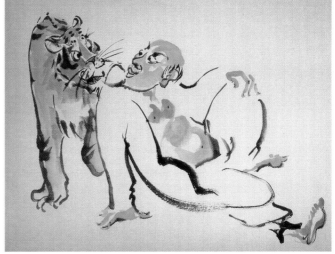

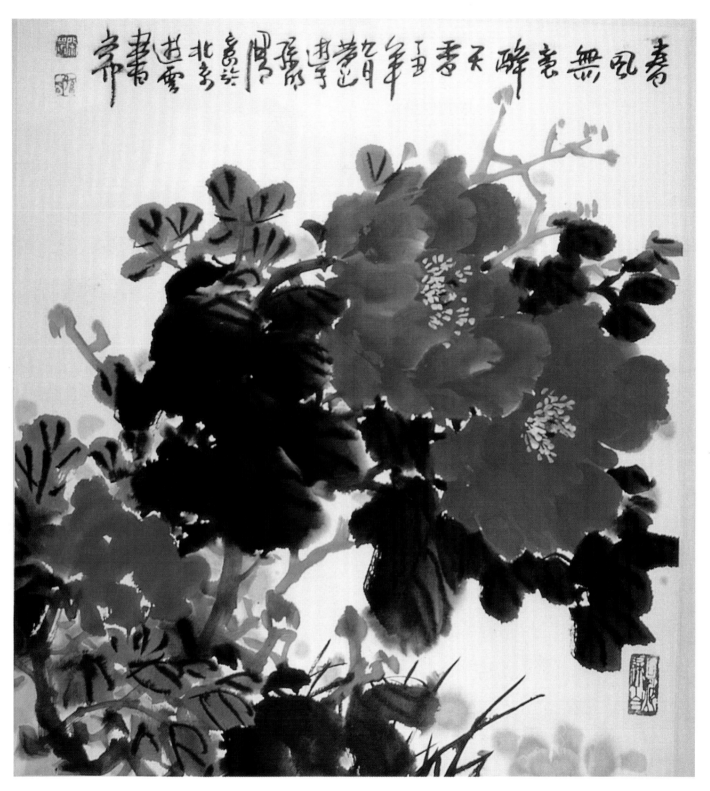

Above A very dramatic peony painting by Sun Ming. The colours of
the flowers are hot and intense in contrast to the cool blues and greens
in the background. The impression given is that the flowers are so
sensational that they are bending the stems with their weight. The size
of the painting is 48 x 43 cm (around 19 x 17 in).

Left A demonstration painting of roses by Chung Chen Sun, showing the various principles of dense and loose, large and small and so on. Notice the amount, and distribution, of space within this painting, which measures 70 x 94 cm (around 28 x 37 in), and is therefore larger than many learners would attempt. The pale strokes in the background create depth.

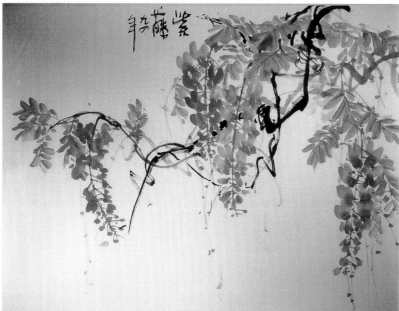

Left A wisteria by Chung Chen Sun (measuring 70 x 92 cm, or around 28 x 36 in), painted vertically as a demonstration, which is more difficult to achieve. Note the contrast between the delicate blossoms and the dramatic stems. There is a sense of the picture conveying more than the eye initially sees.

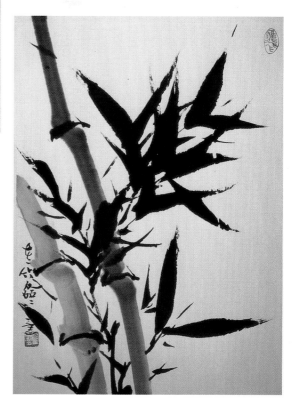

Right A wonderful bamboo painting by Qu Lei Lei, emphasising the upright nature of the plant – the 'perfect gentleman' protecting the new growth.

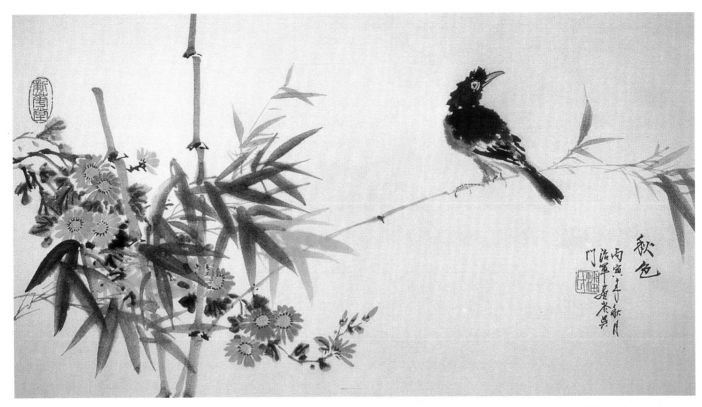

Above A good combination of bird, bamboo and chrysanthmums, by Pan Zhi Jun

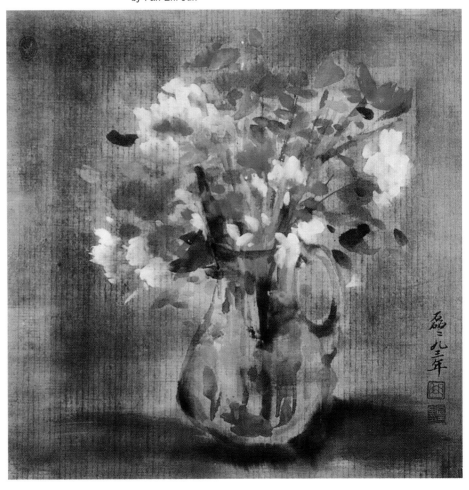

Right A Present of Flowers. This painting, by Qu Lei Lei, uses the qualities of the paper to express the delicacy of the glass jug of flowers.

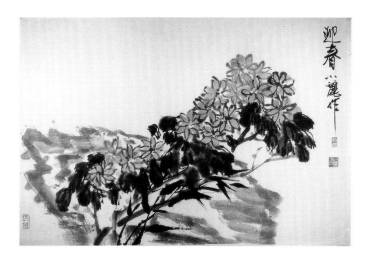

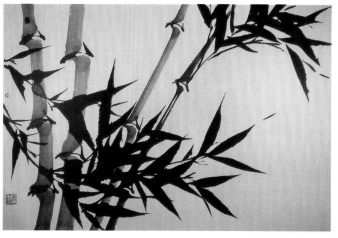

Above Chrysanthemums against a rock – a favourite combination for Chinese artists – an xieyi painting by Cai Xiaoli.

Above This bamboo painting, by Qu Lei Lei, shows the flexibility of the plant and its ability to bend with the wind (and with other vicissitudes).

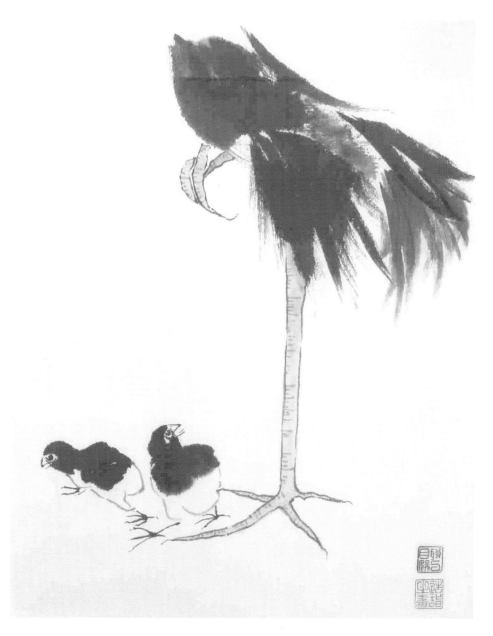

Left Big Trouble, by Zoë McMillan. An unusual and excellent design, leaving the viewer to imagine what those chicks have been up to!

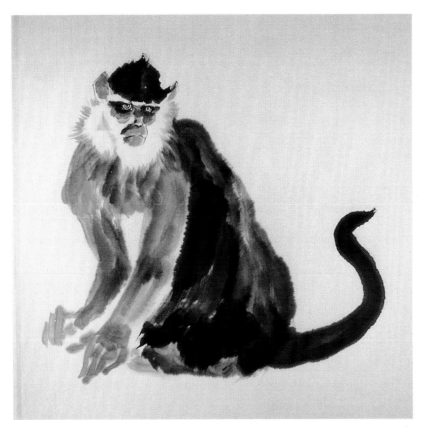

Above and right Rhesus Monkey, by Jane Dwight (above). Note the variation in style compared to the monkey at right by Jennifer Scott, whose style is very different. Jennifer has painted more of a cheeky scene, whereas Jane's version emphasises her monkey's wistful character.

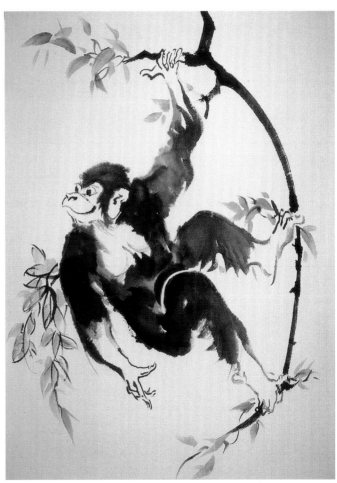

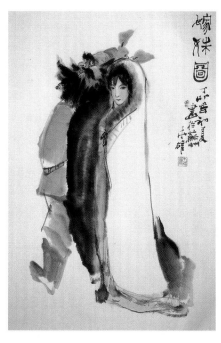

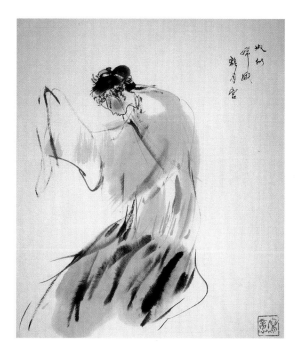

Far left Picture of Marrying Younger Sister. This was painted by Ben Xong in Suzhou. I love the incongruity of the figures, as well as their expressions.

Left I am Like the Lady in the Moon [Chang E] Leaving the Moon Palace. The moon goddess figures in Chinese legend. In mortal life, she stole the herb of immortality and fled to the moon, where she was trapped forever as an Immortal. The seal says 'Write an idea', that is, freestyle.

Below This is a painting by Ben Xong of an elegant lady seemingly thinking about her next painting! Notice how the outline banana leaves give a delicacy to the background, while her robes are suggested by only a few lines.

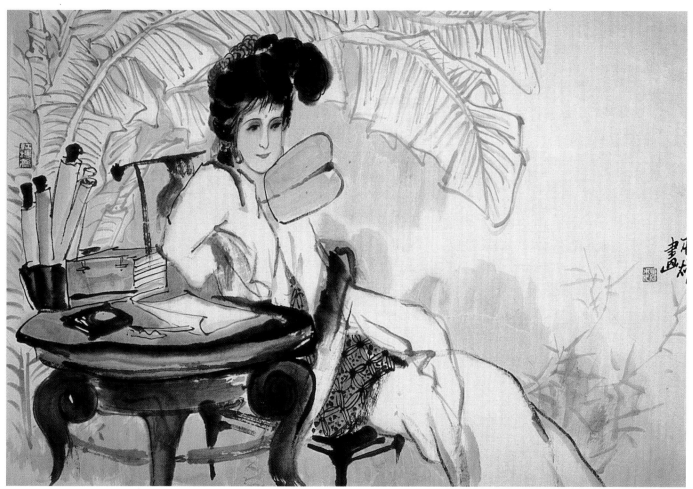

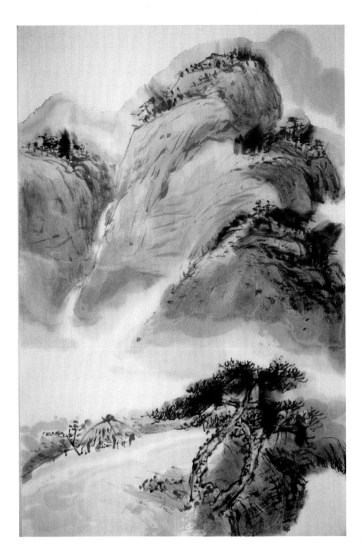

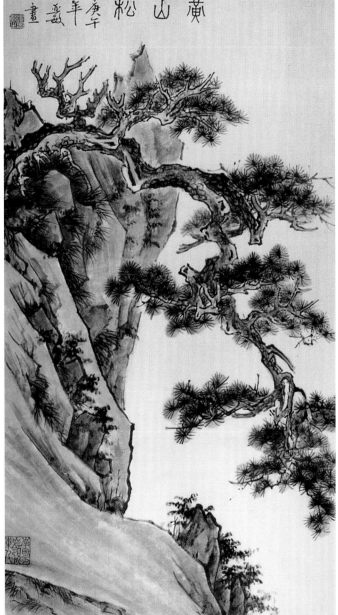

Left A landscape demonstration painting by Chung Chen Sun, painted in a vertical position. From the ancient pine trees through to the mountains at the top, there is great depth, accentuated by the strokes, ink work and choice of colour. Examine the spaces that suggest mist and sky and see how they vary in shape and size. The painting measures 70 x 46 cm (around 28 x 18 in).

Right A very contorted pine tree, by Ya Min, suggesting the agelessness of both the tree and the rocks in which it is rooted. Creating this type of painting requires a calm mind and patience. It measures 67 x 37 cm (around 26 x 15 in).

寒山幽居 庚辰 春物居斎 迫於 藝 居 先生

Above A chilly landscape, with wonderful mist suspended in the valleys, by Eric Ng. This painting measures 31 x 60 cm (about 12 x 24 in).

Left A traditional, ink landscape on grass paper, by Qu Lei Lei. Look carefully, and you will see something extra each time, such as a small building, a bridge, a path, and then another bridge. Size: 48 x 33 cm (about 19 x 13 in).

Below An exciting and lively painting by Hu Fang. The red sun suggests heat, and the green swirls of land a feeling of fertility. The blue-roofed buildings appear to be nestling under the trees for shelter.

Below A detail from a much larger painting by Eric Ng. It is full of small cameos: a few roofs amongst trees, a cascading waterfall and so on. The overall effect is of the grandeur of nature. The whole painting is 72 x 54 cm (about 28 x 21 in) in size.

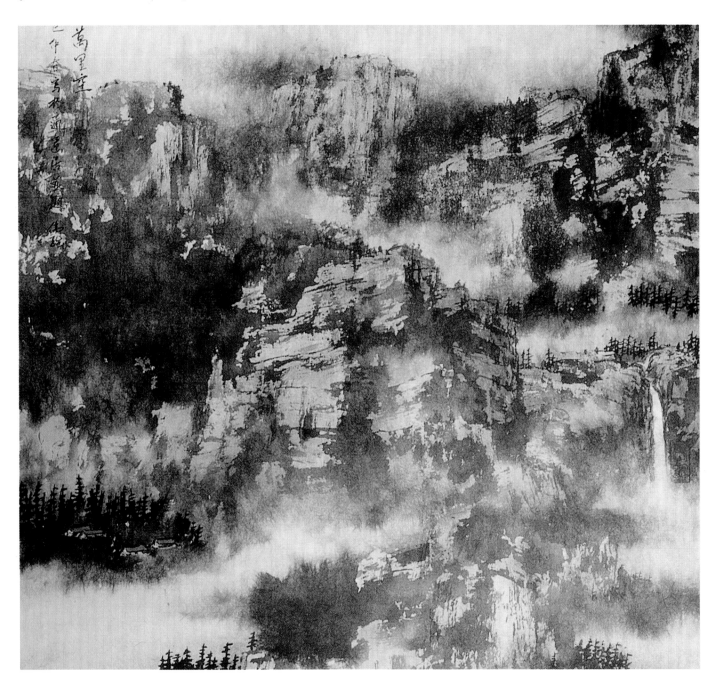

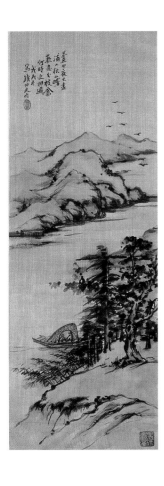

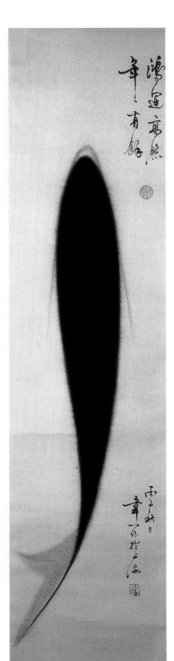

Left A wonderful scroll painting by Wai Yi. The fish is expressed with one large ink stroke and a few details in light ink. This painting was given to me by the late Alec Bates. The picture area is 118 x 30 cm (about 46 x 12 in).

Far left In That Area the Night Light is All Gone, the Dawn in the Mouth of the River is as Autumn, Mountain Bird Leaves the Branch With a Sigh, When Will we Meet Again? This delightful landscape bears a poem by one person, yet is painted by another. It is not signed, except for an indecipherable studio seal at the bottom. Size: 53 x 20 cm (about 21 x 8 in).

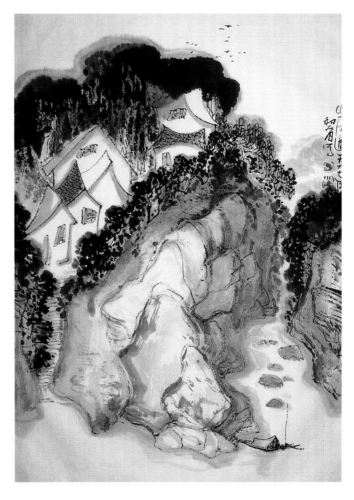

Right Village on a Hill, by Hu Fang. The immediate impression is of a limited palette: ink and the two traditional landscape colours (sky blue and burnt sienna). Yet the style is not what most viewers would associate with traditional painting. The distribution of shapes and density creates an energetic, yet restful, result.

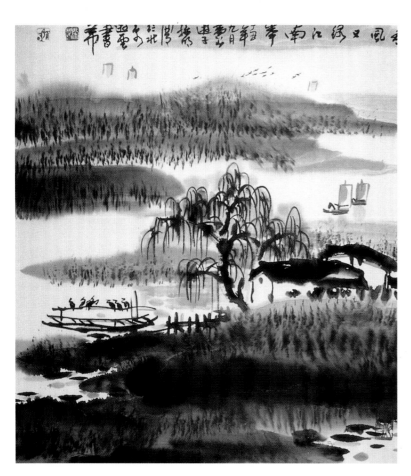

Left This green, wet landscape, illustrated with plenty of lively brushwork by Sun Ming, suggests a damp and fertile area. Notice how the various boats recede into the distance. Sun Ming's work is widely collected. Size: 48 x 43 cm (about 19 x 17 in).

Right We are All in the Same Boat.

Above A fan painting, by Fang Xian Ting, called Morning Light. There are many textures here, created with brushstrokes, colour-loading and the use of mineral (stone) colours, which are balanced by the painting's bold orange background.

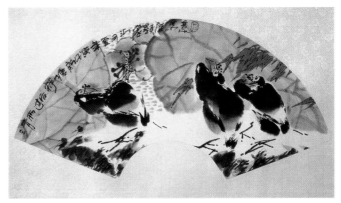

Above Lotus Pond After Rain, a fan painting by Fang Xian Ting. This painting shows a number of techniques and strokes. The clear colours suggest that the rain has washed everything clean, including the three birds! The overall size of this fan is 28 x 58 cm (around 11 x 23 in).

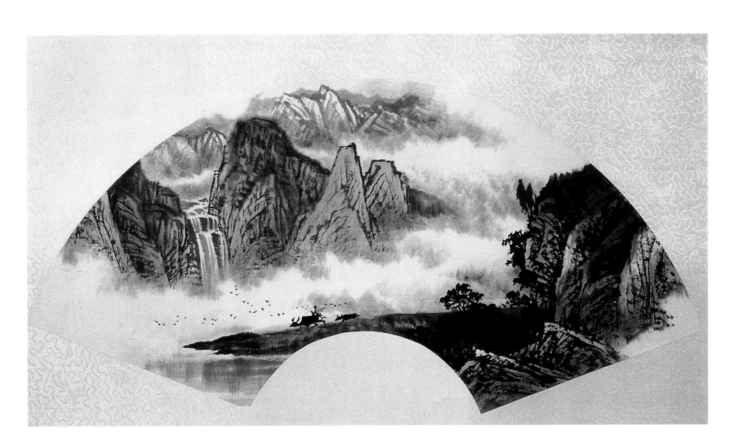

Above Endless Green and Blue Mountains, a fan painting by Yao Ye Hong. The impression of depth is enhanced by the layers of mist between the painting's elements.

Right A rather traditional landscape by Hu Fang. By emphasising the space at the bottom of the painting, the idea of the spray and mist created by the waterfall is enhanced. The over-run of blue and green boosts the watery effect. At 35 x 22 cm (around 14 x 9 in), this is a small painting.

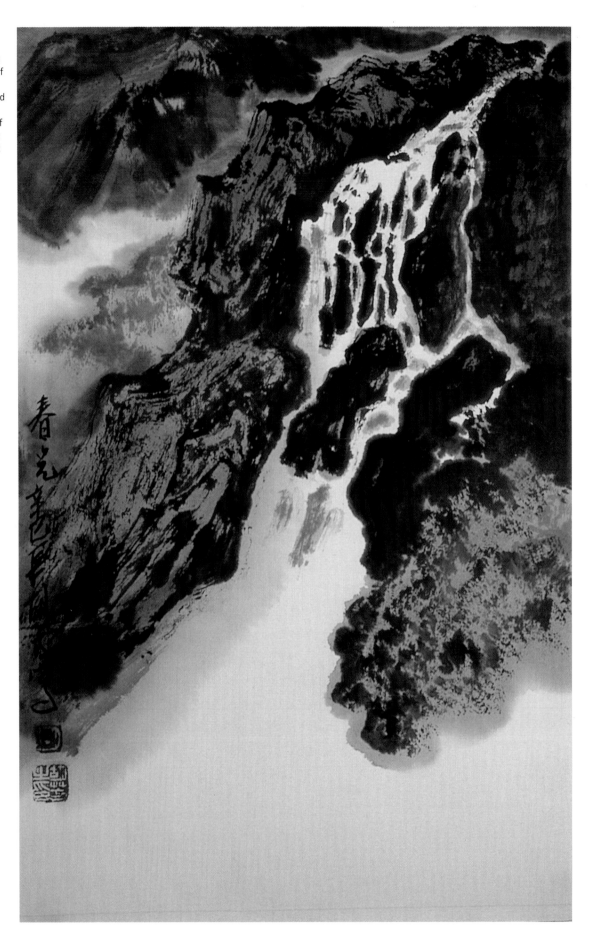

Appendix: Chinese dynasties

Below is a simplified chart showing the different dynasties, their dates and major artistic events.

Dynasty	Dates	Events	
Zhou	1050–221 BC	Development of Confucian, Daoist and other philosophies	
Qin	221–206 BC	Development of various scripts, especially clerical	
Han	206 BC – AD 220	Buddhism, paper and standard script	
Sanguo	AD 220–265	(Three Kingdoms)	
Xi Jin	265–316		
Dong Jin	317–420	(Six Dynasties)	
Nanbeichao	386–589	Regular script dominant, woodblock prints	
Sui	589–618		
Tang	618–907		
Wudai	907–960	(Five Dynasties/Ten Kingdoms)	Landscape painting
Bei Song	960–1127	(Northern Song)	Literati painting
Nan Song	1127–1279	(Southern Song)	Imperial Painting Academy, moveable-type printing
Yuan	1279–1368	Many famous masters	
Ming	1368–1644	Many literati painters	
Qing	1644–1911	Individualists coexist with orthodox	
Republic	1912–1949	First art school opened in Shanghai	
People's Republic	1949–	Contemporary artists	

Index

Note that Chinese names have been indexed in Western fashion.

Page numbers in italics refer to captions.

Bibliography

James Cahill	Chinese Painting (Bookking International, 1995).
Bamber Gascoigne	The Treasures and Dynasties of China (Cape, 1973).
Paul Griffiths	A Timeline for Chinese and Japanese Histories (2000).
Boyle Huang	Chinese Art: The Pastime of Literati (Vantage, 1991).
Qu Lei Lei	The Simple Art of Chinese Calligraphy (Cico Books, 2002).
Ka Bo Tsang	More Than Keeping Cool: Chinese Fan Paintings (ROM, 2002)
Soiku Shigematsu	A Zen Forest: Sayings of the Masters (Weatherhill, 1981).

Credits

My thanks to those English and Chinese artists (both past and present) who have very generously lent paintings for this book, or have allowed me to show their paintings in my possession. My thanks also go to those who have specifically created work for me to use. Efforts to contact some artists in China whose work I have collected has not proved successful. On some of the paintings, even my Chinese colleagues have not been able to decipher the signatures or the seals.

My gratitude, as always, to Dave for holding the fort while I have been deep in this book and for the support and encouragement from both him and all my wonderful friends.

My thanks, of course, to David and Sarah King for their interest, encouragement and bullying!

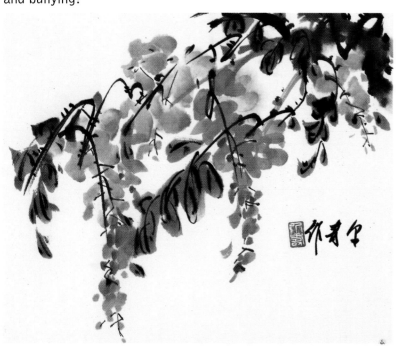